THE NAKED ARTIST
'Art and Biology' & Other Essays

PETER FULLER

Writers and Readers

Writers and Readers Publishing Cooperative Society Ltd.
144 Camden High Street, London NW1 0NE, England

Published by Writers and Readers Publishing Cooperative 1983

Cover Design Chris Hyde

Photoset and printed in Great Britain by Photobooks Ltd,
Barton Manor, St Philips Bristol

ISBN Case 0 863160 45 X

ISBN Paper 0 863160 46 8

CONTENTS

LIST OF ILLUSTRATIONS

ACKNOWLEDGEMENTS

'Art and Biology' first saw the light of day as a seminar which I delivered to M.A. students at Goldsmith's College in 1980; a revised version was given at the Tate Gallery in 1981, in a series of lectures held to commemorate the 150th Anniversary of the British Association for the Advancement of Science; and the text of this appeared in *New Left Review* No 132. 'The Necessity of Art Education' was first given as a seminar at the Polytechnic of Newcastle-upon-Tyne, in January 1981, when I was 'Critic-in-Residence' there; subsequent versions were given at the Ruskin School of Drawing in Oxford, and to the conference of the art section of NATFHE, the National Association of Teachers in Further and Higher Education, in 1982; texts of it appeared in *Art Monthly* and subsequently more fully in *Aspects*. 'Aesthetics and Nuclear Anaesthesia' originally appeared in *Artscribe*; 'Poussin: Et in Arcadia Ego', 'Gainsborough and Sociology', 'Edwin Landseer: animal crackers', 'Wyeth's World', 'Spencer's Lost Paradise', 'Strange Arts of Ancient Egypt', 'A New Spirit in Painting', 'Sebastiano Timpanaro', and 'Donald Winnicott' in *New Society*; 'Salvador Dali and Psychoanalysis', 'Aftermath in France', 'Patrick Heron', 'Jennifer Durrant', 'Adrian Berg', 'Ken Kiff', 'Lee Grandjean and Glynn Williams', 'The Arts Council Collection', 'Painting and Weaving in Africa', 'The Maker's Eye', and 'Morality and the photograph' in *Art Monthly*; 'Richard Hamilton', 'Who Chicago?', 'Hayward Annual 1979', and 'Hayward Annual 1980' in *Aspects*; and 'Textiles North' in *Crafts*. I am grateful to the editors and publishers of all these periodicals, both for publishing these texts in the first place and for allowing me to reprint them here.

I would also like to extend my thanks to Glenn and Sian Thompson, of Writers and Readers, who went far beyond the call of duty in shepherding me through the difficult period when many of these essays were being written, and to Jane Clemson for her editorial work on the text.

Many of these essays were written when I was 'Critic in Residence' at Newcastle Polytechnic. I am grateful to Professor Thomas Bromly, the Head of Faculty of Art and Design both for inviting me to Newcastle in the first place—and for his unfailing support and encouragement while I was there.

PREFACE

The lectures, essays, and reviews collected here were written after those contained in *Art and Psychoanalysis, Beyond the Crisis in Art*, and *Seeing Berger*, all of which were published by Writers and Readers in 1980. In many ways, these texts represent developments from and applications of the themes first stated there.

'Art and Biology' is, in effect, an attempt to take the argument on one stage further from the last chapter of *Art and Psychoanalysis*. In a generous review of that book in *The Sunday Times*, Anthony Storr wrote that in my work he missed 'a biological perspective unconnected with inter-personal relations'. I hope he will now feel that I have at least gone some way to putting this ommission right. Equally, however, my attempt to show how the achievement of the capacity for fully human aesthetic experience and cultural life was dependent on certain developments in our natural history cannot, of course, exclude consideration of the development of 'interpersonal relations'.

'The Necessity of Art Education' poses the question as to whether those potentialities are not now perilously threatened by certain historical factors—in particular, the development of advanced technologies in conjunction with alienating economic systems. It also argues that much post second world war teaching, in British art schools at least, has tended to collaborate with those forces which are eroding the 'aesthetic dimension' in our time. I call for a re-routing of art education in a way which will emphasise imagination, basic skills, tradition, and perception of the natural world: I think that a higher education in Fine Art should be based on *drawing* rather than the pursuit of some intangible fine art attitude—as the second Coldstream Report recommended.

'Aesthetics and Nuclear Anaesthesia' reflects my involve-ment with artists' anti-nuclear and peace initiatives: in this essay, I try to show that the end product of the sort of cultural

'de-aestheticization' we see around us will be the 'General Anaesthesia' of nuclear war. The elimination of the aesthetic dimension from human culture may be synonymous with the destruction of the very basis upon which that culture depends for its survival.

The essays on individual artists, and exhibitions, inevitably reflect these overall perspectives: above all, they indicate the importance I place on the artist's capacity to create 'new realities within the existing one'; on material practice; on affective and imaginative nuance; and on the importance of tradition. Indeed, my aesthetics are in most respects *conservative* (or at least *conservationist*). I am sceptical about notions of 'progress' when applied to the arts, and I have little sympathy with the Modernist idea that stylistic newness, and accommodation to the dominant means of producing and reproducing imagery, are somehow *necessary* for the creation of significant art. For example, I cannot abide the work of Richard Hamilton, reviewed below: Hamilton, in my view, prostituted Fine Art by allowing his imagination, and his material practices, to be deeply penetrated by (and at times dissolved into) contemporary anaesthetic means of making imagery. Aesthetic conservatism seems to me to be necessary as a defence of the fullness and breadth of what is possible in the making of art: nor does it seem in any way incompatible with intelligent economic and political radicalism. There is no more reason why a socialist should support the extreme philistinism of the contemporary avant-garde than the Japanese whaling fleet, or the pro-nuclear arms lobby.

Indeed, I am sure that these essays reflect a shift in taste which is not only personal, but also cultural: all around us, in art, design and architectural activities and institutions, we can see the final collapse of Late Modernism. Today, there is a healthy revival of interest in the expressive possibilities of painting, sculpture and drawing; the crafts are going through an unprecedented (but not unproblematic) revival; ornament is flooding back into architecture: understandably, those great critics and practitioners of the 19th century, John Ruskin and William Morris, are being revalued and revisited. Whether vital new aesthetic practices and traditions will succeed in emerging out of all this ferment, only time will tell. There are major obstacles, including the absence of a shared symbolic order of the kind provided by a religion. Indeed, logic and

sociological analysis conspire to indicate that pessimism is well-founded. But it is one of the themes of this book that neither logic, nor sociology, on their own can provide us with a sufficient account of the phenomenon of art.

PETER FULLER
MARCH 1982

For Rosie van der Beek

I THEMES

ART AND BIOLOGY

I originally gave this lecture at the Tate Gallery in November 1981 as a contribution to a series of talks on 'Art and Science' held to celebrate 150 years of the British Association. However, I had first explored many of the ideas put forward here in a seminar with students on the Goldsmith's College M.A. course in Fine Art during the summer of 1980. In effect, this paper represents the development and extension of the line of inquiry I was pursuing in my book, Art and Psychoanalysis.

You may wonder what contribution to this topic might be made by someone associated with the Marxist tradition of writing about art, a tradition which has always stressed sociological and historical factors, and in which the very category of 'Art and Biology' would appear to have no place. About ten years ago, a comparable series of lectures was organized at the Institute of Contemporary Arts—in fact by one of the contributors to this series, Jonathan Benthall—and a Marxist was asked along to give the final talk. He told everyone that he found it worrying that the ICA was—I quote—'turning deferentially to science for social and cultural wisdom and guidance'. He proceeded to argue that there was no such thing as 'human nature' accessible to science, that all the findings of science were historically relative . . . and so on, and so forth.[1] Perhaps you thought that was going to be my role in this series. But it isn't.

Recently, I have come to realize that the natural sciences—especially the biological sciences—have a great deal to teach us about art, and that the sociological traditions have ignored biology at their own peril. For example, a few years ago I was asked to contribute to one of those interminable conferences 'Art, Politics and Ideology' which were so typical of the late 1970s. In the course of a heated exchange with a prominent post-structuralist art historian, I found myself saying to her, 'Well then, how do we know the Laocoon is in pain?' To which

she replied, 'We know the Laocoon is in pain because we have
studied the modes of production prevailing in Greece at the
time it was made, and the signifying practices to which it gave
rise.' To which I replied, 'But Griselda, he's being strangled by
a sea monster.' 'Yes,' she retorted, 'but we have no means of
knowing whether or not he's enjoying it. . . .' And she was not
joking. It was then that I realized that it was high time that I
turned deferentially to science for some social and cultural
wisdom and guidance.

I cannot, however, claim that I am the only writer coming
out of the Marxist tradition to start thinking in this way.
Indeed, Marx himself once recognized that art could not easily
be accommodated within his theories; he wondered about how
it was that if the Greek arts were bound up with certain forms
of social development (as they so manifestly were), they could
still afford us pleasure today. Since Marx's time, this question
has become ever more acute with the uncovering of the arts of
ancient cultures of which he knew nothing. As the late Glyn
Daniel, an eminent prehistorian, once pointed out, if we want
to *understand* prehistoric art we certainly need to know
something about the chronology of prehistory and its various
cultures; but, even without such knowledge, we can *enjoy* in a
discriminating way the artistic creations of prehistoric man.
Until very recently neither Marx, nor any of his followers, had
anything at all intelligent to say about this vast problem of the
aesthetic transcedence of great works of art.

In the last few years, however, some thinkers within the
broad Marxist tradition have begun to recognize that, the great
historical transformations of human societies notwithstanding,
there are very important elements of human experience that
remain 'relatively constant' and are subject to change only
through the infinitely slow processes of biological evolution,
not through social, political, or economic developments. The
Italian, Sebastiano Timpanaro, is one such thinker who has
influenced me deeply: he points out that man as a biological
being has remained essentially unchanged from the beginnings
of civilization to the present, and that 'those sentiments and
representations which are closest to the biological facts of
human existence have changed little.' Much art, Timpanaro
suggests, touches upon and indeed draws its strength from
such sentiments and representations: it deals with birth,
infancy, love, sexual reproduction, ageing, death, and our sense

of smallness given the limitlessness of the cosmos.[2] Of course, the experience of such things is necessarily socially mediated; but if, using socially inflected conventions, the artist is able vividly to speak of such fundamental elements of experience, there is no great mystery as to why his work has the potentiality to outlive its time. We are moved by the Laocoon at least in part because—whatever our knowledge of Greek society—we know something of the capacities of the human body in struggle and suffering, and these have not changed much since Greek times.

But it isn't just a question of enduring sentiments and representations. Raymond Williams has pointed out that the deepest significance of a relatively unchanging biological human condition is probably to be found in some of the basic material processes of the making of art: in the significance of rhythms in music and dance and language, or of shapes and colours in sculpture and painting. Williams argues that where such fundamental physical conditions and processes are in question, there can be no reduction 'to simple social and historical circumstances': the material processes of the making of art involve biological processes which can be, and often are, the most powerful elements of the work.[3]

The scattered clues in thinkers like these set me off on a long journey in search of the biological roots of art, a journey which took me through mountains of ethological, biological, archaeological, and psychoanalytic evidence which I was peculiarly ill-equipped to climb. Certainly, my conclusions remain speculative: but I believe that they amount to a new hypothesis about the nature and origins of artistic activity which is, at least, rooted in materialist knowledge. I think we have to begin by recognizing that when we are dealing with the problem of art, we are always dealing with two separate but closely related questions: aesthetic response, and aesthetic (or perhaps 'expressive') *work*. The sorts of questions we need to begin by asking are what are the rudiments of these twin roots of art in species other than our own, and what can we learn from the study of them about the nature of these phenomena in our own species?

Take first the question of aesthetic response. Self-evidently, although we experience this in relation to works of art, we also experience it in relation to other things—like flowers, animals, mountains, minerals, waterfalls, vistas and natural scenery of

all kinds as well. Darwin pointed out that this sort of response was almost universally observable among men, however variable the objects they admired might be. The problem, for him, was to account for this widespread trait in evolutionary terms.

Darwin tried to separate out a 'sense of the beautiful' (by which he intended to refer only to the pleasure given by certain colours, forms and sounds) from complex ideas and trains of thought with which, he says, it is self-evidently associated in 'cultivated men.' 'Obviously', Darwin writes, 'no animal would be capable of admiring such scenes as the heavens at night, a beautiful landscape, or refined music.' Such 'high tastes', he explained, 'are acquired through culture and depend on complex associations; they are not enjoyed by barbarians or by uneducated persons.' (One has to forgive Darwin his Victorian prejudices!) Nonetheless, Darwin believed that this 'sense of the beautiful' was something man had in common with other animals. 'When we behold a male bird elaborately displaying his graceful plumes or splendid colours before the female,' Darwin wrote, 'whilst other birds, not thus decorated, make no such display, it is impossible to doubt that she admires the beauty of her male partner.'

As we shall see, others have doubted it; but Darwin went on to argue that, with the great majority of animals, 'the taste for the beautiful is confined . . . to the attractions of the opposite sex.' In this term, 'sense of the beautiful', Darwin of course included not just visual phenomena but also, as he put it, 'the sweet strains poured forth by many male birds during the season of love.' He also noted that certain humming and bower birds even gathered petals, coloured stones, and other bright objects with which they decked their nests; an activity in which, perhaps, we can see the instinctive sense of the beautiful beginning to phase into residual aesthetic *work*. Darwin offered no explanation as to *why* certain colours, tunes or combinations of shapes might be found pleasing to individuals within any given species, beyond suggesting that habit came into it, and, as he put it, 'habits are inherited.' He did refer, *en passant*, however, to the work of the great Helmholtz, who had explored the physiological bases of harmonies, certain cadences, and tones among men.

But Darwin was concerned only to argue that when such preferences arose—in whatever species—they played a role in

natural selection because, as he put it, 'the males which were the handsomest or the most attractive in any manner to the females would pair oftenest, and would leave rather more offspring than other males.' He went on to suggest that the original function of the 'sense of beauty' was not radically different among human beings, drawing attention to the apparent likeness between the patterns with which 'even the lowest savages' (as he called them) ornament themselves, and the similar adornment with which natural selection endows certain parts of some animals—for example, the facial and genital regions of many male monkeys. We do not even have to go along with Darwin's specific explanation of the phenomenon in terms of sexual selection, to which there are serious objections to accept his general point, namely that the rudiments of a sense of beauty are discernible in species other than our own.

Since the late nineteenth century, however, Darwin's view has been challenged, not only by aestheticians, but also by other biologists who have sometimes argued that lower animals experience only 'an instinctive congenital response', to 'signal stimuli', and not true aesthetic feelings. Those who take this line, however, invariably have to admit that certain phenomena like complex bird-song, with all its infinite variations, often incorporating mimetic elements, are peculiarly difficult to explain. Jackdaws, for example, after being trained to certain rhythms, are able to recognize them even when played by different instruments, ie with a different tone quality (or timbre), or even when the tempo, pitch or intervals are altered.

This suggests something more complex than 'congenital response'. But Darwin and his critics may not be as far apart as they appear. In the nineteenth century, Grant Allen argued in his book, *Physiological Aesthetics*, that aesthetic experience was the specifically human manifestation of an instinct deeply rooted in animal nature; he tried to explain why we enjoy certain combinations of colours, certain forms, patterns, and musical structures in anatomical and biological terms. I, too, believe that the aesthetic response in human beings probably has its roots in congenital, instinctive responses, but these are subject to some peculiarly human (rather than merely bird-like) processes of transformation.

The pursuit of the physiological roots of aesthetics passed

out of fashion when it was ridiculed by such idealist thinkers on art as Benedetto Croce, at the turn of the century. But I believe that researches of this kind have a lot to teach us about why it is that we can enjoy, say, medieval madrigals, Japanese kimonos, Islamic architecture, Navajo Indian rugs, or many kinds of decoration and rhythm without knowing the first thing about the societies from which they came. They may also eventually tell us quite a lot about why we enjoy decorative and rhythmical elements in much more complex works. Perhaps they will ultimately demonstrate something that should make 'pure' formalist painters think: that is that there is, indeed, an isolatable, 'pure', aesthetic faculty, but this is no more than a crude animal capacity like oral taste which man shares with many lower species. Indeed it seems to me that the formalists who say that aesthetic response is just a matter of having a 'good eye', or a 'good ear,' are on a very dangerous wicket. But so was John Ruskin when he said 'I take no notice of the feelings of the beautiful we share with spiders and flies.' In the narrowest, formalist sense the aesthetic achievements of animals clearly outstrip our own. For example, all birds, dogs, and even fish (gudgeons as a matter of fact) ever investigated in this respect were found to have perfect pitch. Few humans possess this. Gudgeons then presumably have 'better ears': but, as we shall see, it is precisely because the 'sense of the beautiful' in man, though rooted in the sense organs, and genetically inherited responses, is *not* wholly dependent on them that it acquires its specifically human character.

Let us turn now to the question of aesthetic expression as opposed to aesthetic response. If you think about so-called 'primitive' cultural activity with its roots in song, dance, body ornament, ritual, rhythm, and mime, it really is not difficult to point towards parallels for such pursuits in nature. I have already had something to say about the songs of birds; but think now of an equally interesting aspect of bird-life, the elaborate courtship and mating rituals, with all their attendant dances and displays, in which so many birds engage.

A pioneering study in this terrain was Julian Huxley's extraordinary little book, *The Courtship Habits of the Great Crested Grebe*, first published in 1914. Its implications extend far beyond ornithology: Huxley observes that there are many birds—penguins, swans, divers, guillemots, and so on among them—which lack special physical display, or ornamental

structures, on the male but which nonetheless go through courtship rituals of very great complexity. The nature of these rituals fascinated Huxley. He realized they could not be accounted for by Darwin's theory of 'sexual selection'. Their overall pattern seemed in some ways determined by genetically inherited codes; nonetheless they could be shown to include elements which had lost all functional use for the species, and seemed to be being pursued for their own sake—or rather for the ritual's sake. Moreover, the choice of dance movements, shaking-bouts, displays, etc. was subject to wide-ranging individual variation. Huxley records the surprise and reluctance with which he was forced to the conclusion that these rituals were essentially the *expression of emotions* among male and female birds; the material through which such expression was realized being the often functionally useless inherited behaviour patterns. As Konrad Lorenz has pointed out, the revolutionary element in Huxley's work was that he discovered the remarkable fact that certain movement patterns, in the course of phylogeny or the evolution of a species, lose their original, specific function and become almost symbolic ceremonies. Here, I think, we are coming very close to a rudimentary version of certain aesthetic pursuits among men.

Indeed, in a fascinating study on behaviour and civilization, Otto Koenig showed that the laws of biological phylogeny are apparently valid for certain cultural historical-processes: he demonstrated that in many man-made objects, like items of dress and armaments, the gradual loss of functional significance of a particular element or feature is commonly associated with an increase in its ornamental character. One example among many which he gave was the evolution of the chin-strap in Austrian military helmets, and its transformation from a protective device to an ornamental element with no functional purpose at all. Thus the strap that once secured the helmet became an embellishment of it, an expressive or *aesthetic* feature.[4]

But it is by no means clear that the movement is always *from* the functional *towards* the aesthetic—at least not in any straightforward way. We cannot get far in our investigation of the biological roots of art without considering the question of *play*. Play, of course, is an activity which humans share with many other species: the play of, say, kittens and young chimpanzees is known to everyone. In the late nineteenth

century, there was a flurry of really rather interesting books studying the play of both man and animals and relating both to artistic activity and expression. For example, Herbert Spencer argued that artistic activity was just a specially valuable form of play. In beauty, we enjoy the greatest quantity and intensity of stimuli with the least effort. I do not think we have to go along with Spencer's dubious theories likening biological processes to mechanical concepts of 'energy' to realize the importance of his general point that there *is* something about art which resembles play, and that this something has to do with the fact that both seem to belong, as Spencer himself put it, to a realm beyond that of function and necessity.

Nonetheless, it must also be admitted that, in creatures other than man, play is clearly biologically functional. Jane Egan once made a very interesting study of the play of a kitten with a woollen ball. She concluded that this play was not a category of behaviour distinct from true predation. In its play the kitten's behaviour follows the same motor-patterns as in prey-catching, and it responds to the same stimuli —small size, fur, 'animal smell', movement, and so forth. The kitten's relation to the wool ball is thus functional: it is a form of learning about solitary hunting; and, indeed, when the kitten has mastered the skills necessary to hunt, it ceases to play. As we shall see, play in children, and indeed in adults, seems much less immediately adaptive—much more dissociated from the development of specific, instinct-rooted skills.

It is possible that although phenomena like courtship and play are precursors of artistic activity in general they tell us very little about expression in those art forms with which we are primarily concerned: activities like painting, sculpture and drawing. The decisive difference here is that between a performance and workmanlike pursuits, culminating in an aesthetic (or non-functional) object which exists outside the organism's own body. Of course, many animals—like bees, ants, birds and beavers—work; but their labours are highly functional. A possible exception is that mentioned earlier: the case of the bower birds with their brightly coloured ornaments. But, as Darwin suggested, their activities seem like the precursors of mere fancy, rather than the imaginative labour characteristic of high art.

There is however a much more instructive exception than that: that is the case of *primate* art. John MacKinnon has

pointed out that chimpanzees, in captivity, dress up and enjoy self-decoration; they have a natural sense of rhythm and love to beat on drums; they make wind-borne patterns with dust, scratch in the mud, and execute splendidly colourful paintings.[5] These paintings have been studied by several researchers. For example, Desmond Morris—on whose findings I have drawn heavily—worked with an ape called Congo in the 1950s; and Congo even got a one-chimp show at the ICA.[6]

Morris compared the development of the chimpanzee's drawing closely with that of the child. Chimps and children both become interested in the activity at about one-and-a-half years of age. They start by covering the sheet with scribbly lines, which become firmer, more rhythmical, and more organized as time goes by. But, during the third year, child and ape art become markedly different. The average child starts to simplify its confused scribbling, to experiment with basic shapes—crosses, circles, squares, triangles and so on. Meandering lines are led round the page until they join to enclose a space. Lines turn into outlines. The simple shapes are then combined one with another, to produce abstract patterns. A circle is cut by a cross; the corners of squares joined by diagonal lines. Then, when the child is about three, comes the great break-through into representation; in the chimp, it never comes.

Like the child, the young chimp develops its composition —even using colours more harmoniously. The chimp gets to the point of making fan patterns, crosses and circles . . . and it goes no further. It is particularly tantalizing that the marked-circle motif is the immediate precursor of the earliest representation produced by the child. A child will place a few lines and dots inside the outline of a circle, and then, with a sudden flash of recognition, realize that a face is staring back at him, that his marks, out there in the world, stand for, or represent, something else . . . thence-forth, representation dominates in child art over and above abstract and pattern invention. The ape stops without making that leap: once it has drawn and marked its circle, on the threshold of an image, it continues to grow, but its pictures do not.

Now let us look back at the evidence we have been exploring: all these rudimentary biological precursors of aesthetic experience and aesthetic expression; the sense of beauty; natural ornament and decoration; expressive rituals

even ape painting. Why among all of them is there nothing we would feel happy to call 'a work of art'? The clue, I think, lies in the phrase itself: a work of art. This implies a complete symbolic world, which can exist independently of the organism's own body, but which belongs, as it were, neither to the organism itself nor to existing external reality (in the sense which both natural and man-made functional objects do). It is certainly possible to discern something approaching symbolic activity among animals. Remember the grebes, or the kitten's ball of wool? But there is always something meagre about this symbolism, something intolerably close to the functional appearances and behaviour patterns as given by natural selection. The degree of symbolic transformation remains slight; the animal appears to be constantly constrained by its immediate functional relationship to reality; the ape's circle is always just that. An ape's circle. It never constitutes a face. In short, the animal's aesthetic activities exist without a culture.

We must now ask, and very briefly answer, a vital question: 'What is culture?' Everyone argues about what culture is. As Leslie White has written, 'Stone axes and pottery bowls are culture to some anthropologists, but no material object can be culture to others. Culture exists only in the mind, according to some; it consists of observable things and events in the external world, according to others.' But White drew attention to what he calls, 'a class of phenomena, one of enormous importance in the study of man, for which science has as yet no name: this is the class of things and events consisting of or dependent on symboling.' White called such phenomena 'symbolates'. A symbolate, he said, can be a spoken word, a stone axe, a fetish, avoiding one's mother in law, loathing milk, saying a prayer, sprinkling holy water, a pottery bowl, casting a vote, or whatever. A symbolate, he argued, could be considered in two contexts. From what he calls 'the somatic context', that is the point of view of the behaviour of the individual organism; but symbolates can also be considered in an 'extrasomatic context'; ie in terms of their inter-relationships among themselves. Culture, White suggests, 'is the name of things and events dependent upon symboling, considered in an extrasomatic context.'[7]

Culture, therefore, is an outgrowth of man's capacity for labile symbolization, and his ability to detach his symbols from himself into a third area of experiencing which is neither quite

'objective' nor quite 'subjective'. But here it is important to emphasize a point made by two well-known socio-biologists (with whom I don't agree too often), Lionel Tiger and Robin Fox. 'Men', they say, 'are not simply creatures of culture, they are the creatures that create culture because that is the kind of creature that they are.' Or, as Grahame Clark puts it at the beginning of his little book, *From Savagery to Civilization*: '. . . the evolution, nay the very possibility of culture depends on physical attributes which in man have attained a unique stage of development. However much the organism is overlaid by culture, (the organism itself) remains the basis of life, and though it may be modified by culture, culture itself must perish without a firm and sound foundation in biological reality.'[8] What then is this foundation of culture in biological reality, for it is culture, more than anything else, that distinguishes the life—including the aesthetic life—of man from that of the animals?

Now I think we can begin to understand this problem of the biological roots of culture if we consider two quite different kinds of evidence: firstly the evidence from the study of prehistory and biological theory; and secondly that produced by recent psychoanalytic research. Let us take the former first.

This is a very complicated subject, filled with contention and rival theories. I want to give you just the bare bones of an argument. 'Culture' is a recent development in the natural history of human beings. A rough chronology for you: the mammal species ancestral to both man and ape lived about twenty million years ago. The first recognizable departure from that along the hominid line occurred approximately fourteen million years ago. Along this line we then find two hominid species—africanus and erectus—before the emergence of homo sapiens, whose development includes various types— Neanderthal man making his appearance around 35,000 years ago. Neanderthal man is the creature around whom controversy rages, for it is with him that we get the first glimmerings of higher culture. True, stone axes and so forth appear at least two-and-a-half million years earlier, but, with Neanderthal man, we find evidence of burial rites, and simple carvings incorporating unmistakable bodily and sexual symbolism, and even representations of animals in painting and engraving which we first come across a little before 30,000 BC. Then, suddenly, there is an efflorescence of cultural activity evidenced

in those famous prehistoric cave paintings which belong to a period between about 30,000 and about 8,000 BC. This efflorescence was associated with a major evolutionary transformation of homo sapiens, in which Neanderthal man slowly gave way to Cromagnon or modern type man—who became increasingly culturally adept, and artistically sophisticated. If we want an answer to the biological origins of culture, we have to look closely at what happened in human evolution at this time.

As a matter of fact, we know a good deal about what was going on in the biology of our species as Neanderthal man changed into the Cromagnon type. Here, I wish to draw attention to one vital factor, which played an enormous part in human development. I am referring to the phenomenon of neoteny. Neoteny is a process through which the early stages and features in the development of an animal are retained into later periods of growth; it is easiest to think of it as a sort of slowing down of growing up.

Neoteny, it seems, played a part in the development of humankind even from the earliest times; one can see its effects in human beings in innumerable ways. For example, the growth process for humans takes roughly twice as long as for the African apes—twenty years as against ten to eleven years—whereas foetal duration and the onset of sexual maturity are roughly the same. There are innumerable features in adult human beings—like the skin flaps beside the vaginal entrance—which are matched only in the juvenile stages of apes. The most famous of these is, of course, hairlessness— hence 'The Naked Ape' and all that. Like the infant ape's, most of the adult human's hair is clustered at the top of the head. To survive, of course, neotenous features must bestow some biological advantage. Now although neoteny operated at several stages in human evolution, it was transformingly operative in Neanderthal times. Indeed, the difference between hairy, ape-like, squat, early Neanderthals and their Cromagnon successors can largely be explained in neotenous terms.

What advantage derived from this accentuation of neoteny? Here, I am relying on the fascinating findings of Desmond Collins.[9] He points out that the most extraordinary fact about late Neanderthals was their large brain size—larger even than today's average. Now, other things being equal, it would seem that increasing brain size was an adaptive advantage. But there

was a good reason why the brain could not go on increasing indefinitely: childbirth.

Every infant born normally passes—usually head first—through its mother's pelvic aperture. There is so little room to spare that the child's head has to be forced through. Today, this squashing of the skull is possible because, in the human infant, the skull bones—thanks to neoteny—ossify much later than in apes. But Collins invites us to imagine the predicament of Neanderthal mothers, whose pelvic size was much the same as that of modern human's, trying to give birth to babies whose brain size had increased by twenty per cent and whose skulls were too rigid to squash. It has been suggested that infant mortality among late Neanderthals may have run as high as ninety per cent.

Neoteny—or this attentuation of growth processes—was the perfect escape mechanism from this evolutionary impasse: in apes, the infant's brain size at birth is fifty five per cent of its full size. In modern humans the figure is only twenty three per cent. Thus neoteny gave the big-brained a new lease of birth. Those infants with a low birth-to-adult brain size percentage survived to become the parents of the next generation. So in late Neanderthal man we see these child-like creatures emerging, and taking longer to grow up. Why should such changes have been associated with the capacity to make 'symbolates' and works of art? One result of neoteny was the prolongation of the infant's dependency upon the mother: so slow did the infant's growth became that, for a greater part of its life than ever before in higher primate natural history, its relations to the external world had to be mediated through the person of the mother.

The little pig, when it is born, runs round the side of its mother, fights for a place in the line against its siblings, and vigorously suckles the teat. The infant monkey immediately clings tightly to the fur of its mother's belly. The bison falls from the womb, dries itself in the sun, and within minutes is following the herd. The human infant lies helpless, lacking even the motor power to seek out the mother's breast if it feels hungry. If the mother declines to attend to its every need, it dies. *Objectively*, this infant-mother relationship is radically different from that to be found anywhere else in the animal kingdom. *Subjectively*, we may suppose, the experience of the infant within it is radically different too.

And it is the nature of this unique subjective experience that—thanks to recent advances in psychoanalysis—we are just beginning to understand. As you may know I have a high admiration for the late psychoanalyst, D. W. Winnicott, and his descriptions of the infant's eye view of this biologically unique relationship. I make no apologies for outlining his insights again here—since they are absolutely central to my arguments.

Winnicott describes the infant as enveloped within and conditional upon the holding environment (or mother) of whose support he becomes gradually aware. Winnicott speaks of a primary condition which is, simultaneously, one of 'absolute independence and absolute dependence.' The 'absolute independence', of course, comes from the infant's blissful unawareness, in the first instance, of anything other than self—whereas, say the piglet, has to make immediate, active contact with external reality. Winnicott says the infant makes its first contact with reality through 'moments of illusion' which the mother provides. For example, such a 'moment of illusion' might occur when the mother offered her breast at exactly the moment the child wanted it. Then the infant's hallucinating and world's presenting could be taken by him as identical, which, of course, they never in fact are. In this way, Winnicott says, the infant acquires the illusion that there is an external reality that corresponds to his capacity to create. But, for this to happen, the mother has to be bringing the world to the baby in an understandable form, and in a limited way, suitable to its needs. Later, she has also to take the baby through the process of 'disillusion' (or acceptance of a separate external reality), a product of weaning and the gradual withdrawal of that identification with the baby which is part of the initial mothering.

Winnicott's conception of illusion had taken him beyond a sharp distinction between 'inner' and 'outer' worlds; thus he was led towards his famous theory of 'transitional objects and transitional phenomena.' He began to describe what he called 'the third part of the life of a human being, a part that we cannot ignore, an intermediate area of *experiencing*, to which inner reality and external life both contribute.' Winnicott drew attention to 'the first possession'—the rag, blanket, teddy bear, or other 'transitional object' to which a young child becomes attached. He saw that the use of such objects

belonged to an intermediate area between the subjective and that which is objectively perceived. The transitional object presents a paradox which cannot be resolved but must be accepted: the point of the object is not so much its symbolic value as its actuality; and then again, it is not so much its actuality as its symbolic value. The use of the transitional object, Winnicott said, symbolized the union of two now separate things, baby and mother, and it did so 'at the point in time and space of the initiation of their state of separateness.'

In this way, he came to posit what he called a 'potential space' between the baby and the mother, which was the arena of 'creative play'. Human play, for Winnicott, was thus itself a 'transitional phenomenon'. Its precariousness belongs to the fact that it is 'always on the theoretical line between the subjective and that which is objectively perceived.' This 'potential space' he saw as arising at that moment when, after a state of being merged in with the mother, the baby arrives at the point of separating out the mother from the self, and the mother simultaneously lowers the degree of her adaptation to the baby's needs. At this moment, Winnicott says, the infant seeks to avoid separation 'by the filling in of the potential space with creative playing, with the use of symbols, and with all that eventually adds up to a cultural life'. He pointed out that the task of reality acceptance is never completed: 'no human being is free from the strain of relating inner and outer reality.' The relief from this strain, he maintained, is provided by the continuance of an intermediate area which is not challenged: the potential space, originally between baby and mother, is ideally reproduced between child and family, and between individual and society or the world. This potential space, Winnicott believed, was the *location of cultural experience*: 'this intermediate area,' he wrote, 'is in direct continuity with the play area of the small child who is "lost" in play.' He felt it was retained 'in the intense experiencing that belongs to the arts and to religion and to imaginative living, and to creative scientific work.'[10]

Now it seems to me that we have here, at least in part, an explanation of why the acceleration of the biological process of neoteny in late Neanderthal times was associated with the emergence in our species of symbolism, art and culture. Winnicott demonstrates that the psychological processes of the human infant—given its strange position of absolute

independence and of absolute dependence—differ from those of other creatures. The piglet is constrained (if it is to survive) to relate immediately through its instinctual drives to the reality of the sow's teat. But the human infant's instincts play rather into a world of illusion and imagination. When the human infant is hungry he does not seek the breast; he *imagines* it: and the mother, if she is good enough dips reality into those imaginings, so that the infant believes he has created reality through fantasy. The adult is never free of this longing to create a world through imagination again, and this, I believe, is the biological core of the cultural activity which erupted in late Neanderthal, and early Cromagnon times, and continues down to our own times.

It would, of course, be wrong to imply that the higher species, other than human kind, are altogether lacking in imagination: imagination, after all, is simply the faculty of forming images (or concepts) of external objects not present to the senses. The empirical study of the Rapid Eye Movements of mammals strongly implies that—with the possible exception of ungulates—they all dream; and dreaming, as Charles Rycroft has put it, is merely the form the imagination takes when one sleeps.[11] However there is every reason to suppose, and of course no way of proving, that the dreams of animals contain no complex symbolizations, but are concerned with simple imagery relating to basic drives, like food, sex, flight, fight, submission, etc. Because the human infant is, as it were, out of gear with reality, its imagination acquires this infinitely labile, transforming, and world-creating quality which, as far as we can surmise, is unique in the animal kingdom. Darwin and Marx both recognized this peculiar quality of imagination as *the* decisive human faculty, affecting all man's pursuits and activities. Traditionally, of course, it has been explained through religious categories; but we have been tracking it back to its biological roots.

The way in which man's instinctive activity can relate to his imaginative life, rather than to his immediate struggle for survival, is of course reflected in all his drives. Our sexual drives, eating habits, and needs for shelter and protection for our vulnerable naked bodies all conspicuously detach themselves from mere function and necessity. It is this relationship to imagination rather than immediate reality which accounts for the disinterested quality of human play, in comparison with

that of, say, our kitten. It also explains why the aesthetic instincts which humankind shares with other animals acquire in us a freedom from congenital response, and a capacity to be deployed in symbolic and cultural life.

But here we have to be very careful. Neoteny (combined, no doubt, with the neurological evolution of the brain) enriched humanity's psychological processes, endowed us with the capacity for symbolic and imaginative thought, and gave rise to a dream life fuller than that of any other species. But it did not, in and of itself, render the production of art possible. A dream is an intra-psychic process, a message from one part of the self to another. A work of art exists materially in the world where it can be seen and experienced by others; it is, if you will, *expressed*.

The roots of expression in the plastic arts lie not only in the aesthetic instincts, but also in *bodily expression*, in facial expression, or physiognomy, in particular. Facial expression was probably the basic form of communication in our species. Humans have the most complex facial masculature of any animals. By making small movements of the flesh around the mouth, nose, eyebrows, and on the forehead, and by re-combining these movements in a wide variety of ways, we can convey a whole range of complex mood-changes. In biological terms, it seems probable that facial expression was a means of cementing that infant-mother social bond, so necessary if the young human infant is to survive. In no other species is there so great a necessity for an infant and mother to communicate their needs to each other . . . And again, as Winnicott has shown, the mother's face (together with her breasts) enters deeply into the child's first conception of self and other. Although pure formalists appeal to what I think are our biologically given aesthetic instincts, Leonardo and Poussin were not alone in seeing physiognomic expression as the very root of a paintings capacity to move us.

The extension of expression from inter-somatic communi-cation to the capacity to create autonomous, expressive works of art required however the evolution of the human hand, which took place at the same time as that of the brain, and the onset of those neotenous phenomena we have been considering. For it was in Neanderthal times that man first developed that unique feature of his hand, the precision grip, *along with* the power grip he had long possessed. Without this precision grip,

the extraordinary delicacy of the works we see in Lascaux and Altamira, or for that matter in Poussin, Vermeer, or Rothko would never have been possible—whatever might have been going on in these artists' heads.

These then seem to me to be the principal biological roots of art: residual, genetically given aesthetic responses; a particular human capacity for work on the external world, and above all—this uniquely human faculty for transforming such elements, through labile symbolic and imaginative activity whose roots are to be found in the particularities of the infant-mother relationship in our species.

1981

1 Jonathan Benthall and Ted Polhemus, *The Body as a Medium of Expression*, London 1975
2 Sebastiano Timpanaro, *On Materialism*, London 1975
3 Raymond Williams, 'Problems of Materialism', *New Left Review* 109, p. 10
4 Otto Koenig, 'Behaviour Study and Civilization', in Gunther Altner (ed.), *The Nature of Human Behaviour*, London 1976
5 John MacKinnon, *The Ape Within Us*, London 1978
6 Desmond Morris, *The Biology of Art*, London 1962, and *The Naked Ape*, London 1967
7 Leslie A. White, 'The Concept of Culture', in M. F. Ashley Montagu (ed.), *Culture and the Evolution of Man*, New York 1962
8 Grahame Clark, *From Savagery to Civilization*, London 1946
9 Desmond Collins, *The Human Revolution: From Ape to Artist*, London 1976
10 D. W. Winnicott, *Playing and Reality*, London 1974
11 Charles Rycroft, *The Innocence of Dreams*, London 1979

THE NECESSITY OF ART EDUCATION

This paper was first given in Newcastle-upon-Tyne Polytechnic in January, 1981, when I was Critic-in-Residence there. Subsequent versions of it were also delivered at the Ruskin School of Drawing in Oxford—and at the National Association of Teachers in Further and Higher Education's Conference, in London, in February 1982. Newcastle University (as opposed to the Polytechnic) was an important centre for the development of the 'Basic Design' theories here criticized. When published in Art Monthly this text produced an intemperate response from one of the principal Newcastle 'Basic Design' protagonists—Richard Hamilton. I have not felt it necessary to amend my remarks in any way following Hamilton's intervention.

I have no need to remind anyone involved in education that we live in an era of rabid governmental cut-backs. Unfortunately, there are those in this situation who look upon art education as a sort of optional icing, or even a disposable cherry, on the top of a shrinking cake. Government education cuts have fallen disproportionately upon the art schools: the future of art education in this country is politically vulnerable in a way in which, say, the education of chemical engineers is not.

I want to begin by saying that I am an unequivocal defender of art education in general and of Fine Art courses in higher education in particular. I do not make this defence so much in the name of art as in that of society. I believe that 'the aesthetic dimension' is a vital aspect of social life: our society is aesthetically sick; without the art schools it would be, effectively, aesthetically moribund.

What do I mean by an aesthetically healthy society? The anthropologist, Margaret Mead, once noted that in Bali the arts were a prime aspect of behaviour for all Balinese. 'Literally everyone makes some contribution to the arts,' she wrote, 'ranging from dance and music to carving and painting.' This,

of course, did not mean that the arts were reduced to the lowest common denominator, or anything of that sort. As Mead puts it, 'an examination of artistic products from Bali shows a wide range of skill and aesthetic qualities in artistic production.'

If Mead's account is correct, I would certainly be prepared to say that the Balinese lived in an aesthetically healthy culture: that is one in which individual expression (in all the manifold imaginative and technical variations of each of its specific instances) can be freely realized, through definite, material skills, within a shared symbolic framework. This surely is what Ruskin and Morris were getting at when they contrasted Gothic with Victorian culture. Basically, I find myself in agreement with Graham Hough when he points out in his book, *The Last Romantics*, that, in the nineteenth century, a spreading bourgeois and industrial society left less and less room for the arts. As Hough puts it, the arts 'no longer had any place in the social organism.'

Once, the term 'art' had referred to almost any skill; but as so much human work was stripped of its aesthetic dimension, 'Art' with a capital 'A' increasingly became the pursuit of a few special individuals of imagination and 'genius', a breed set apart: 'Artists'. Of course, high hopes were invested in the new means of production and reproduction—from the mechaniza-tion of architectural ornament, to photography, mass printing, and eventually television and holography. But these things did not even begin to fill that hole in human experience and potentiality which opened up with the erosion of 'the aesthetic dimension' and its retraction from social life.

And so the art education system today is not just the most extensive form of patronage for the living arts in this country: it is the soil without which the arts would just not be able to survive at all. I would go so far as to say that the primary task of the art schools in general, and of Fine Art courses in particular, should be to hold open this residual space for 'the aesthetic dimension'. In one sense, this is a conservative function—like preserving the forests, or protecting whales. But in another it is profoundly radical: it involves the affirmation that a significant dimension of human experience is endangered in the present, but could come to life again in the future, and once more become a vital element in social life. In other words—and this really is at the root of all the problems in art education—it is

the destiny of the art schools, if they are successful, to stand as an indictment of that form of society in which they exist and upon whose governments they are dependent for all their resources. In such a situation, of course, it is inevitable that art education should be fraught with contradictions and conflicts about its aims and functions. Although the battle lines are rarely clearly drawn, the underlying struggles are usually pretty much the same: they are between those who are basically 'collaborationist' in outlook towards the existing culture, and those who perceive that the pursuit of 'the aesthetic dimension' involves a rupture with, and refusal of, the means of production and reproduction peculiar to that culture. This may sound a bit complicated, so let me give you a specific example: some of you may have read in the press some months ago about the battles at the Royal College of Art in London. Basically, these were about the 'usefulness' of painting and sculpture as taught in the Fine Art Faculty.

Richard Guyatt, who was then the rector, wanted the College to become a servant of industry. Guyatt had a background in advertising and the Graphic Arts: indeed, he was personally responsible for such triumphs of modern design as the Silver Jubilee stamps, the Anchor Butter wrapper, and a commemorative coin for the Queen Mother, issued in 1980. Predictably, when Guyatt was subjected to pressures from the Department of Education and Science, he responded by trying to drive the College along in a commercial, design orientated direction. As *The Guardian* commented, one question under debate was 'whether scarce resources formerly offered to scruffy painters and sculptors should be switched to designers who might make some concrete contribution to Britain's export drive.'

Inevitably, Guyatt clashed heavily with Peter De Francia, Professor of Painting, who clearly thought that it was preferable to teach students to create a 'new reality' within the illusory space of a picture, rather than to encourage them to design coins so ugly that consumers would want to get rid of them quickly in return for the slippery delights of New Zealand dairy products, or whatever. The battle was long and hard fought. Fortunately, given the support of his students, De Francia was able to win in the end: he remains as Professor of Painting, whereas Guyatt is no longer rector. But I have not

brought this up as an example of academic intrigue: the Royal
College affair was symptomatic of that struggle which has
constantly to be waged against the anaesthetizing encroach-
ments of the cultural collaborationists, even within the art
schools themselves.

Of course, it is not often that the values of a major painter
are so starkly pitted against those of a designer of coinage and
butter-wrappers. In this situation, I think that most people
who are involved, in any way, with the Fine Arts would have
little doubt about where we stood. But, of course, it is not
always as simple as that, and a major problem in recent years
has been the betrayal of the 'aesthetic dimension' within Fine
Art courses themselves. Indeed, I do not think that it is just a
matter of protecting and conserving Fine Art courses against
the Guyatt's of this world, but rather one of reforming and
rebuilding them, above all of undoing some of the damage that
has been done, especially since the last war.

You could, I think, see something of this damage in a recent
exhibition 'A Continuing Process: The New Creativity in
British Art Education, 1955–65', which told the story of the
establishment of the so-called 'basic design' courses, for Fine
Art students, and of the way in which they proliferated until
they became, effectively, the orthodoxy for a higher education
in art. 'Basic design' was pioneered at the University in
Newcastle by Victor Pasmore and Richard Hamilton, and
elsewhere, along rather different lines, by Harry Thubron and
Tom Hudson.

The fundamental premises of 'basic design' are not easily
identifiable; the various artist-teachers involved in the move-
ment pursued different, and sometimes contradictory, emphases.
But this much can be said with certainty: they are all united
negatively. 'Basic design' involved a wholesale rejection of the
academic methods of art education, rooted in the study of the
figure and traditional ornamentation. As Dick Field has
written, the watchword of the 'basic design' pioneers was 'a
New Art for a New Age', and they set out to be deliberately
iconoclastic towards what had become established academic
methods of teaching art.

David Thistlewood, who organized the exhibition, has
written that, as a result of 'basic design', 'The aims and
objectives underlying a post-school art education in this
country have changed utterly during the past twenty-five

years.' He says that 'Principles which seem today to be liberal, humanist and self-evidently *right* would have been considered anarchic, subversive and destructive as recently as the 1940s.' He claims that what used to exist, the old academic system, was 'devoted to conformity, to a misconceived sense of belonging to a classical tradition, to a belief that art was essentially technical skill.' For decades before the arrival of 'basic design', Thistlewood complains, there had been unhealthy preoccupations with drawing and painting according to set procedures; with the use of traditional subject-matter—the Life Model, Still-Life, and the Antique—with the 'application' of art in the execution of designs; and above all with the monitoring of progress by frequent examinations. But, he claims, the advent of the new methods of teaching art constituted a 'revolution' against all that: in its place there now exists 'a general devotion to the principle of *individual* creative development.'

But was the advent of 'basic design' such an unmitigatedly beneficial occurrence? Far be it from me to defend the old academicism; nonetheless, I believe that British art education of the last quarter of a century has, in general, been peculiarly disastrous and the sort of thinking that went into 'basic design' has had a lot to do with this. It is not just that today, instead of providing an alternative to academicism, 'basic design' is itself a new academicism (i.e. it is just about as 'revolutionary' as Leonid Brezhnev!) I also believe that, from the beginning, it exerted a restrictive and finally 'collaborationist' influence. I think we really need to get rid of most—although not quite all—of the attitudes which it embodies if art education is to become truly healthy.

Evidently, I cannot do justice to 'basic design' philosophy here, but I want to draw attention to two of its most fundamental assumptions—which I believe to be wrong-headed. The first of these is the attitude to 'Child Art', which one finds in Pasmore and Hudson in particular, and which has had an extraordinary effect upon the way in which most art students have been taught in recent decades. To put it crudely, the 'basic design' view seems to be that the intuitive and imaginative faculties of the child are repressed by culture, and the primary function of art education of adolescents should be to restore that earlier pristine state. Thus the spontaneous and intuitive productions of the child are often

supposed to be paradigms of human creativity. All art is assumed to aspire to the condition of infantilism.

I have to be careful here because I believe that enormous gains were made through the recognition of a 'natural' potentiality for creativity in all children. As a result of the 'Child Art' movement, which began in the nineteenth century and gathered pace throughout the first half of the twentieth, art slowly came to play an integral part in nursery, primary and secondary school education. The 'Child Art' movement underlined the fact that learning was not just a matter of the acquisition of knowledge and functional skills: creative living also involved the development of imaginative, intuitive and affective faculties of the kind which play such a conspicuous part in the making of art. And so this movement stressed the fact that the capacity for creative work is an innate, biologically given, potentiality of every human being, of whatever age, class, culture, or condition. This affirmation seems to me to have an importance extending far beyond its immediate applications in nursery, primary, and secondary school education. Nonetheless, there is a great gulf between the acknowledgement of the child's capacity for creativity, and describing that creativity as some kind of exemplar, or epitome, for adult art.

Indeed, I have been forced to the conclusion that, healthy as the 'Child Art' movement may have been, in itself, it was also symptomatic of a profound cultural loss: that is the loss of what I have called the 'aesthetic dimension' in adult, social life, of the space for imaginative and fully creative work among those who are no longer children. Surely, in an aesthetically healthy society, the capacity for creative work should develop continuously from the spontaneously individualistic self-expressions of the child (shaped by the proccesses of psycho-biological growth and development) into more complex, meaningful, and fully social (but no less creative) productions of the adult. I came to realize that we have tended to fetishize 'Child Art' to such a degree only because aesthetic creativity is so rare in our society at other developmental stages.

To put it another way: I suggested earlier that Bali was an 'aesthetically healthy' society. In what sense could a Balinese painter recognize an infant's immature aesthetic activities as any kind of model for his own? Think, too, of those forms of aesthetic creativity manifest in, say, Amerindian rugs, the

Parthenon frieze, Islamic tiles, or those magnificent carvings of leaves which cluster round the tops of the Gothic pillars in the Chapter House of Southwell Minster. Such forms of art do not seem to me, in any way, to contradict the growth of 'individual creative development'; but, in such instances, that development has been allowed to mature, to rise beyond and above the infantile, through an adult, social, aesthetic practice.

Even when such practices were driven out of the everyday fabric of life and work, painting and sculpture permitted the creation of a new and definite reality within the existing one, an illusory, re-constituted world within which the aesthetic dimension could survive, mature, and truly develop. Again, as soon as we ask in what sense 'Child Art' could have provided an exemplar for, say, Michelangelo, Poussin, Vermeer, or Bonnard, we begin to realize that the celebration of 'Child Art' may have reflected an extension of human experience in one direction, but it also revealed its diminution in another.

So one of my quarrels with recent art education in general and with 'basic design' in particular is that by venerating 'Child Art' as the paradigm of human creativity and expressive activity, they have *not*, as they claim, served the cause of 'individual creative development.' Rather, they have simply institutionalized the fact that we live in the sort of society in which such development tends to be *arrested at the infantile level:* i.e. everyone engages in the arts in our society, but only up until the age of about thirteen. In my view, higher education in the Fine Arts should involve the search for ways of breaking out of this aesthetic retardation rather than the celebration of it. The child may paint solely through bold, impulsive gestures, covering his surface in a matter of seconds: but that, to my mind, is no good reason why art students up and down the country should seek to imitate him.

But I think that 'basic design' type teaching reflects the aesthetic retardation of our culture in another way, too. What I have in mind here is manifest in, say, Richard Hamilton's contempt for the traditional art and craft practices, his obsession with consumer gadgetry and functional machinery, and his preoccupation with what he calls 'the media landscape' —that is with such things as advertising, fashion magazines, pulp literature, television, photography and so forth, which he thinks have replaced nature as the raw material for the attention of the serious artist. More generally, much recent art

teaching has tended to foster the view that in order to be a Fine Artist today, some sort of radical accommodation with the mass media—that is with what I call the 'mega-visual tradition'—is necessary. For Hamilton was not just the Daddy of Pop: he was also the Grandaddy of all those who believe that Fine Art practices should be displaced, or at least deeply penetrated, by such things as 'Media Studies', video-tape, and so on, and so forth.

I said earlier that, despite claiming to be concerned with 'individual creative development', 'basic design' type teaching just institutionalized the retardation of such development, which is so typical of our culture, and I think that Hamilton's uncritical preoccupation with these non-Fine Art media proves my point. For the proliferation of these media seems to me to be one of the major reasons why infant creativity within our culture so rarely flowers into an adult aesthetic practice. These forms of mechanical production and reproduction of imagery are fundamentally anaesthetic: they do not allow for that 'joy in labour', that expression of individuality within collectivity through imaginative and physical work upon materials, within a shared and significant symbolic framework, which is characteristic of aesthetically healthy societies—like Bali, as described by Margaret Mead, or Ruskin's idealization of 'Gothic'. Indeed, that 'mega-visual' tradition, and those mechanical processes, which Hamilton celebrated are a major reason why 'individual' creative development' tends to be so inhibited. But instead of challenging the aesthetic crisis, and proposing alternatives to it, the new art education simply mirrored it, encouraging the art student either to regress to an infantile aesthetic level, or to immerse himself in the anaesthetic practices of the prevailing culture. Behind this basic contradiction it is not difficult to detect the ghost of Bauhaus, the last movement within modernism which enshrined the belief that individual creativity was fully compatible with the methods of mass-mechanical production. I believe this to be nonsense: it is a simple historical fact that Bauhaus regressed, in its design practices, into the dullest of dull functionalisms—with appalling effects on the whole modernist tradition in architecture and design. I think we may have to accept that William Morris was right; machines may be useful to us for all sorts of things. They are, however, fundamentally incompatible with true aesthetic production.

I think the point I am making about the way in which 'basic design' type teaching *internalizes* this aesthetic crisis in our culture is clearly visible if you look at the development of its two principal Newcastle proponents, Victor Pasmore and Richard Hamilton, *as artists*: 'A tree is known by its fruit.'

In my view, Pasmore's art has regressed steadily since the late 1940s, when he began to apply the kind of principles in his own art which he later inflicted upon his students. I have no doubts about my judgement that his painting of a nude woman, *The Studio of Ingres*, which he made in 1945–7, is far better than anything that came later: it was made when Pasmore was still under the influence of the 'objective' methods of the Euston Road School. I was shocked by the regression from this level of work to the blobs and daubs of Pasmore's recent work, in his recent retrospective. I really could see no qualities in many of these works at all; indeed, they looked precisely like the offerings of someone who had been seduced by the paradigm of Child Art, and pursued it in a literalist way. Pasmore's amoeba-like forms, and his barely controlled techniques, like running paint over tilted surfaces, splattering, fuzzing and so forth, remind one—if you will forgive the expression—of the work of a grown-up baby.

Hamilton took the other route. With his bug-eyed monsters from film-land, his quasi photographic techniques, and his modified fashion-plates, he began to offer little more than parasitic variations of 'mega-visual' images. All the awkward promise, and half-formed sensitivity of his early pencil drawings vanished into slick, collaborationist practice. I have a lot more respect for Guyatt's coinage and butter-labels, than for Hamilton's recent adaptations of Andrex toilet tissue advertisements: although neither have any grasp of the 'aesthetic dimension', at least what Guyatt does has some sort of social *use*.

However, I do not just wish to criticize two individuals. Over the last decade, I have been into art schools all over the country, and (until recently at least) I noticed how frequently the work done divided into two, for me, almost equally unsatisfactory categories. On the one hand there were the slurpy, 'gestural' abstractionists, and on the other what I would characterize as 'media-studies' styled modernists. I have tried to show you how these two approaches seem to me to be just two sides of the same rather debased art-educational coin,

which deprives art students of those real, material skills
through which their creativity might develop into something
more than that of the child's, and other than that of the sterile
forms of the 'mega-visual' tradition.

Maurice de Sausmarez, a spokesman for the 'basic design'
approach, has said that the new art education set out to teach
'an attitude of mind, not a method'. This view, unfortunately,
gained official sanction when the 1970 Coldstream report on
art education declared that studies in Fine Art should not be
too closely related to painting and sculpture, because the Fine
Arts 'derive from an attitude which may be expressed in many
ways.' There is, however, an enormous gap between an attitude
in the mind, and the realization of a great painting: and I do
not, myself, think that it is possible to teach art except through
definite material practices in which the student is encouraged
to achieve mastery.

In 1973, Charles Madge and Barbara Weinberger, two
sociologists, published a book, *Art Students Observed*, which
was in effect a study of the way in which the new art education
was working out in practice. They reported that 'half the
tutors and approaching two-thirds of the students of certain
art colleges agreed with the proposition that art cannot be
taught.' Understandably, the authors then asked, 'In what
sense, then, are tutors tutors, the students students, and
colleges colleges? What, if any, definitionally valid educational
processes take place on Pre-Diploma and Diploma courses?'
There can be few involved in art education who have not asked
themselves these questions at some time or other. The authors
reported, that nearly all tutors 'rejected former academic
criteria and modalities in art', but none had any others to put in
their place.

My own view is that it is quite useless to go on teaching this
peculiar mixture of infantilism, media studies, and Fine Art
'attitudes' in post-school art education. Of course, I believe
that a relatively unstructured situation is healthiest for young
children, making their first tentative explorations into drawing
and painting. (In such cases, the structuring comes from innate
developmental tendencies, rather than from 'culture'.) None-
theless, it is at least worth pointing out that many infant art
teachers are now beginning to argue in favour of a more
'directed' approach much earlier than has been fashionable in
recent decades, and to look again at the creative value of

practices like *copying*, which were once abhorred as being completely sterile.

I believe that, by the time the student reaches post-school level, he or she simply cannot develop creatively without the acquisition of culturally given skills. That is why Fine Art education should be based much more firmly and unequivocally than it is at present in the study of painting and sculpture. Imagination and intuition are indeed *essential* to the creation of good art; but these faculties are impervious to instruction. There are, however, many others integral to the creation of good art which *can* be taught. Drawing is, of course, the most significant of these: and, rather than 'the Fine Art attitude', I would like to see drawing of natural forms, especially the human figure, reinstated as the core of an adult education in Fine Art.

Of course, as soon as one mentions the figure, those who have been brought up within the ideology of the new art education raise the bogey of 'academicism'. But this ignores a well-established tradition of anti-academic figure drawing in this country which, for my money, has produced far more impressive results as an educational method than 'basic design', or anything resembling it. I am referring to that tradition which emerged in the Slade at the end of the last century, under the influence of that great teacher, Henry Tonks. Tonks saw that there was nothing wrong with learning to draw from the figure, as such, although there was everything wrong with the stereotyped togas, and mannerist pretensions in which the traditional academics swathed this practice. Tonks held that drawing should always be both poetical and objective, but he recognized that only the objective part could be taught. Before becoming an art teacher, Tonks had practised as a surgeon: he denied there was such a thing as outline, and stressed the structural aspects of the figure. If you mastered the direction of bones, Tonks taught, you had mastered contour, too. Tonks certainly taught a *method*, and not just an attitude of mind. He wanted students to spend all day, every day, in the life room. Now according to today's art educational theorists, he ought thereby to have strangled any conceivable talent that came his way. But he didn't. Those pupils interested in the 'objective' aspect of painting certainly thrived under his influence: William Coldstream, himself a doctor's son, went on to elaborate his own clinically 'factual'

system of figure painting. But those drawn towards the
'poetical' dimension often flourished, too. Thus Stanley
Spencer—than whom few can be considered more imaginative
—learned what he needed to realize his great compositions in
Tonks' life room, too. Similarly, Bomberg, who laid an almost
equal emphasis on imaginative transformation and empirical
exactitude in his pursuit of 'the spirit in the mass', benefited
from Tonks' rigorously methodical approach . . . And then
there were Bomberg's pupils, painters like Frank Auerbach,
Leon Kossoff, and Denis Creffield, all of whom show a
similar respect for the empirical and imaginative dimensions,
and also for the specific traditions and potentialities of their
chosen medium: painting. Work of this calibre is, to me,
altogether more impressive and worthwhile than anything
produced in the wake of latter-day Pasmore, or Hamilton.

But I do not want to be misunderstood: I am *not* saying that
students should be shut up in the life-room all day long and
made to do 'Tonksing' against their will. I am however saying
that what makes painting a particularly valuable and exceptional
form of work is that, in it, the intuitive and imaginative faculties
do not stand in opposition to the rational, analytical and
methodical: rather, they can be combined together in ways
which most work in our anaesthetic society disallows. This, if
you like, is the excuse for painting, the reason that, when it is
good, it stands as a kind of 'promise' for the fuller realization of
human potentialities. And I am saying that precisely in order
that the student can be helped to realize his individual creative
potentialities to the fullest, art education must begin to
concern itself with the 'objective' end of the expressive
continuum much more than it has done in recent years.

It is *nature* which has somehow disappeared from recent art
educational practices. I prefer a much wider view of natural
form than that implicit in Tonks' approach. There are even
elements of 'basic design' which I would like to see preserved
and extended: the most significant of these is the attention
which Pasmore and Hamilton, at least in the early days, gave to
the structure and growth of natural organisms—like crystals.
My only objection to their approach here is that it was much
too narrow: the student should be encouraged to attend to the
full gamut of natural forms, beginning with the figure, and
extending outwards.

Tonks once said that he had no idea what the body looked

like to those who had not studied anatomy. I believe that *before* students involve themselves in the microscopy advocated (though not in fact much practised) as an element in 'basic design', they ought to achieve a real knowledge of the structure of the human body itself, of anatomy. It is no accident that Ron Kitaj, who is one of the best figurative artists working in this country, is also one of the very few who has actually conducted an autopsy, and worked with a cadaver. Of course, that guarantees nothing: but, equally, it remains true that neither Leonardo, nor Michelangelo, could have achieved what they did without this sort of knowledge. But I would go further than this: I believe that the practice of drawing needs to be supplemented with certain knowledges, beyond anatomy, which the present art schools simply do not teach. Why, in complementary studies, does one find so little instruction for Fine Art students in such topics as metereology, botany, geology, and zoology: in order to offer an imaginative transformation of the world in one's work, one must first attend to that world, and above all to the visible forms through which it is constituted. But most art students grow up with an impoverished conception of reality which owes more to cigarette advertisements and sociological theory (with perhaps a dash of art history) than to empirical perception and the natural history of form. Personally, I think you would learn much more about the business of painting if you spent an hour, say, drawing quietly in a natural history museum rather than studying that 'media landscape' which seduced Hamilton, or 'expressing yourself' in abstract, like a child.

I have put a lot of emphasis on painting and sculpture. What about the 'other media'? In an 'aesthetically healthy' society, the aesthetic dimension permeates throughout all work, and extends to every part of the social organism, regardless of class and condition. But we do not live in such a society: and painting and sculpture, alone, offer this promise of a new reality, realized within the existing one. That is why I think that the priority of Fine Art education should be the preservation and encouragement of these practices.

Nonetheless, I also believe that it should be part of a *Fine Art* education to learn about, and to practice, other aesthetic pursuits—namely those offered in the whole field of the ornamental and decorative arts. Indeed, this is where recent education has gone so wildly wrong: it has encouraged Fine Art

students to engage in the anaesthetic practices of the prevailing culture, not only the sorts of things that interested Hamilton, but the whole field of video, applied photographic processes, mixed media, etc., etc. I think it would be much more valuable if they were encouraged to look at things the other way round: i.e. to think about taking fully *aesthetic*, creative practices out into that aesthetically sick society.

Dennis Gabor was the man who invented the new medium to end all new media, the hologram which offers a fully three-dimensional image. But he certainly did not think that he had rendered traditional aesthetic pursuits obsolete. He once wrote, 'Modern technology has taken away from the common man the joy in the work of his skillful hands; we must give it back to him.' Gabor went on, 'Machines can make anything, even *objets d'art* with the small individual imperfections which suggest a slip of the hand, but they must not be allowed to make everything. Let them make the articles of primary necessity, and let the rest be made by hand. We must revive the artistic crafts, to produce things such as hand-cut glass, hand-painted china, Brussels lace, inlaid furniture, individual book-binding.' These are sentiments with which I agree entirely; and there would be nowhere better to start *this* revolution than on Fine Art courses.

I am not, of course, suggesting that students should set off along that narrow path which leads to a potters wheel in Cornwall: a better paradigm of the sort of thing I have in mind would be say, the revival of mosaic in Newcastle, linked to an officially sponsored project to produce wall decorations for the new Metro system. The project, as I understand it, is that well-known artists will design mosaics, and that students from the Polytechnic Fine Art Department will assist in the making of them. I think that the arts schools could, and should, do much more in this sort of direction. Indeed, in short, rather than allowing Fine Art values to be assimilated by mega-visual tradition, art schools should be encouraging students to take aesthetic values out into that anaesthetic culture: otherwise, one of the most significant of all human potentialities risks being lost altogether.

1981

AESTHETICS AND NUCLEAR ANAESTHESIA

What images could be more terrible than Goya's 'horrors of war'? And yet as soon as we try to contemplate what it would be like to experience nuclear warfare, Goya's lacerated figures become as reassuringly familiar as any English water-colour of a rural scene in the Suffolk countryside on a summer's afternoon. The threat under which we live in reality defies the worst our imagination can do.

It helps to think of the standard, ten megaton bomb as resembling a miniature, negative sun. The energy of the true sun indeed comes from thermo-nuclear reactions within it; but the sun is the great sustainer of life. Recently, Keith Grant exhibited some paintings he had made in his romance with the sun: he realized some of them through the perilous process of gazing into the nearest star with the naked eye. A ten megaton nuclear bomb, when exploded, produces a fireball three miles wide within forty seconds. This annihilates life around it. Anyone who so much as looked at the flash from a distance of up to 200 miles would be blinded.

Instantaneous loss of sight however, would probably be but an academic injury. Assuming the bomb exploded 500 yards or so above the ground, the ensuing blast would leave a crater up to a quarter of a mile deep, and one and a half miles across. Within a radius of seven miles, every tall structure—houses, shops, factories, offices and bridges—would collapse as in a Colman apocalypse. Almost everything combustible within twenty miles would burst into flames, and a fire-storm would follow in which all the small fires fused together to form a huge burning pillar sucking in winds of up to 150 miles an hour. Down-wind from the explosion, everyone within a corridor twenty to thirty miles wide, and a hundred miles long, would be killed by a plague cloud of radioactive dust.

Recited like this, such facts have a way of sounding as remote as John Martin's fantasies, or the sonorous imagery of the Old Testament and the Book of Revelations. Another way of

putting it is this: we all share an historical memory of what
happened at Hiroshima at 8.15am on 6 August 1945. But
Hiroshima is just a jab in the arm compared with what we are
now trying to conceive. Today's standard, ten megaton bomb
is 800 times more powerful than that exploded over the
Japanese city. It has been estimated that in a global nuclear
war—lasting, perhaps, a matter of hours—about 10,000 bombs
would be exploded by the USA and USSR, with perhaps a
further fifty each from Britain, France and China . . . Such a
scenario, which belongs not to myth or paranoid imaginings
but to our probable historical future, infinitely exceeds any of
the eschatalogical dreams that have exercised Western religious
and artistic traditions for millenia.

In nuclear war, we are confronted with such an absolute of
evil, destruction and the voiding of life that it is perhaps not
surprising that so few artists have tried to envisage it. The
aesthetic dimension must root itself in hope if it is to thrive.
But recently I saw a propaganda exhibition, 'No Nuclear
Weapons', at the Side Gallery in Newcastle Upon Tyne. This
urged the case against Pershing II's, Tomahawks and Trident
through documentary photographs, photomontage and text
(by Mike Abrahams, Peter Kennard and Ric Sissons, res-
pectively). Aspects of their presentation might have been
better done; but I was delighted to see such a clear and
unequivocal intervention concerning this, the most significant
issue of our, or indeed of *any*, time.

A particular image from this show by the photomontagist,
Peter Kennard, has haunted me since I first saw it, and
stimulated the development of a train of thought about
aesthetics and nuclear anaesthesia. The montage—which has
also been used as a poster for the exhibition—consists simply
of a photograph of Constable's *The Haywain*. But in
Kennard's version, the dog turns its head to look not at an
empty farm cart, but rather at one laden with those instruments
of armageddon—Cruise missiles. Constable's rustics are
decked out in military helmets, too: one sports goggles and a
protective mask.

First, I want to be clear about the claims I am making
concerning this work. It suffers from the inherent limitations
of its medium, and is not even a good example of what is
possible within that medium. Montage, like collage and much
constructed sculpture, consists largely of the imaginative

juxtaposition of preconstituted elements. Such elements always loudly refer back to the contexts from which they originated: they resist complete transformation into some new and radically other whole. There is thus a built-in limitation to montagist aesthetics: the montage artist is, like Levi-Strauss' *bricoleur*, constrained by the prior 'sets' from which his selected fragments came. Photo-montage is thus a lesser art than mosaic, and evidently than painting; but it remains, of course, much more of an art than photography. Indeed, it might reasonably be argued that photo-montage's indelible attachment to the appearances of that which is historically given makes it particularly appropriate for imaginative, political and social comment, more so than painting whose essence lies in its *otherness*. It is hard to conceive of a convincing photo-montage of the Last Judgement or Europa and the Bull.

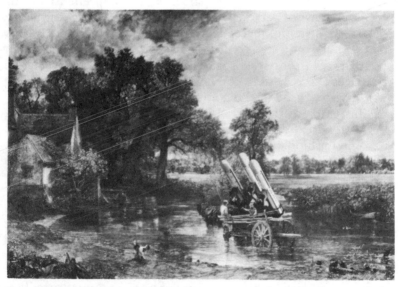

Peter Kennard, *The Haywain-Cruise Missiles*, 1981, photomontage

But, even *as a montage*, Kennard's work is flawed: it relies far too much on the mere placement of an incongruous element within Constable's given design. After all, you could put almost *anything* on *The Haywain*: I remember a cartoon at the time of the Carl André affair which showed the cart loaded up with bricks, and a balloon above the driver reading, 'To the

Tate . . .' By contrast, the most successful Heartfields are much more deeply penetrated by the montagist's imaginative activity: Heartfield re-works his selected materials into something which is a much closer approximation of the painter's created totality. But, at the moment, I am not concerned with the narrower issues of art criticism, alone. For the strange placement of elements in Kennard's montage evoked (even if it did not fully express) an important paradox: that of the simultaneous futility and necessity of the aesthetic dimension in the present historical moment. It is that paradox which I am concerned with here.

Take first the background set for the Kennard montage: *The Haywain*, Constable's painting of 1821. This was one of Constable's major 'machines'. As Leslie Parris has pointed out, a comparison of the full-scale study for *The Haywain* with the finished version reveals the extreme difficulty Constable had in reconciling to traditional patterns a comprehensive but confused mass of personal observation. But, extreme difficulty or no, Constable succeeded: in the finished painting, his percepts are subjected to imaginative transformation, through the material processes of painting itself, in such a way that he produces this coherent, convincing, and aesthetically satisfying world-view, through the composition of his forms.

This composition, of course, is anything other than a 'reflection' or transcription of a given reality. Recently, it has become fashionable to say that Constable's sketches are 'better than' his major set pieces: I once mouthed such judgements myself. Now, however, I believe that, fine as many of the sketches undoubtedly are, such views are just symptomatic of a camera-conditioned preference for the instantaneous and incomplete, or, deeper still, a prevalent blindness to the value of aesthetic wholeness. The habitual preference for the fragment over the whole, the collage rather than the carving, and the sketch in place of the masterpiece may be correlated with the eclipse of hope in our culture. For, in his great set pieces, Constable offers much more than an evocation of 'great-coat weather', or lyrical annotations of his sensations derived from the sight of clouds, foliage and water. Through the convincing realization of aesthetic wholeness, Constable bears witness to the fuller realization of human sensual and perceptual potentialities within a world trans-formed. In short, even when, as in *The Haywain*, he draws

upon certain nostalgic props, he offers a promise of the world
as being better than it is in reality: like Poussin, Cézanne, or
Bonnard, Constable reminds us of Marcuse's defence of
aesthetic form on the grounds that it constitutes the very
means through which art 'can create that other reality within
the established one—the cosmos of hope.'

So the use of Constable's painting as background for this
montage means that it alludes to that which montage (by its
very nature) cannot express—that 'other reality', this cosmos
of hope. But let us now turn to the other element in Kennard's
work: the juxtaposed photograph of a cluster of Cruise
missiles. The Cruise missile (of which there are several types) is
about twenty feet long and as many inches in diameter, with a
range of 2,000 miles. It is really a pilotless aircraft, tipped with a
nuclear war-head, which can (or so it is claimed) guide itself
with remarkable accuracy to preselected targets even over such
large distances.

The immediate point of Kennard's montage is that Cruise
missiles will soon be on their way to the British countryside: to
be precise, ninety-six of the Tomahawk variety are expected at
Greenham Common, near Newbury, and a further sixty-four
at Molesworth, near Huntingdon, by 1983. The characteristic
of Cruise missiles is that they are readily transportable: it is
proposed that, in times of emergency, they will be dispersed
around our green and pleasant land on trailers in groups of
four.

Why are Cruise missiles coming to Britain? The short
answer is, 'in what the Americans take to be their interests',
that is, in pursuance of NATO policy. The Cruise missiles in
Constable country will be under unconditional American
control: a 'two-key' policy will not apply; the decision to
involve Britain in a nuclear exchange could thus be taken, and
implemented, from Washington without any consultation
with the British Government (let alone the British people).
This is a surrender of national sovereignty of inconceivable
proportions: *no* decision could have a greater effect upon this
nation's future, or lack of a future. But what will the effect of
cruise be upon our national security? Dan Smith has written,
'NATO war planning amounts to preparing to defend Europe
by blowing it up.' If Smith is right—and I believe that he
is—then NATO war planning represents the inverse of that
image affirmed by the aesthetic dimension, a world trans-

formed for the better.

In what sense then is NATO preparing to blow Europe up? The old theory of nuclear 'deterrence' (such as it was) depended upon the assumption that each side in the arms race maintained its nuclear stock-pile at such a level that the other side always knew that it could only initiate an attack at the risk of unacceptable danger to itself, as well as to the other side. Strategists referred to this policy as MAD, or Mutual Assured Destruction. Deterrence thus requires an acceptance by both parties that nuclear war is 'unthinkable'. Now it has often been argued convincingly that the whole logic of deterrence was false: the balance of power could not be maintained in a stable state. Inevitably, it involved the leap-frogging spiral of an arms race which acquired its own autonomous dynamic: only a fool could seriously believe that peace could be maintained *indefinitely* through feverish preparation, on either side, for an ever more absolute holocaust.

But, in recent years, this whole false logic of 'deterrence' has become obsolete anyway, since it is now clear that the Americans are preparing to survive, indeed to win, what they now believe to be an inevitable exchange. American defence policy is now primarily concerned with the notion of 'limiting' this nuclear war and with ensuring that when it does come, it does not take place on American soil. And this is what all that talk about 'tactical' nuclear weapons, and a 'theatre' nuclear war is about: it is also why we are getting Cruise. As E P Thompson has written, 'it is thought by persons in the Pentagon that a "theatre" nuclear war might be confined to Europe, in which, to be sure, America's NATO allies would be obliterated, but in which immense damage would also be inflicted upon Russia west of the Urals, while the soil of the United States remained immune.' Thompson goes on to say that, in this scenario, the President of the USA is presumed to be on the 'hot line' with Brezhnev, while Europe scorches, 'threatening ultimate inter-continental ballistic retribution, but at last making "peace".' Indeed, as Thompson puts it, from the American (stroke NATO) point of view, 'if world-wide nuclear war seems to be ultimately inevitable, then the sooner that can be aborted by having a little "theatre" war the better.' But that 'theatre' war would involve the obliteration of Europe and the reduction of its civilizations and cultures to a smouldering, polluted desert of radio-active dust.

Cruise missiles are coming to Britain for but one reason: to play their part in that intended little 'theatre' war. It is, of course, unlikely that, in the event, the American scenario would in fact be played out. The Russians have shown no sign of accepting Washington's 'ground rules' for a nuclear war which would leave America unscathed; but there is no comfort to be drawn from that. All this means that, once commenced, nuclear war will probably not be 'limited' to the annihilation of Europe, but will almost certainly expand rapidly into an inter-continental exchange taking out much of Russia, America, and who knows what else besides. The point is that whichever way one looks at it—even if one accepts the need for a British nuclear defence strategy—there are no arguments in favour of Cruise from a British, indeed a European, point of view. Our national and continental security will actually be weakened by the arrival of these missiles, and our ultimate engulfment in a nuclear holocaust made that much more likely. Cruise thus emerges as a symbol of absolute despair: if *The Haywain* bears witness to the possibility of a world transformed for the better, Cruise represents, *in reality*, the denial of such transformation and the extinction of 'the cosmos of hope' to which the aesthetic dimension bears witness. This, I think, is the secret of my fascinated response to Kennard's montage: he blandly alludes to two utterly irreconcilable opposites.

But I have already suggested that, though Kennard's montage may (or may not) be effective as propaganda, it cannot, in and of itself, fully realize that 'aesthetic dimension' to which it refers through its dependence upon the 'set' of Constable's masterpiece. I have often quoted Marcuse's statement, 'The political potential of art lies only in its own aesthetic dimension. Its relation to praxis is inexorably indirect, mediated, and frustrating. The more immediately political the work of art, the more it reduces the power of estrangement and the radical, transcendent goals of change.' And indeed Marcuse specifically criticizes 'the collage, or the juxtaposition of media' because they involve renunciation of 'aesthetic mimesis', deriving from the assumption that the given reality is disjointed and fragmented in a way which militates against any aesthetic formation. But, Marcuse argues, reality is in fact not fragmented: it is rather exceptionally unified and integrated, albeit in a false way. In the face of such unification, however, the anti-art of collage and mixed media

remains impotent; Marcuse claims, 'it is the aesthetic form which, by virtue of its otherness, can stand up against this integration'; renunciation of the aesthetic form is, for Marcuse, an abdication of responsibility which deprives art of that very form in which it can create that other reality within the established one, 'the cosmos of hope'.

I am not, therefore, recommending Kennard's montage as an example of good art, or the realized aesthetic dimension, but rather as a necessary polemical allusion to the importance of the pursuit of that dimension in the face of the appalling alternative posed by existing reality—the cosmos of annihilation and despair. But here we have to be careful: of course, I am not trying to say that the aesthetic dimension must only concern itself, at the level of subject matter, with hope. Indeed, one of the most beautiful pictures ever painted is Poussin's *Winter*, which is based upon his conception of that moment when the world was about to be submerged beneath the flood, and life was on the verge of extinction.

Now *Winter* was the work of an ageing, depressive man, who had abandoned hope and was in the process of accepting the unalterable finality of death. Everything in the picture is overhung with that ash-like greyness, which one associates with the pictures Rothko painted just before he killed himself. Indeed, Ruskin objected violently to this picture on the grounds that wetness and moisture produced fullness of colour; but, he said, Poussin 'in search of a false sublimity' had painted every object in his picture, vegetation and all, 'of one dull grey and brown'. This had 'rendered it impossible for an educated eye to conceive it as representing rain at all; it is a dry, volcanic darkness.' Ruskin castigated Poussin for his inattention to nature, and for producing a work (or rather 'a monstrous abortion') 'whose subject is pure, acute, mortal fear'.

Now here, as elsewhere, I believe Ruskin to have been faulty in his judgement. It is true that the boat will be over-turned; everyone depicted will die. The swimming horse, the figure clutching a raft in the foreground, the infant who is being held up towards the rocks for 'safety', and the slithering serpent will all soon drown. The content of this picture is the inverse of that rural idyll depicted in *The Haywain*: Poussin has projected his personal intimations of an imminent death onto his vision of the world as a whole. Indeed, if I were to name that picture which, as it were, came closest to my own imaginative

conception of the experience of the extinction of life in a nuclear holocaust, *Winter* (or perhaps those all-grey late Rothkos) would probably be it. Nonetheless, *Winter*, for me, is saturated in hope. The picture's consummate form, the way in which it has been made, redeems Poussin as its creator, and us as its viewers, from the despair which it depicts. In *Winter*, the aesthetic dimension is realized through the way in which content has become form. The 'unnatural' grey dryness of Poussin's flood (to which Ruskin objected) is itself one such element in the painting's *transformation*: this wetness is neither colour-enhancing, nor life-giving. Such is this moment that even the waters of the deep have turned into funereal dust and ashes.

However devoid of hope the overt subject matter of this painting, the way in which its form and content have been faultlessly combined emerges as a triumph over despair, and an affirmation of the enduring possibilities of human life. Nuclear war menaces us with the subject matter of this painting, without the redemption of its form, not within the safe 'otherness' of a canvas surface, but within the reality of the physical world and of history. Nuclear war thus holds forth not that 'moment of becoming' characteristic of the aesthetic dimension, but rather only an unbecoming future, a negative utopia, or general anaesthesia, the mirror image of that grey, primordial slime from which life first sprang, and into which it may now again be slithering, to be subsumed in a polluted, ashen grey monochrome of non-existence.

Later in his life, Ruskin almost certainly would not have made the criticism of Poussin that I have quoted; indeed, he became convinced that (as a result of man's activity) nature itself had somehow 'gone bad', and failed. When he looked at it, he saw something very similar to that which he accused Poussin of depicting in *Winter*. Ruskin made his revised view of nature clear in 1884, through one of his most seemingly bizarre lectures, 'The Storm-Cloud of the Nineteenth Century'. As early as 1871, Ruskin had begun to detect this storm cloud and accompanying 'plague wind': in his diary, in July of that year, he noted that the sky was 'covered with grey cloud;—not rain-cloud, but a dry, black veil, which no ray of sunshine can pierce.' He observed that 'morning after morning has come grey-shrouded thus.' He seems to have believed that, as a result of what men had done—in particular through

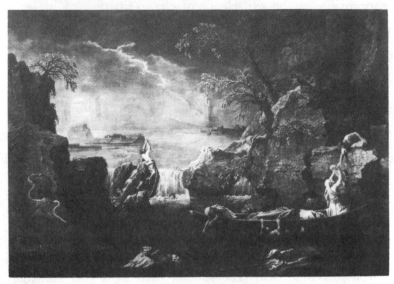

Poussin, *Winter*, 1664, The Louvre, Paris

nineteenth century industrialization—nature itself had become
contaminated, and man was menaced by this vile, filthy,
poisonous phenomenon, seemingly made of 'dead men's souls'.
Man had brought down upon himself an apocalyptic thread
which Ruskin characterized as a 'blanched Sun,—blighted
grass,—blinded man', and an earth rendered ultimately desolate
and uninhabitable.

Ruskin's editors provide a rationalistic explanation of all
this, arguing that he was describing the environmental
pollution caused by increased production of coal. No doubt
this had much to do with it; but Ruskin even detected the
storm cloud and plague wind in the Alpine summits. If they
were not just projections of his inner despair, neither were they
wholly objective. But, as with much that Ruskin wrote, his
imaginative conception turned out to be insightful and
prophetic: in the twentieth century, at least, man's activity
really does threaten to produce a failure within Nature itself,
to blight the grass, blind the human species and render the
earth a desert of cinders. As Edward Thompson wrote
recently, 'the twentieth century is slouching to its end, gorged
with goods and human blood.' And that end appears to be
punctuated by a mushroom cloud, comprised of dead men's
souls.

Against such a scenario, of course, the mere affirmation of the aesthetic dimension seems as foolish as to attempt to stop a hurricane by blowing. Nonetheless, it is worth insisting that those cultures in both East and West which have led the spiralling movement towards the anaesthesia of nuclear holocaust have shown a predictable contempt for the aesthetic dimension. Furthermore, we must remember that all the great promises of a better future as held out by nineteenth century socialist, progressive bourgeois, and religious prophets, ring peculiarly hollow as they reach us through the stomach walls of our gorged century. In these circumstances, the aesthetic dimension remains like a firework of hope, illuminating the grey bleakness of a winter sky.

But, of course, it is not enough in itself. In his novel, *A Painter of Our Time*, Berger makes his hero, the painter Janos, say that even the greatest violinist in the world is not justified in playing on the bank when a man is drowning in mid-stream. Certainly, I believe that the contribution of art to the struggle against nuclear armaments will be *as art*, i.e. through the realization of an aesthetic dimension which, in and of itself, will testify to the possibility of a better future than that proclaimed in Cruise. But I also believe that those of us interested in this 'aesthetic dimension', as either critics or producers, have an urgent duty to join and support that mass movement which is now welling up against nuclear weapons. This democratic upsurge—which seems already to have been successful in keeping Cruise missiles out of Belgium and Holland—alone can preserve those conditions in which the assertion of the 'aesthetic dimension' becomes something more than whimpering in a storm, and civilization and social life remain on the agenda. Thus that studio work which looks to, and struggles to realize, the hope implicit within its own aesthetic dimension needs now to be combined with active membership of CND, the Campaign for Nuclear Disarmament, and END, its sister organization, pointing the way to the establishment of Europe as a nuclear free zone. We should do our part in helping to ensure that the haywain carries no alien cargo into East Anglia.

1981

II PAINTERS

POUSSIN: ET IN ARCADIA EGO

The National Gallery of Scotland houses a group of seven implacable and yet compelling paintings: the second series of Sacraments Poussin painted for his patron, Paul Chantelou, between 1644 and 1648. Usually, these pictures hang together in magnificent, silent solemnity on the walls of a single room. I can think of no comparable experience in any British art gallery—except, perhaps the famous Rothko room at the Tate.

Of course, the comparison is based more on mood than appearance. Rothko's paintings are wholly abstract: their effects depend solely upon undulating planes of purple and black. Poussin's pictures involve monumental figures whose 'passions' are expressed through vivid yet intensely restrained bodily gestures and facial expressions. With the exception of *Baptism*, they carry out their dignified ceremonials against massive, architectonic stage sets. The paintings are also redolent with Poussin's detailed knowledge of the artifacts and customs of the ancient world.

Rothko said of his own paintings that anyone who saw only the forms and colour harmonies was missing the point: though not a religious man, he was concerned with 'basic emotions'; he insisted there was a deep 'spiritual' dimension to his work. Conversely, it has often (and rightly) been said of the Poussins that they contain 'superb passages of abstract design.' Both series certainly share a concern with high sentiment, with the evocation of a mood of humanist spirituality. Rothko and Poussin used and developed very particular kinds of pictorial conventions, peculiar to their respective moments of history; but through such timely means they both consciously created self-contained illusions which aspired to the condition of the timeless.

Poussin's Sacraments may be superficially 'religious'; but Poussin utterly rejected that florid, superstitious yearning for the miraculous manifested by the counter-Reformation artists

who were working close by him in Rome. The Sacraments reflect his moral and stoical rationalism. They revolve around basic human themes, common to all cultures: the understanding of the origins and frailty of human life, the inevitability of death (so powerfully evoked in the painting which shows a Roman centurion receiving *Extreme Unction* from an early Christian priest), the union of man and woman, and spiritual regeneration. Poussin was fifty when he began these works, and they represent the breakthrough to the silent, decorously majestic style of his long-delayed maturity.

This was made clear in a remarkable special exhibition at Scotland's National Gallery in which these Sacraments were temporarily rehung alongside their precursors, a cycle of pictures on the same subject begun in the mid-1630s. The earlier Sacraments are almost 'intimist' in comparison; they are technically and aesthetically uneven and full of incident and gesture which has not been ruthlessly subjected to the overall conception.

Poussin's vision of man was certainly more fragmented at that time. Simultaneously with the first series of Sacraments, he was working on a series of Bacchanals for Cardinal Richelieu. The finest of these is probably *The Triumph of Pan*, specially cleaned for this show, and revealed in all its brilliance of hue and riot of carnal exuberance. This painting exudes a uniformly lush sensuality which could hardly be more different from the varied and carefully individuated, but always noble, sentiments expressed through the gestures and faces of the characters in the later Sacraments.

In Edinburgh, one can now also see early paintings Poussin made after his arrival in Rome in 1624. None is more beautiful and typical than *Cephalus and Aurora* (from London's National Gallery) which shows all the nostalgic yearning, Titianesque touch, honey tones and milky mergence of forms, characteristic of the first formulation of Poussin's arcadian utopia.

This Edinburgh exhibition is thus an introduction to Poussin, not a blockbuster retrospective. Many of his greatest paintings, and regrettably all his landscapes, are absent. But Poussin *needs* introducing here. There are many fine Poussins in our public collections; but apart from a small presentation in a provincial university thirty years ago, there has never before been a Poussin exhibition in Britain. Poussin has long attracted

a daunting and voluminous scholarly literature; he has also always been celebrated among painters themselves. (Cézanne wanted to do Poussin over again—but from nature rather than the antique.) But he has never been greatly loved by the ever growing army of mass consumers for art.

Certainly, Poussin is an acquired taste. I know because, for years, I passed by his paintings with the contemptuous indifference of a Pharisee. But one day, quite suddenly, my interest was aroused and Poussin became, for me, something close to an addiction. Today I can think of no painter, dead or alive, whose works I enjoy more. And that seems to be a common pattern among those who admire him.

It is easy to see why Poussin resists casual glances. His greatest work, that of his maturity, is refined, sophisticated, highly artificial, academic and often heavy with esoteric references and classical allusions. He eschews the spontaneity, incompletion, sketchiness and immediacy which have been so elevated in post-romantic taste. (The late drawings made with a sick and shaking hand are, perhaps, an exception.) Furthermore, he makes nonsense of the contemporary critical cant that, to be great, a painting must, in every significant respect, be of its own time.

Poussin insists that, if you are to enjoy his paintings, you must enter a strange and forbidding world of his own creation, one without any easy sociological keys. Certainly, Poussin is rich in identifiable appurtenances; but they tell us next to nothing about the seventeenth century France from which he came, or the seventeenth century Rome in which he worked. And yet it is the *completeness* of this invented world which forms the basis of his fascination for those who yield to him.

In Poussin, opposites unite: the great sculptor, Bernini, once said of Poussin's work, '*O che grande favoleggiatore!*' ('Oh what a great storyteller!'). But Roger Fry, the formalist critic, who did more than anyone to foster the contemporary contempt for narrative painting was also among Poussin's most enthusiastic admirers. Fry believed that the aesthetic value of painting was solely a matter of emotional response to the disposition of colours, shapes and forms.

This is not as contradictory as it sounds. I have often drawn attention to the mandrake-like root of *expression* in painting. One branch of this is dependent upon the body as objectively perceived and depicted; the other is enmeshed in abstract and

rhythmic qualities (such as touch, form, composition and so on) ultimately deriving from the subjective experience of the artist's, and thus, by extension, the viewer's own body. Poussin was a master of both these modes.

He followed Leonardo's physiognomic theory of expression, according to which in painting the spectator's emotion is primarily aroused through the expressivity of the characters depicted. Poussin developed this into his own concept of the *affetti* (ie the 'passions' or emotions) as made manifest through the interacting bodily gestures of the various characters portrayed.

Such ideas, of course, have much in common with certain theories about acting. Before painting a picture Poussin would set up a miniature stage upon which he experimented with tiny wax figures in various postures. *Extreme Unction* even includes the near edge of the floor in the extreme foreground as if one were looking into a stage set. All these techniques create an illusory space which emphasizes the separateness and otherness of the high drama depicted on the other side of the footlights.

But Poussin also likened the way in which paintings work upon us to music: this can most easily be seen in those early works, like the *Cephalus and Aurora*, in which his figures are much less sharply individuated from each other, and everything flows and merges across a shallow, decorative space close to the canvas surface, so that mood is evoked through abstract elements. But the genius of Poussin's pictures resides in the way in which he blends these two extremes of expression into a harmonious whole.

Poussin thus unites the objectively perceived and the subjectively experienced in a new way. Both his 'theatrical' representational devices and his 'musical' forms are symbolic. And this is the clue to the 'new realities' he constitutes through his pictures. Rothko tried to evoke a subjective pictorial utopia through formal means alone; but in Poussin's paintings, ancient history provides an additional metaphor which speaks both of the objective world, and of those yearning remembrances of a lost psychological experience, expressed through his forms.

Poussin possessed a rarefied intellect; yet he was fascinated with the infant's eye view. The *putti* who hover in his skies, or crouch in the foreground of his pictures, are more than conventional devices. Indeed, he sought out obscure subjects

—like the nurture of Jupiter by a goat—through which he could make the infant, who feels blissfully fused with all he surveys, the explicit focus of attention. In *The Arcadian Shepherds*, of 1627, three figures gaze at the words *Et in Arcadia ego* engraved upon a tomb. The most likely translation is, 'I too lived in Arcadia.' Poussin recreates the lost paradise of childhood and combines it with the heights of adult experience. But like Rothko, with his black spaces, he does not let us forget that we who have fallen into hard reality will lose even that in death.

1981

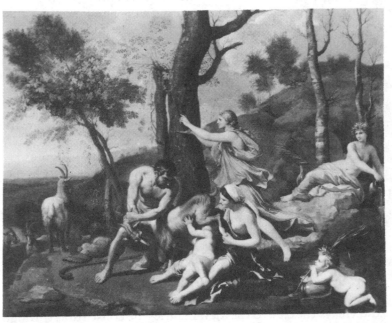

Poussin, *The Nurture of Jupiter*, Dulwich College Gallery, London

GAINSBOROUGH AND SOCIOLOGY

Ten years ago, Professor Lawrence Gowing of the Slade clashed with John Berger over Gainsborough's extraordinary early painting, *Mr and Mrs Andrews*. Their exchanges are documented in Berger's *Ways of Seeing*. Gowing suggested that Mr and Mrs Andrews were engaged in philosophic enjoyment of 'the great Principle . . . the genuine Light of uncorrupted and unperverted *Nature*.' Berger did not deny this was possible, but he insisted the Andrews were also proud landowners at a time when a peasant could be whipped for stealing a potato. Among the pleasures the portrait gave the Andrews' was that of seeing themselves depicted as landowners. This pleasure, Berger argued, was enhanced 'by the ability of oil paint to render their land in all its substantiality.'

Berger reproduced details of the Andrews' faces. These dramatically revealed that Gainsborough had captured the proprietorial expressions of his sitters, especially the look of

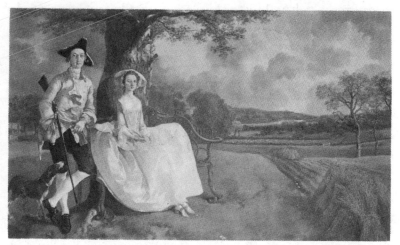

Thomas Gainsborough, *Mr. and Mrs. Andrews*, National Gallery, London

arrogant contempt in the woman's eyes. Anyone who claimed
the couple was taking pure, philosophic enjoyment in 'un-
perverted *Nature*' was clearly deluding himself. At the time, I
thought Berger had won the exchange, game, set and match.
But, over the last ten years, Mr and Mrs Andrews have
continued to fascinate me. And I have begun to wonder
whether Berger wasn't serving from the wrong court.

During the last decade, there have been some marvellous
landscape exhibitions. In 1973, there was 'Landscape in
Britain, c.1750–1850' at the Tate; then came the great Turner
show of 1974, and the Constable exhibition of 1976. The Tate
also had a Gainsborough exhibition in 1980. In fact, this was
not as well done as the others. There were too many omissions
of key works. It is all very well for John Hayes, the organizer,
to claim that Gainsboroughs in collections all over London
comprise 'an indispensable part of the exhibition', but he did
not give visitors a rebate on the admission charge in respect of
the bus fares needed to get round his show. It would have been
better if more of Gainsborough's major works had been
brought together in the same place at the same time.

But I do not wish to labour the inadequacies of exhibition
here. I am more concerned with the critical response these
shows evoked. Now Berger's comments were made before this
great series began: they involved fresh and original insights. He
has pointed out that his observation needed to be made
'because the cultural history we are normally taught pretends
that it is an unworthy one.' But times change. Today, even
populist critics tend to argue that the social relations
purportedly manifested or denied in the subject matter of a
picture can easily be transmuted into a qualitative judgement.

For example, in 1976, Richard Cork, a weather-vane critic,
argued in the *Evening Standard* that Constable was a bad
painter because he reduced the rural poor to 'freely applied
wriggles of paint—little more than formal devices to help him
compose satisfactorily.' A year later, Cork wrote that in *The
Haymakers* and *The Reapers*, Stubbs showed his willingness to
deal 'seriously, carefully and clearly with people so bucolic that
their mundane character had to be dressed up by all other
artists who depicted them in eighteenth century England.' In
fact, no one dressed up the peasants more than Stubbs; but
since Cork could not allow that anything except a crude social
naturalism directed towards the poor could lead to goo(

painting, he just failed to see that these fine works were contrived, Arcadian compositions.

There is no shortage of such muddled argument. John Barrell has published a book, *The Dark Side of the Landscape*, in which Gainsborough's later works are attacked for attempting to assimilate the image of the toiling peasant into a pastoral idyll belonging to an earlier age. All that Barrell can see in these works is 'what the polite wished to believe about the society of the countryside and the condition of the poor, whether that wish was conscious or not.' And so Barrell prefers the tiresome genre painter, George Morland, to Gainsborough, and praises Morland's 'social and ideological independence' and his supposed ability to produce more 'actualized' images of the rural poor.

Now I do not wish to tar Berger with Barrell. Indeed, it was in a review of the latter's book that Berger asked, 'Poussin relayed an aristocratic arcadianism, yes, but why was he a greater painter than any considered here?' All the sociological landscape critics should be asked this. But the question, of course, must raise doubts about Berger's own earlier comments on Gainsborough. If Poussin is so much greater a painter than Morland (as of course he is) then why was it *so* important to insist upon the tainted social and ideological character of the Andrews? How can that help us to appreciate or evaluate the painting?

I do not think one can say much about the value of a painting by talking about the ideology, or social relations, of its subjects alone. Such information may be interesting, and help to set a certain context for viewing, but discussions of ideology in painting only make sense if one also asks questions about the material skills of the painter, his relationship to the pictorial tradition, and the nature of his imaginative vision.

Gainsborough's material skills as a painter can hardly be doubted: he was a dazzling virtuoso. For example, he was a master of physiognomic expression. You can see this best in the great series of Bath society portraits he produced between 1759 and 1774. They are magnificent, not least for the look of ageing pride in the face of the Duchess of Montagu, the aimiable disdain of General James Johnston, or the pulsating sensuality of Mary, Duchess of Richmond.

But Gainsborough was the master, and indeed often the originator of other kinds of expressive skill, too. He did not

just accept the pictorial conventions he inherited. His best works show a new relish for the sensuality of the medium itself, and for its capacity to be expressive through the very brush-strokes themselves of the experience of the effects of light on drapery, flesh and foliage. I know of nothing to suggest that Ann Ford was other than a conforming member of her class: but, once that has been said, why should it inhibit us from enjoying the astonishing way in which Gainsborough has captured the tumbling translucence of her lacey white dress? Anyone who *prefers* Morland to such things really has no business to be writing about painting.

But this is only half the story. Gainsborough was no intellectual: he read little, and his letters, though charming, are full of spelling mistakes. Yet it seems to me quite wrong to try to identify his view of man in nature with the ideologies prevalent in his day. Gainsborough's greatness resides in the *exceptional* character of his vision, which, I believe, transcends its own time and remains radical for us today (whatever incidental ideological residues might also be imbedded within it.)

Let us go back to *Mr and Mrs Andrews*. One reason why this is a much better painting that anything Morland ever did is *because* Gainsborough has used his physiognomic skills to capture the landowners' proprietorial expressions. And what a splendid piece of painting that landscape is! Gainsborough was only twenty when he did it, yet such was his skill that after more than two centuries the landscape seems clear, fresh, bright and new.

And, the more you look at it, the more you feel that Gainsborough did *not* see or depict it in the way that the Andrews surveyed it. Berger says that the way the picture is made emphasizes *property:* yet the dominant symbol of property for any eighteenth century landowner was un-doubtedly his house. It is no accident that this can only just be glimpsed through a clump of trees. It is as if Gainsborough did not want it there at all, and, indeed, we know how, as Gainsborough's career progressed, it became increasingly irksome to him to have to take his patrons' point of view into account at all. Later, he was to write to a noble Lord, 'Mr G. hopes that Lord Hardwicke will not mistake his meaning, but if his Lordship wishes to have anything tolerable of the name of Gainsborough, the subject altogether, as well as figures, etc.,

must be of his own brain! otherwise Lord Hardwicke will only
pay for encouraging a man out of his way . . .'
This is already evident, even in his earliest paintings of
aristocrats in landscape. The more you look at *Mr and Mrs
Andrews*, the more you realize that there is a contradiction
between the painting of the figures and the vision of nature.
Apart from the acute (and critical) observation of facial
expression, all Gainsborough's life and energy is invested in the
latter. The body of Mrs Andrews, with its tiny dangling feet, is
more like that of a puppet than a person. (Gainsborough may
have modelled it from a doll). The fact that she is unfinished
accentuates this: in the centre of her lap, where Gainsborough
(or perhaps the Andrews) intended a dead pheasant is a patch
of bare canvas. This makes one feel she is not really alive: under
the marvellous blue dress, there are only rods, segments, and
space. Yet the landscape vibrates with life.

It is not just the figures which give rise to this sense of
contradiction: so, too, does the spatial organization of the
picture. The puppets do not seem to *belong* in this living
landscape. Pictorially, they do not occupy the same space.
They are displayed upon a foreground stage; only the bundles
of corn, on the right, occupy the same space as they, and these
appear almost like scenic props in a pantomime. Indeed, in
early Gainsborough, the aristocrats *never* rest easily in the
landscape: the picture of John Plampin of Chadacre (also in the
National Gallery) is typical. He, too, is like an awkward and
intrusive doll. His bottom does not even rest upon the bank on
which he is supposed to be sitting . . . Thus Gainsborough
expressed his sentiment (and there is no indication that it was
more than that) that there was something wrong with the
'natural' rights these people claimed over the land.

Critics like Barrell attack Constable for developing an
unrealistic 'romantic image of harmony with nature whereby
the labourers were merged as far as possible with their
surroundings, too far away from us for the questions about
how contented or how ragged they were to arise.' But this
'romantic image of harmony' (which transcends the given
social relations of the day) provides the true source of a great
landscape painter's imaginative strength. Gainsborough too
was concerned to offer an imaginative vision of the world
transformed.

It was not, of course, just the existing *social* relations which

Gainsborough transcended: he may have been schooled through the observation of nature, but that which he observed, he also imaginatively transformed. (Many of his best landscapes were in fact painted from bits and pieces of twig and stone arranged on a table in his city studio.) And it is the *otherness* of Gainsborough which makes him a good painter. For his 'image of harmony' undoubtedly drew deeply upon that inner aspiration for a complete reconciliation with others and the world, which is, I believe, a potentiality of sentiment common to all who possess human being. This potentiality lies at the root of all man's aspirations for a better world, including socialism.

Before this time, painters had used religious or classical mythology to articulate these aspirations: with secularization, the 'raw materials' available to them increasingly became perception, and the material processes of painting itself. Gainsborough certainly made use of these. Nonetheless, it is no accident that one of his very finest paintings is in fact a classical scene: *Diana and Actaeon*, in which the naked figures among the water and woods, are painted with a loving lightness of touch. The picture looks back to Poussin, and forward to those dazzling late Cezannes, in which, through his painterly forms, he articulated a new vision of man in nature. *Diana and Actaeon* embodies many of those qualities which I think make the pursuit of painting, and the quest of the aesthetic dimension worthwhile. And yet there isn't an 'actualized' peasant in sight . . .

1980

EDWIN LANDSEER: ANIMAL CRACKERS

More than 130 years after it was painted, Edwin Landseer's *The Monarch of the Glen* remains one of the best known pictures in Britain. But when I came across it at the centre of a full-scale retrospective of Landseer's work at the Tate Gallery I was struck by what a fresh painting it is.

Of course, I fully expected the bulky form of the great, twelve-pointed beast in the immediate foreground of the

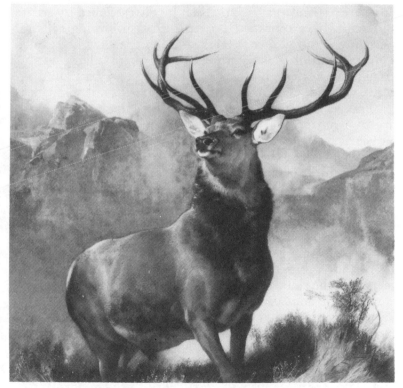

Edwin Landseer, *The Monarch of the Glen*, 1851, John Dewar & Sons Ltd.

picture, and even the contrast with the sublime airiness of the
scene behind where vaporous mists rise out of the valley and
distant rocks are swathed in clouds. All that is familiar enough
from a thousand cartoons, parodies, and reproductions. But
the astonishingly sensuous accuracy of Landseer's atmospheric
effects were altogether less expected: and these seem to spring
directly out of the brilliance with which he handled the paint.
Landseer captured perfectly the bright crispness of early
morning light in the Scottish Highlands. You see it in the
sheen of the stag's fur; the glint of the mucus round its raised
nostrils; the illuminated background mists; and the carefully
painted dewy grass at the bottom of the picture. Everything
shines and sparkles in a way which pricks memory and desire.

The Monarch of the Glen confirms Landseer's reputation as a
great virtuoso painter. No painter living today could put on
such a dazzling performance as this. Nonetheless, despite his
popularity, Landseer has not been highly esteemed by artists
and critics this century. It is true that, following a Royal
Academy exhibition in 1961, his landscape sketches gained
some recognition. But his major set pieces were still regarded as
a laughing-stock. This new exhibition invites a radical re-
evaluation: we are asked to consider Landseer not so much as
the Barbara Cartland of Victorian painting, but rather as a truly
major Romantic artist—a peculiarly English Géricault,
perhaps.

Certainly, the exhibition will provoke some new thinking
about this most paradoxical of painters. Landseer shares some
things in common with Picasso, beyond a mutual obsession
with animals in conflict. Both painters were sons of artist
fathers, and both became infant prodigies, capable of extra-
ordinary academic accomplishments in drawing at a very early
age. By the time he was four, Landseer was already compul-
sively and proficiently drawing cows, horses and dogs. Ten
years later, he could produce fine écorché (or flayed) anatomical
drawings of animals which at least stand comparison with
Stubbs's great studies of the horse. Picasso once said that he
spent all his time as a student learning to draw like Raphael and
the rest of his time trying to draw like a child again. Landseer, it
seems, never could draw like a child: his works are the products
of a precocious technical facility, which he never questioned.

Landseer's style was fully formed during his teens, and his
rise to fame had all the appearance of effortlessness. His

pictures were as well received at the Royal Academy, as he himself was by high society. He specialized in Highland scenes, and doggie paintings, later celebrating stags and lions. He also became, in effect, the last distinguished court painter, a confidant of Victoria and Albert, and the painter to whom they turned for conversation pieces, equestrian portraits, and pictures of their favourite pets, parrots, and marmosets.

Landseer thus came to live the life of a bachelor dandy, socialite, and huntsman. Although he never married, he developed romantic attachments towards a number of eminent older women—most notably the Duchess of Bedford who probably bore his illegitimate child. Nonetheless, his life was not devoid of that *angst* necessary if his claim to be considered as a full-blown Romantic is to be taken seriously. In 1840, Landseer was at the peak of his powers and success. However, he suddenly suffered a debilitating mental break-down. This may have been precipitated by a number of events in his private life: in 1839, the Duke of Bedford, the husband of his mistress, died. The following year, Landseer's own mother followed him to the grave. About this time, too, he asked the Duchess of Bedford to marry him, but she refused.

For the rest of his life, Landseer was dogged by madness. His virtuosity became inhibited by chronic procrastination. He found it increasingly hard to complete commissions, and his hypochondria became monstrous rather than merely tiresome. His suspicion turned to paranoia; and his charming narcissism to malevolent egocentricity. By the end of his life, he had become a jaded and drooling figure, shunned by the very society that had once elevated him.

Landseer, however, had never been just a good observer and draughtsman: he was always a highly imaginative painter, who freely projected the moral and psychological dilemmas of his inner world into those objects, persons, and animals in the outer world which he re-created with such consummate skill through his art. Indeed, for all their conventionality, Landseer's pictures seem peculiarly vulnerable to psychoanalytic readings.

Take, for example, his pictures of Queen Victoria. Landseer's lifelong obsession with the aristocracy and the Royal Family certainly cannot be explained in economic terms, since he frequently failed to submit his accounts and, even when he remembered to do so, ludicrously under-priced his work. Rather, it is possible to see here the outlines of a 'Family

Romance', or a psychological longing for origins more noble than those which he had. Little is known about Landseer's own mother, though she seems to have been an obscure and rather unprepossessing woman—perhaps tainted by some distant scandal.

Similarly, Landseer's internal conflicts with his father affected both his life and work. We know that Landseer senior was a cantankerous, bad-tempered, and cranky figure, who spent much of his life fighting the Royal Academy, and trying to persuade it to recognize engravers. Edwin's effortlessness—technically, socially, and in terms of sales from engravings—was not unaccompanied by guilt in respect of his father; hence the pathological procrastination, insulting behaviour of his later years, and chronic under-pricing. Landseer's ambivalence concerning his father was expressed in such activities as hunting and gambling: it also poured out in the pictures themselves.

Although Landseer was a passionate supporter of movements to restrict cruelty to animals, the totemic imagery of his animal painting is shot through with references to sadism and gory violence. His favourite theme is that of anthropomorphized animal conflict. Thus, in 1838, he painted one of his finest pictures, *None but the Brave Deserve the Fair*, which shows two stags locked in mortal conflict on the edge of a precipice while the nervous hinds look on. We need not marvel at the fact that when the Duke died the following year, and the Duchess refused him, Landseer experienced acute emotional problems; nor need we be surprised to learn that *The Monarch of the Glen*—one of the few pictures which shows a sole stag, triumphant, rather than locked in struggle, or menaced in some way by forebodings of death—was conceived and painted when Landseer's father was terminally sick.

Landseer, then, was a good observer of nature and, even if his colour was sometimes weak, a master of the conventional pictorial means he was using. Moreover, his contemporaries often found his projection of human concerns onto the animals entirely convincing. John Ruskin was no protagonist of Landseer's. Nonetheless, he could write without irony that *The Old Shepherd's Chief Mourner* was 'one of the most perfect poems or pictures . . . that modern times have seen.' Ruskin praised Landseer's observation and execution, but said it was on account of the 'thoughts' expressed through such skills

rather than the 'mere painting' that the picture ranked 'as a work of high merit' and its author 'not as the neat imitator of the texture of a skin or the fold of a drapery, but as a Man of Mind.' But the sophisticated gallery-goer who looks at *The Old Shepherd's Chief Mourner* today is not likely to find it perfect: indeed, it is more probable that he will turn away in disdain, or experience a desire to throw up.

Clearly, it is much harder for us to accept representations of animals as suitable symbols of high sentiment in human beings. And yet it is not difficult to understand why the Victorians should have turned to them in this way. Once the framework of a shared Christian iconography began to be shattered, and the mythology of classicism seemed culturally exhausted, *natural form* seemed to offer one of the few hopes for a common, pictorial, symbolic order. Indeed, the pathetic fallacy (of which the anthropomorphization of animals is only a special variety) was one of the few ways in which subjective, imaginative, and ethical experience could be redeemed from privatization: from the inauthentic chaos of Daliesque Surrealism, in fact. Thus, as we have seen, Landseer's struggling animals can, in one sense, be 'interpreted' in terms of his psychology. But it also makes sense to see him as searching for equivalents for the crucifix, pieta, and holy family in such forms as the dying stag, the mourning dog, or Victoria's court.

We find this solution unacceptable in part because of a massive shift in the 'structure of feeling' in our own time; in recent years, Modernism has insisted that the only legitimate kind of symbolism is that of form itself. The pathetic fallacy has given way to abstraction, and the attribution of sentiments and emotions to animals seems bizarre to those who do not hesitate to attribute them to undulating surfaces of pure colour.

And yet, of course, there are many who remain unmoved by abstraction: though the animal solution has vanished from High Art, it remains exceedingly popular. In 1981, the best-selling print in Britain depicted a tiger dipping its paw into a pool of water. Perennial favourites, like David Shepherd's *Wise Old Elephant*, and the wildlife work of his rival, Terence Cuneo, do not decline in their appeal. Those who sneer at Landseer, too, rarely hesitate before buying their children stories about anthropomorphized rabbits, mice, dogs, ducks, or even dinosaurs.

I am not, of course, attempting to denigrate abstract painting, still less to defend the banality of the contemporary animal print market. Rather, in a situation in which shared religious symbolism has vanished, it is probably merely fashionable to argue that animal painting, in and of itself, is necessarily inherently worse as imaginative art than the quest for symbolization through pure form and pure colour. Everything depends on the authenticity of the informing imagination, and the way in which it is welded with the substance of the paint. Joyce called sentimentality 'unearned emotion': by this criteria, Landseer certainly has many sentimental pictures. (I would rank *The Old Shepherd's Chief Mourner* among them.) But the emotion in *The Monarch of the Glen* seems to me to have been more authentically *earned* than in many, if not most, abstract pictures . . . As an image of the conquering son it seems to me as felt, powerful and effective as many Christian representations of Christ returning in glory.

1982

SALVADOR DALI AND PSYCHOANALYSIS

First, I suppose, credit where credit is due: Salvador Dali was among those who opened up a new area of experience to painting—that of the 'internal world', inner space and dreams. Despite the reservations I have about the *way* in which he did this it must be admitted that there are aspects of his project as a painter which are convincing for many of his viewers. We still hear a lot from those who think that the diminution of the audience for modern art can be correlated with its lack of social content. How, I wonder, do they explain the fact that, apart from Picasso, Dali, egotist and dreamer, is the only modern artist who has succeeded in exciting the popular imagination?

Moreover, Dali is a painter of considerable fanciful inventiveness and technical virtuosity. At a time when much that passes for painting is merely bland and slovenly abstraction, such qualities are too easily sniffed at. Dali himself once wrote, 'To understand an *aesthetic* picture, training in appreciation is necessary, cultural and intellectual preparation. *For Surrealism, the only requisite is a receptive and intuitive human being*'. Nonetheless, several of his paintings do show concern for compositional effectivity (though others admittedly do not). *The Persistence of Memory* and the Tate's *Metamorphosis of Narcissus* are not bad pictures. For once, the Tate deserves praise for having acquired a work which, on the evidence of this exhibition at least, is among this artist's best. These two paintings manifest an exemplary economy of scale and a capacity to weld heterogeneous imagery into a convincing unity.

But that is about the extent of the commendable residue I could salvage from my experience of the Tate's Dali exhibition in 1980. The overwhelming impression which Dali's work, as a whole, made upon me was of emotional shallowness and, above all, of *inauthenticity*. There are many advertisements which touch upon significant fears and wishes—concerning sexual

enjoyment, good health, child-care, longevity, happiness, peace, etc., etc.—and which yet banalize them by associating them with the most petty decisions we make in our lives, such as whether to buy Omo rather than Daz, to drink Pepsi instead of Coke, or to commit attenuated suicide with or without a menthol taste in our mouths. These advertisements insult because of the enormity of the gap between the experiences and sentiments they allude to and that which they are in fact selling to us. Similarly, Dali evokes such things as our fears about bodily ageing, fantasies infantile and adult about our own bodies and those of others, and our capacities for imaginative and iconic symbolization in dreams: but he, too, insults because all these intimate impingements are deployed for but one purpose, that of impressing upon us what a smart-ass painter he is. A typical quotation from Dali: 'In the city of Figueras, at 8.45 am, the eleventh of the month of May, in the year 1904, Salvador Dali, Domenech, Felipe, Jacinto, was born. Let all the church bells ring! Let the stooped peasant in his field straighten up his arched back . . .', etc., and so forth, until, 'Look, Salvador Dali is born!' The trouble is, he means every word of it. Indeed, that is the repeated message of his paintings, 'Look, Salvador Dali is born!'

To put the same criticism another way: the experiences and emotions which Dali alludes to are vicariously evoked; they are not *earned* through authentic expressive work upon materials and conventions. This can be demonstrated by considering two aspects of his work: his drawing and his touch.

Dali's drawing is full of the stereo-typed spiralling of dead lines which describe conventionally elongated figures: these are executed with the numbing cleverness of the *artiste*, acrobat or clown, someone who has learned how to run through a set repertoire. In a painter, that leads to a jaded, prostituted look: Dali's pencil exudes feigned sentiment. As for his touch, he often goes for a finished meticulousness which occludes all those nuances of gesture through which the affective value of a painting is realized. Although he blathers about his debt to Vermeer, you only have to compare the way in which the latter modulates light across the back wall of an interior with Dali's 'picturesque' skies in his dreamscapes, to realize why the master of Delft still looks fresh after three centuries, whereas even Dali's best work has a decidedly stuffy feel after less than

twice as many decades. But you really get to see the extent to which Dali is faking it when he presents himself without make up on: i.e. in those paintings where he roughs up the surface a bit, for example, *Palladian corridor with dramatic surprise*, or *The tunny fisher*—a perfectly hideous 1966/7 work. Here, you can follow the stiff, insensitive, and repetitive movements of the artist's hand which demonstrate that, far from being 'the greatest living artist' as advertisers of his wares claim, he is often as banal as a Bayswater Road sunset painter.

Julian Green, one of Dali's earliest collectors, once said that Dali spoke of Freud as a Christian would speak of the apostles. Indeed, Dali's reputation as a painter is rooted not so much in his material abilities—which are slight—as in his parasitic relationship to Freudian psychoanalysis. That relationship has queered the pitch for the potential contribution psychoanalysis has to make to the aesthetics of painting: here, I wish to raise certain questions about it.

How accurately did Dali depict or reflect Freud's insights in his paintings? First, I should stress that there can be no question of seeming to equate the achievements of Dali with those of Freud. Whatever criticisms one may have of him, Freud was one of the few true giants of twentieth century

Salvador Dali, *Portrait of Freud*, 1938, Boymans-van Beuningen Museum Rotterdam

culture, a man who has irrevocably transformed our perceptions of ourselves and each other. Dali, however, is dispensable. And yet there is a real sense in which Freud got what he deserved in Dali. I can clarify this by considering their brief encounter.

Freud had always sought to establish psychoanalysis as a *science*; he refused to have anything to do with the Surrealist movement. In 1938, however, Freud, frail and dying of cancer, left Austria in the wake of the Nazi invasion: he came to live in England. That July, his friend, Stefan Zweig, brought Dali to visit Freud. Dali, who thought that Freud's cranium was reminiscent of a snail, made a drawing of him on the spot. Zweig says in his autobiography that he dared not show this to Freud 'because clairvoyantly Dali had already incorporated death in the picture'. Dali's perspicacity was, however, hardly remarkable since, as Zweig himself admits, at this time 'the shadow of death' showed ever more plainly on Freud's face. In any event, Freud must have seen the sketch because the following day he wrote to Zweig concerning it. (The inconsistencies in Zweig's account may relate to his own attempt to deny identification with the dying Freud; Zweig, also a refugee from the Nazis, delivered the oration at Freud's funeral. Two and a half years later, he and his wife killed themselves. Zweig wrote in a suicide note that he lacked the powers to make a wholly new beginning.) Freud's letter said, 'I really owe you thanks for bringing yesterday's visitor. For until now I have been inclined to regard the surrealists, who apparently have adopted me as their patron saint, as complete fools (let us say 95 per cent, as with alcohol). That young Spaniard, with his candid fanatical eyes and his undeniable technical mastery, has changed my estimate. It would be very interesting to investigate analytically how he came to create that picture'. To put this judgement in its context, it is now necessary to say something about Freud.

Freud had been educated as a neurologist under the great mechanist, Ernst Brücke, who was an associate of Helmholtz himself. The generation of Freud's teachers believed in the measurability of all phenomena: ideologically, they were materialists and determinists, bitter opponents of vitalism and its derivatives. They would not, of course, have approved of psychoanalysis, but their influence upon Freud's development cannot be overestimated. Only with the most extreme

reluctance did he give up the hope of correlating psychological phenomena with the activity of neurones. Indeed, he never ceased to think of the mind as a 'psychic apparatus' within which different sorts of 'energy' circulated. Freud retained a key distinction from Helmholtz: that between 'freely mobile' and 'bound' energy. He brought this into contact with what he regarded as the most significant of his own discoveries, the distinction between two types of mental functioning, the primary processes and the secondary processes.

For Freud, primary process thinking displayed condensation and displacement, e.g., as in dreams, where images tend to become fused and can readily replace and symbolize one another. Furthermore, it denied the categories of time and space, and was governed by the pleasure principle, *Lustprinzip*, —or the tendency to reduce the unpleasure of instinctual tension by hallucinatory wish-fulfilment. Freud thought that primary process thinking was characteristic of the Unconscious, or, as he termed it in later formulations, the Id: it made use of *mobile* energy. Secondary process thinking, however, he saw as obeying the laws of grammar and logic, observing the realities of time and space, and governed by a reality principle which sought to reduce the unpleasure of instinctual tension through adaptive behaviour. Secondary process thinking thus made use of *bound* energy.

Now Freud always tried to associate the primary processes with sickness and neurosis. This is one reason why he regarded natural mental functions—such as dreaming while asleep—as analogous to psychopathological symptons. Conversely, he associated the secondary processes not just with the ego, but also with *health*. Indeed, he sometimes likened a psychoanalytic cure to land reclamation, whereby the ego took over that which once had belonged to the Id. Inevitably, this led Freud into some peculiarly unsatisfactory formulations about those activities—especially artistic activities—in which the *imaginative* modes of mental functioning, characteristic of the primary processes, played a vital part. At first, he tended to link art with neurosis, but later on he simply despaired of making any contribution to aesthetics, saying that when confronted with the creative artist, psychoanalysis must lay down its arms.

Freud's conception of the psyche was inflected not just by his cultural origins but also, inevitably, by his own psycho-

logical make-up. He was the founder of psychoanalysis, and as
such was analysed by no one except himself. He was also an
obsessional, and, like many obsessionals, tended towards a
dissociation between the affective and the intellectual combined
with a fear of the former insofar as it refused to submit itself to
rational control and explanation. Indeed, it is a singular fact
that although, as Marjorie Brierley has put it, 'the process of
analysis is not an intellectual process but an affective one',
Freud's psychoanalytic metapsychology lacks any adequate
theory of affects—with the exception of anxiety.

We have to conclude that Freud's historic self-analysis (on
which, of course, the first discoveries of psychoanalysis were
based) was incomplete. As is well-known, Freud took precious
little account of the infant-mother relationship. Although he, I
think rightly, correlated oceanic feelings of mergence—
characteristic of many mystical, religious, and aesthetic
experiences—with the infant's lack of differentiation between
ego and the external world, he himself reported that he had
never experienced such 'oceanic feelings'. Clearly, he regarded
them as regressive, *tout court*. And yet we know that Freud
disliked music, and was singularly lacking in true aesthetic
sensibility.

This is manifest in his attitude to painting. As he himself
once wrote, 'I have often observed that the subject-matter of
works of art has a stronger attraction for me than their formal
and technical qualities, though to the artist their value lies first
and foremost in these latter.' After spending an evening in an
artist's company, he wrote complaining to Jones, 'Meaning is
but little to these men; all they care for is line, shape, agreement
of contours. They are given up to *Lustprinzip*'. And similarly,
when one of his followers, Oscar Pfister, wrote a book on
Expressionist art and sent it to Freud, Freud wrote back, 'I
must tell you that in private life I have no patience at all with
lunatics. I only see the harm they can do and as far as these
"artists" are concerned, I am in fact one of those philistines
and stick-in-the-muds whom you pillory in your introduction,
but after all, you yourself then say clearly and exhaustively why
these people have no claim to the title of artist'.

Freud owned few pictures: what attracted him was invariably
subject matter. (He had, for example, a particular interest in
the theme of death). He did own engravings by Wilhelm von
Kaulbach—an arid salon painter, comparable with Bouguereau

or Meissonier. Indeed, it might be said that, insofar as he liked painting at all, Freud liked only those aspects of it which could be associated with the secondary rather than the primary processes. He was interested in that about painting which could be put into words without loss (i.e. 'meaning'): he was indifferent to line, and colour as such—regarding them as symptomatic of disruptive '*Lustprinzip*'. He wanted paintings which conformed with nineteenth century spatial and temporal conventions, which were regulated by 'reason', and the 'reality principle'. None of that 'lunatic' 'oceanic feeling' (or aesthetic experience) evoked by the ambiguities and fusions of modernism!

And yet, when all this has been said, it must be emphasized that Freud was in a highly paradoxical position. He was scientistic by inclination; and yet his chosen terrain was that of subjectivity itself. As Charles Rycroft has put it, 'Since psychoanalysis aims at being a scientific psychology, psycho-analytical observation and theorizing is involved in the paradoxical activity of using secondary process thinking to observe, analyze, and conceptualize precisely that form of mental activity, the primary processes, which scientific thinking has always been at pains to exclude'. We can now see, I think, why Dali proved so acceptable to Freud.

Freud endeavoured to cope with this contradiction at the heart of psychoanalysis by talking about the human psyche *as if* it could be adequately explained using models derived from the nineteenth century natural sciences—hence his continued reliance on the Helmholtzian theory of two kinds of energy, and his belief in psychic determinism, etc. Dali is a painter who, though he draws on the contents of 'the unconscious', succeeds in subjecting them entirely to a nineteenth century world-view, to a sensibility compatible with the nineteenth century 'reality principle'. (His work involves innovations in subject matter, but significantly *not* in form.) Dali has said that his favourite artist is Meissonier, and indeed, he regularly 'Meissonises' imaginative activity, by which I mean he brings it to heel through the conventions and devices of nineteenth century salon art. Furthermore, as I hope I demonstrated earlier, the way in which Dali paints is such that, although he deals with 'the inner world', he effectively suppresses all the dangerous affective connotations which might have been aroused by such a terrain—beyond those which are readily put

into words. Dali's conception of 'inner space' is really of a modified, mathematically coherent, perspectival vista. If post-Renaissance art purported to offer a 'window on the world', Dali purported to offer a window on the psyche, and that, of course, is exactly what Freud, the 'scientific' observer, wanted to look through.

It remains, however at best doubtful whether psychic processes are really analogous to those models through which Freud endeavoured to describe them. Charles Rycroft (whose writings have had a considerable influence upon much that I have argued here) has suggested that Freud's theory of 'energy', upon which his psychological model depends, is in fact *a theory of meaning* in disguise. Indeed, in his view, psychoanalysis is not really like the natural sciences at all: he implies it might be something *sui generis*, that is 'a theory of biological meaning'. Such a position implies a radical revision of psychoanalytical terminology. (This has already been attempted in Roy Schafer's *A New Language for Psychoanalysis*, which endeavours to dispense with all concepts about human behaviour and feeling derived from the deterministic models appropriate to physics and chemistry.) Such a revision involves the relinquishment of some of Freud's most cherished notions. Rycroft, for example, argues 'concepts like the unconscious are unnecessary, redundant, scientistic, and hypostasizing—the last since the concept of the unconscious insinuates the idea that there really is some entity somewhere that instigates whatever we do unconsciously, some entity which is not the same entity as instigates whatever we do consciously'.

If Rycroft is right—as I am convinced that he is—then of course Dali's 'vistas' on 'the unconscious' will soon seem even more dated than they do now. But Rycroft's position also involves great gains: throughout his work, he emphasizes that the primary processes are not, as Freud perceived them, on the side of neurosis, sickness, and aspects of the self which require 'reclamation' or repression. He argues that they form an integral component in healthy and creative living and mental functioning, co-existing alongside the secondary processes from the earliest days of life. Characteristically, Rycroft's most recent book, *The Innocence of Dreams*, describes dreams not as 'abnormal psychical phenomena', but rather as the form taken by the imagination during sleep. Similarly, instead of associating symbolism exclusively with the primary processes as 'the

language of the unconscious', Rycroft has characterized it as 'a general tendency or capacity of the mind, one which may be used by the primary or secondary process, neurotically or realistically, for defence or self-expression, to maintain fixation or to promote growth'.

The great advantage of such a position is that it dispenses with that form of psychoanalytic reductionism which regards non-verbal creativity as a reprehensible, 'immature', sick, or regressive phenomenon—or, at best, a kind of semi-civilized crust formed over undesirable impulses. It removes the notion that a concern with form is dismissable as *Lustprinzip*, and takes us 'beyond the reality principle' to re-instate the imagination in its rightful place. Furthermore, it opens the door to a psychoanalytic contribution to the understanding of all those areas—e.g. music, abstract and expressionist painting, 'oceanic feeling', etc.—where Freud's own sensibility (and his theoretical constructs, too) are literally anaesthetized, i.e. lacking in an aesthetic dimension. (From this point of view, I think that it is also possible to explain why, despite what Dali claims, truly 'aesthetic' paintings, which reach down into relatively constant areas of human experience, are likely to outlive his anaesthetic, culture-trapped vision.) In my book, *Art and Psychoanalysis*, I have sketched the preliminaries for such a contribution, drawing heavily upon the work of the British object relations school of psychoanalysis, especially that of D. W. Winnicott, Marion Milner, and of course Charles Rycroft himself.

1980

WYETH'S WORLD

Like so much in Wyeth's paintings, Karl Kuerner is worn. Time has aged and rubbed him; but he is a survivor. There can be no doubt about that. His gun points towards his wife who stands wizened and uncertain behind him, framed by the blank expanse of the farmhouse wall. The figures do not relate to each other with eyes or bodies. They are each alone. The Kuerners, together with their property, have formed one of the persistent themes of Andrew Wyeth's paintings for thirty-five years. Here they are depicted in dry-brush, an obsessive, meticulous technique which gives a cracked, parched look to everything. It lacks the translucence of wash watercolour, or the sensuality of oil paint; it makes subjects look real, but breathless and dead. And that, one suspects, is what Wyeth wants.

Wyeth is America's most popular painter. In 1976, when the Metropolitan Museum put on its first ever major exhibition of

Andrew Wyeth, *The Kuerners*, 1971, private collection

work by a living artist in bicentennial year, it was Wyeth, and
not an abstractionist or modernist, who was chosen. Wyeth
can command above $300,000 for a single picture. But he paints
from the point of view of people like the Kuerners. In fact, he
has lived all his life next door to them, in Chadds Ford,
Pennsylvania. His values are their values.

Wyeth is a true middle American. He does not travel much,
but every summer he and his family go over to Cushing, Maine,
another small plot of rural America. He has known Cushing
since childhood; he met his wife there. And at Cushing, too, he
became obsessively involved as a painter with one particular
family—the Olsons. His most famous Maine painting (un-
fortunately not in the Academy exhibition) is *Christina's
World*. It shows a woman, crippled with polio, dragging herself
up a sloping field on her arms towards a distant farmhouse.

This bleak picture is painted in tempera, Wyeth's preferred
medium when he is not using dry-brush. Tempera is *hard*. You
cannot achieve the close imitation of natural effects possible in
oils, but since it refracts light very little, colours tend to be
unusually clear and vivid. Through his mastery of this medium,
Wyeth achieves a sense of keyed-up intensity, and yet also of
unreality. *Christina's World* seems closer to a hallucination
than to something calmly perceived.

Until recently, Wyeth was hated by the modern art
fraternity. As Marina Vaizey says in the catalogue, 'His very
popularity has aroused the suspicion of the intellectuals.' He
has been described as a purveyor of the anachronistic aesthetic
values of nineteenth century American realists like Eakins and
Winslow Homer. But as he himself has often said, neither his
vision nor his way of painting is much like theirs. He has
sometimes been called 'sentimental' and 'nostalgic': but the
claustrophobic malevolence which pervades his work makes
these terms sound singularly inappropriate. Then he has been
dismissed as 'photographic.' That is just silly. Everything,
including the often severe spatial distortions in his pictures,
plays its part in a carefully constituted symbolic order: he is
interested in what he once called 'my truth behind the fact'
rather than in instantaneous appearances.

I think that much of the intellectuals' hostility towards
Wyeth derived from the fact that he accurately expressed the
world-view of people like the Kuerners. Wyeth's painting
seems to suggest that if an uninvited urban art intellectual

happened across their land in Chadds Ford bearing Andy
Warhol's *Interview* under his pink-sleeved arm, they would be
quite likely to shoot him in the legs, or at least to unleash one
of those menacing Wyeth hounds to rip out the seat of his
pants. The unfavourable reaction of the intellectuals to
Wyeth's work is understandable. Nonetheless, it now seems by
no means as certain as they once suggested that he is a no-good
painter.

In the mid-1960s, when Wyeth used to say things like, 'In
the art world today, I'm so conservative I'm radical,' he was
regarded as being quaint. Fifteen years on, modernists are
not so confident in their judgments as they once were. In
particular, the view that value in art is created by a historicist
process of stylistic innovation, or reduction, is now pretty well
discredited.

Wyeth himself once said, 'I honestly consider myself an
abstractionist.' He was trying to emphasize that he was not
someone who copied appearance, but rather a painter who
sought forms and techniques through which he could imagina-
tively transform his perceptions and bring them into an
aesthetic whole, which came to constitute its own pictorial
reality. He does not see himself as a 'realist': 'You look at my
pictures . . . there's witchcraft and hidden meaning there.' He
adds that they have 'that eerie feeling of goblins and witches
out-riding on broomsticks . . . the feel of your face under a
mask walking down a road in the moonlight. I love all that
because then *I* don't exist any more.'

The intensity of Wyeth's vision comes then not just from his
eccentric social position, but also from his particular psycho-
logy. He has, indeed, a strange history. Wyeth's father moved
out to Chadds Valley. He was a well-known illustrator of
popular classics; Andrew was the youngest of five children, and
his father taught him to paint. 'My father certainly came down
upon me firmly, pressing me on but at the same time he left me
really free,' he once wrote. At first, the young Wyeth was a
watercolour painter with a fluid, lyrical style, based on
immediate sensations. In 1945, all that changed.

Near Karl Kuerner's house, there is a level crossing. One
day, Wyeth senior's car stalled there and he and his grandson
(Andrew's nephew) were killed by an oncoming train. Wyeth
says that this was 'the real turning point—when the emotion
thing really became the most important.' His style changed at

once. 'When he died, I was just a clever watercolourist—lots of swish and swash.' But he experienced a 'terrific urge' to live up to what his father had taught him, 'to really do something serious and not to play around with it doing caricatures of nature.'

Oppressed by a 'vast, gloomy feeling,' he nonetheless found consolation in his great emotion towards landscape, 'and so, with his death . . . the landscape took on a meaning—the quality of him.' At this time, too, he became fascinated with the 'brutal' and 'sentimental' Kuerner, a father symbol which he associates with animal slaughter, Germany—and hence 'old masters,' like Dürer, Wyeth's favourite. (There is even a portrait of Kuerner standing on his land wearing an old German battle helmet.)

Wyeth's work thus deals as much with his 'inner world,' as with the social realities of Chadds Ford, or the physical landscape. Through the material processes of his techniques, he finds ways of fusing inner and outer into new and strange unities, which are shaped by his ambivalence concerning this central fact in his private life.

One painting, *Winter* (again sadly not in the Academy show), was made the year after the tragedy: it shows a boy 'running almost tumbling down a hill'—part of the Kuerners' farm. According to Wyeth, that hill became a portrait of his father, and is indeed one of his first paintings fully in his father's style. Only by making this painting was he able to overcome that 'feeling of being disconnected from everything.' For the first time in his life, he says, 'I was painting with a real reason to do it.'

Wyeth would undoubtedly repay a detailed psychoanalytic study. If Chadds Valley is indelibly linked to his ambivalent feelings concerning an internalized father figure, Maine seems intimately bound up with a split-off female component within him. Maine is where his wife comes from. It is also *Christina's World*. (Interestingly, Wyeth once ruminated about Rothko, whom he admired, and said that if he was trying to make that painting now he, too, might try to do it through what he called the 'modern dream of absolute symbol,' leaving out the crippled figure altogether.) After Christina's death, Wyeth found himself a new female subject there—a beautiful and sensuous girl, Siri Erickson.

Well, does all this make Wyeth a good painter? I am afraid

not. I think he has created a pictorial world which is genuinely expressive of the embittered and restricted world view of certain middle Americans. Through both his material skills as a painter, and the way in which he charges his pictures with obsessional psychological intensity, he makes that world view accessible to a much wider public. Nonetheless, a painting I was reminded of again and again, especially by the earlier Wyeths, was *The Fairy Feller's Master Stroke*, by the British Victorian artist, Richard Dadd. Wyeth evokes that same frozen moment—what he calls 'the sense of time holding its breath'; he uses similar spatial dislocations; he exhibits the same kind of schizoid-obsessional focusing upon detail; and above all, a parallel sort of detachment from his affects. By this I mean that, in the big set pieces, however charged the imagery, Wyeth rarely breaks out of that stiflingly over-controlled technique.

Dadd, of course, murdered his father with a razor. It is as if Wyeth was forever taking us back to that frozen moment, when the oncoming train hit the car. Nothing changes in the world outside; nothing changes in his head. The repeated symbols of shells, carapaces and uniforms seem to indicate how uneasy he is in his worlds—inner and outer. Only that glacially oppressive technique seems to freeze everything together. I, for one, was glad to get out into the street, where the light played, people breathed, children played and there seemed at least some hope of change and becoming in both the psychological and social worlds.

 1980

EDWARD HOPPER: THE LONELINESS THING

Edward Hopper, a large man as taciturn as the figures in many of his paintings, used to grumble that those who talked about his paintings overdid 'the loneliness thing.' Nonetheless, his best pictures seem to depict the experience of isolation: Hopper's people are lost within themselves even when they are in the presence of others.

Hopper did not like being called 'an American scene painter' either: and there it is easier to go along with him. His famous pictures of a man standing by a row of petrol pumps outside a rural filling station, or of shop facades in Seventh Avenue, Manhattan, on a Sunday morning are as concerned with a certain 'structure of feeling' as with topography. But that 'structure of feeling' is 'the loneliness thing.'

You feel it in Hopper's masterpieces, like *Nighthawks*, with its four jaded figures in the illuminated interior of an all-night cafe, and in many of the pictures of office workers, travellers, hotel guests and theatre people. You can hardly avoid it, either, in the compelling studies of anonymous women glimpsed dressing, or undressing, in the cold but intimate spaces of brilliantly lit bedrooms. It even pervades the pictures of isolated buildings by railroads or the later images of empty rooms in which no men or women appear at all. These too seem somehow dominated by the absence of the figure.

It would, in fact, be hard to say anything convincing about Hopper without stressing 'the loneliness thing.' His paintings are so conspicuously about the vacuity, sadness, futility, emptiness and, yes, experience of alienation on the fringes of 'the American dream.' But how does this relate to the qualities of his work and to his stature as an artist?

According to many contemporary American critics, Hopper has been crippled by his preoccupations. For example, a standard text on American art, declares that 'pictorially' Hopper was as 'limited, average, and undistinguished as the humiliated landscape, the dilapidated and gloomily picturesque

architecture and the drab urban scenes' that he made the 'stock-in-trade' of his subject matter. Hopper is an embarrassment to American partisans of modernism and avantgardism. Their art history books and the lay-out of their modern art museums are designed to prove that all that is of value in recent art has been created by handing down the torch of stylistic innovation first ignited by Cézanne. They assume this was borne aloft in a triumphant, historicist progression through the early European modernist movements and on, into the achievements of American abstract expressionism and its successors. But it was just this development Hopper refused. He objected to the 'papery qualities' of Cézanne, and was not significantly affected by anything that happened later. And yet Hopper clearly could not be dismissed as some hill-billy regionalist or dumb 'primitive'.

When Henry Geldzahler organized his massive 1970 exhibition of American art since 1940 at the Metropolitan Museum, Hopper was the only outsider at the modernist garden party. But he was hardly a welcome guest. Not one of the copious critical essays in the catalogue so much as mentioned his name.

More recently, however, even the art institutions have begun to acknowledge that modernism is in crisis. What once looked like Hopper's weaknesses are now acclaimed as his strengths. He is praised as the painter of 'modern life,' *par excellence*. Alternatively, he is interpreted as a great, neutral 'realist' who refused style altogether, and simply transcribed, exactly, the appearance of contemporary reality.

But these estimates of Hopper won't stand up either. There are many bad paintings about 'modern life.' Hopper himself painted some of them: he is, in fact, a very uneven artist. Not more than fifteen of his pictures are wholly convincing, and there are works in this exhibition so second-rate that it is hard to believe they were made by the man who produced, say, *Nighthawks*. But those Hoppers which approach the condition of masterpieces are certainly not the ones in which he most faithfully transcribes appearances. The working drawings included in this exhibition demonstrate how carefully his best paintings were *constituted*; all sorts of disparate observed elements are used to construct a single picture. The artist's role is anything but 'neutral.' The case of Edward Hopper appears more complex than either the modernists or their opponents allow.

Hopper was taught by Robert Henri, a turn-of-the-century American artist with a deep admiration for Velasquez, Hals, Goya, Daumier and the pre-impressionist pictures of Manet and Degas. Henri wanted an art saturated in 'modern life': but he tried to realize this through physiognomy—the expressions of his subjects. He was a versatile portraitist of men and women in every condition. Henri opposed aestheticism and revived the concerns of earlier nineteenth century American painters, like the great Thomas Eakins, who had tried to root their art in the scientific study of the body. Hopper thought Eakins greater than Manet. Under Henri, Hopper learned to draw the figure; the transformations of its expressions and poses were the first expressive language he mastered.

But in 1906 Hopper went to Paris and encountered impressionism. All he had learned led him to resist the dissolution of concrete forms into hazes of light. Nonetheless, in his painting he began to rely not just on the body (and the world) as objects of perception, but also upon elements drawn from the processes of perception themselves. In particular, transformations of luminosity and of depicted space joined

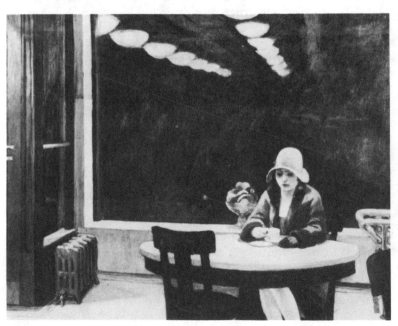

Edward Hopper, *Automat*, 1926, Des Moines Art Centre, Iowa

those of the figure as part of the material upon which he drew to make his pictures.

After 1910, Hopper never crossed the Atlantic again. But it took him a long time to integrate what he had learned during his American apprenticeship with the discoveries of his visits to Paris. For a time, he stopped painting and found work as an illustrator. But he complained that he never felt satisfied drawing people 'grimacing and posturing.' He longed to 'paint sunlight on the side of a house.' Of course, he did not just wish to record it: Hopper was contemptuous of painting which tried to short-circuit imagination. 'Great art,' he once wrote, 'is the outward expression of an inner life in the artist, and this inner life will result in his personal vision of the world.'

In the 1920s, when he was in his forties, Hopper finally found a way of working in which the expressive potentialities of the figure, perceived space, and light were combined together under the directing force of the imagination to create convincing pictures. Through these painterly means he could, when he wished, say something about those 'structures of feeling' characteristic of 'modern life.'

Take *Automat* of 1926. A woman is seated at a circular table near the door of the automat. The chair in front of her is empty. Beneath the dome of her hat, her eyes are downcast. She has just taken a sip of coffee. Perhaps she is thinking about someone who is not there. Behind her, on the sill, is a bowl of fruit. The round lights of the interior, reflected in the window, run out into the night and are swallowed up by it: she is framed by a great pane of emptiness and silence. She is alone.

Why is this such an effective picture? In part, it is because of the handling of the figure itself. She is comprised of very simple forms: yet everything about her—eyes, lips, hands and legs—is expressive of those emotions Hopper wishes to communicate. But the play of lights and colours, particularly the contrast between the uncomfortable luminosity of the cafe and the undispersable darkness of the night outside, serve the same purpose. These elements, however, acquire their expressive strength within the compositional structure of the picture.

This is not, of course, a transcription of a given scene, or anything like it. The forceful geometry of the painting has been built up through Hopper's self-conscious choices and simplifications—for example, in the way he plays off the circular forms of the woman's hat, coffee cup, table, fruit bowl and lights

against the rectangular shapes of this corner of the room. Above all, Hopper has carefully framed the woman against that potentially engulfing plane of blackness. This is intended to tell us more about her emotional state than about his empirical observations.

The content of this painting is thus certainly 'the loneliness thing.' But it is not this, on its own, which makes it effective. James Joyce once said, 'Sentimentality is unearned emotion.' It is easy to imagine a sentimental picture on the theme Hopper depicts here. But the emotion in *Automat* has been earned by the way in which the artist brings it to cohere in all aspects of his expressive practice (including those to do with figure, light and structure) and further unifies all these elements into a convincing compositional whole.

And this is why I think both the modernists (with their insistence that only new styles can be of value in painting) and their opponents (with their vague appeals to 'modern life,' or the need faithfully to record appearances) are both missing the point about Hopper's best work. Indeed, Hopper reminds me strongly of Mark Rothko, who was perhaps the best of America's 'abstract expressionist' painters. Stylistically, of

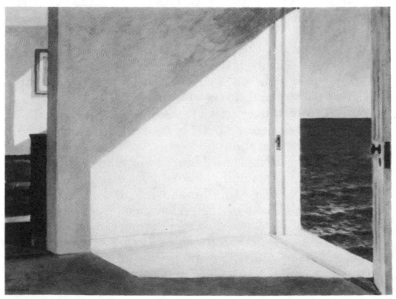

Edward Hopper, *Rooms by the Sea*, 1951, Yale University Art Gallery

course, they have nothing in common. Yet the area of experience which Rothko expressed, through his chosen pictorial conventions, was peculiarly close to Hopper's.

Rothko, at first a figure painter, turned to wholly abstract works of glowing colour fields through which he chronicled his struggle against depression, alienation and despair. Eventually, a billowing black cloud of negative space began to appear ever more frequently in his work: visually, it looked not unlike the purplish, subsuming plane in *Automat*. Finally, it engulfed not just his pictures, but Rothko himself.

Hopper's work seems to follow a similar, though less dramatically extreme, development. As he grew older, Hopper seemed to become less and less comfortable with the presence of figures in his paintings. Sometimes, his later works seem cluttered, as if he was throwing in as many forms as he could to cover that nothingness glimpsed in *Automat*. In other works, the figures are so badly drawn and proportioned that one feels Hopper would have been happier leaving them out altogether. Indeed, the most successful of his later interiors are those of the walls of empty rooms. In these, the proximities to Rothko's concerns are self-evident. It is as if Hopper no longer wished the figures of others, in the world, to impinge upon that expressive space which he was trying to construct in his pictures.

To some, this comparison between Hopper and Rothko may sound forced, or fanciful. But Hopper himself once said, 'To me, form, colour and design are merely means to an end, the tools I work with, and they do not interest me greatly for their own sake. I am interested primarily in the vast field of experience and sensation.' Similarly Rothko, protesting against those who called his works 'abstracts,' wrote, 'It is not [my paintings'] intention either to create or to emphasize a formal colour-space arrangement. They depart from natural representation only to intensify the expression of the subject implied in the title—not to dilute or efface it.'

The painterly means Hopper and Rothko used may have been very different: but the areas of experience and sensation which they each so effectively expressed were, in fact, very similar.

1981

SPENCER'S LOST PARADISE

As a child, I was sometimes taken to see the chapel Stanley Spencer covered with murals of the first world war at Burghclere in Berkshire. Spencer was admired within the Nonconformist milieu, within which I was brought up, as the last *considerable* religious artist. He impressed me deeply: I was fascinated by *The resurrection of the soldiers* on the east wall; there was something compellingly mundane about the way they rose from the ground amid mud and horses and handed in their white crosses to Christ.

Visiting his exhibition at the Royal Academy, I realized how deeply he is etched on my memory. This was not just the result of childhood impressionability. Although Spencer produced some atrocious works, this exhibition confirms that he was, at his best, a good, even a great, painter. But art teachers rarely recommend their students to look at him; art historians do not know what to say about him; and museum curators have no idea where to hang him. For a long time, his magnificent *The Resurrection, Cookham* was almost invisible in the darkness of a Tate stairway.

How are we to explain the Spencer phenomenon? He was born in Cookham in 1891, the seventh of eight children of the village music teacher. The family was intense, closed, talented and religiously fraught—father was church, mother chapel. Stanley and his younger brother, Gilbert (later also a painter), were educated by two elder sisters in a schoolroom behind the house. In 1907, Stanley attended art school in Maidenhead, where he drew from classical casts. In 1908, he went to the Slade where he was taught by Henry Tonks, who believed that the only basis of artistic expression was anatomical drawing.

His fellow-students nicknamed him 'Cookham' because he travelled up and down from the Berkshire village every day by train. Spencer's early religious paintings, like *The Nativity* of 1912, and *Zacharias and Elizabeth* of 1914, are saturated with elements drawn from Cookham. They indicate how carefully

he had been looking at early Renaissance painters, and they are compositionally impressive. But they also have the ring of expressive authenticity about them.

Speaking of these pictures, Spencer himself said in the 1940s that the religion which informed them was 'utterly believed in.' 'Somehow religion was something to do with me, and I was to do with religion. It came into my vision quite naturally like the sky and rain.' Religion was bound up with his continuing experience of his birthplacce, too. He once wrote: 'I could see the richness that underlines the bible in Cookham in the hedges, in the yew trees.'

When Piero Della Francesca painted his *Nativity* (now in the National Gallery), he did so against the background of the Italian countryside. Through his compositional skills, he brought together his personal imagination, and his experience of the world as seen, and unified the two within a shared religious mythology. Few twentieth century painters have ever felt themselves to be in such a fortunate position. Until 1914, however, Spencer was.

The idyll was soon shattered. In old age, Spencer looked back on his early paintings. 'Those pictures,' he said, 'have something that I have lost. When I left the Slade (in 1912), and went back to Cookham, I entered a kind of earthly paradise. Everything seemed fresh and to belong to the morning. My

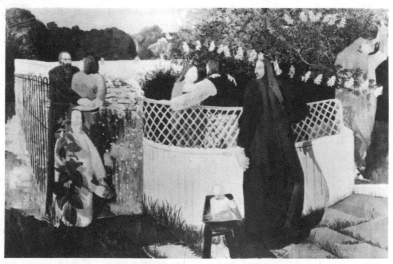

Stanley Spencer, *The Nativity*, 1912, London University College

ideas were beginning to unfold in fine order, when along comes the war and smashes everything.' (Spencer enlisted with the Royal Army Medical Corps and served with field ambulances in Macedonia.) 'When I came home, the divine sequence had gone. I just opened a shutter in my side and out rushed my pictures anyhow. Nothing was ever the same again.'

The first world war split Spencer's imaginative life. Nonetheless, at first, this experience served only to enrich his work. Demobilized, he was commissioned to produce an official war painting. *Travoys*, of 1919, shows a dressing station during a battle in Macedonia. It is among the outstanding British paintings of our century.

Spencer saw the figures on stretchers 'with the same veneration and awe as so many crucified Christs.' Thus he found 'a sense of peace in the middle of confusion,' but one which is neither sentimental nor idealizing. The contrast between the picture's calculated compositional serenity, and the searing tragedy it depicts evokes the sentiments of some of the finest Renaissance crucifixions.

Spencer produced other major works in the 1920s. But his greatest achievement of this, or any period was the Burghclere memorial chapel, which was commissioned to commemorate a dead officer and which he executed between 1927 and 1932. John Rothestein did not exaggerate when he contrasted it favourably with Matisse's more famous chapel at Vence.

Nonetheless, there is a sudden falling off of Spencer's creative powers after the completion of the chapel. In the beginning, the 'earthly paradise' of Cookham had, like all utopias, been elaborated out of transfigured elements of infantile, emotional experience, represented through religious pictorial conventions. Spencer tried to comprehend even the 'negative utopia' of war in these terms.

Significantly, he *never* engaged in 'horrors of war' painting. Burghclere shows ordinary soldiers doing everything *but* fighting, and rising from the dead rather than dying. The attempt to see war in terms of his 'earthly paradise' gave rise to his finest pictures. But the two would not truly fit, and he never successfully revived the idyll. Religion could no longer authentically mediate between his inner and outer worlds.

In 1932, after more than ten years' absence, he moved back to Cookham. He painted many landscapes of the village, but there is about these works a deadening, sharp-focused

literalism: Cookham is now clearly *seen*, but not *felt*. How different this glazed vision seems from when he looked lovingly on the same landscape for the elements of his early religious paintings. But Spencer was also seeking a mythology to fill the vacuum of his collapsed religious world-view. He thought he had found it in bodily relations between human beings.

You find hints of this in his continuing obsession with the resurrection, which began much earlier. Spencer never saw this as the coming of the cataclysmic spiritual Kingdom of God on earth, but rather as the collapse of the spiritual into the mundane. There is something resolutely common-or-garden about all those well-dressed village folk, popping out of their graves.

In the 1930s his view of religion became increasingly sexual. 'The erotic side I am so drawn to really belongs to the very essence of religion,' he once wrote. In 1935, he painted *Love among the nations*, in which utopia now becomes a kind of

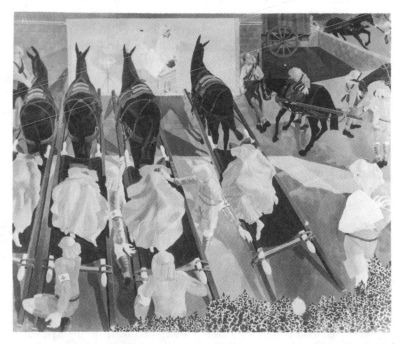

Stanley Spencer, *Travoys arriving at a dressing station*, 1919, Imperial War Museum, London

mutual masturbatory grappling between persons of all colours, races and creeds. 'During the war,' he commented concerning this picture, 'when I contemplated the horror of my life, and the lives of those with me, I felt the only way to end the ghastly experience would be if everyone suddenly decided to indulge in every degree and form of sexual, carnal love, bestiality, anything you like to call it. These are the joyful inheritances of mankind.'

Spencer's attempt to translate religious experience into human terms sounds promising. In fact, it proved a pictorial disaster. *Love among the nations* is hideous. *Sunflower and dog worship* (in which sexual activity is extended to contact with the animal and vegetable worlds) and *Adoration of the old men* (in which a group of infatuated male geriatrics wait to be felt-up by village girls) are even more grotesque. Few of his scenes celebratory of sexual encounters and conjugal life are much better. So what went wrong?

The answer is partly pictorial. Many pioneers of the modern movement discovered that profane illumination could be expressed through a certain kind of aesthetic experience, dependent upon the emotional symbolism of form itself—the handling of paint substances, colours and shapes in ways evocative of significant affective states. You find this in Cézanne, post-impressionism, Kandinsky, Mondrian, and some recent abstract painting. You can see something similar in pre-Renaissance art, and, significantly, in very early Spencer, too. His picture, *John Donne arriving in heaven*, was not out of place in Fry's 1912 post-impressionist show.

But Spencer despised such techniques, when they were not linked to specifically religious imagery. Pictorially, he came to insist exclusively on anatomical expression. He could not even take impressionism, complaining of its 'utter lack of spiritual grace.'

Spencer's failure was as much to do with his personal as his aesthetic limitations. The reduction of religious experience into secular terms cannot be done through instinctual, sexual love alone. The life of adult human beings embraces a gamut of emotions, of which the explicitly sexual forms just a part. Spencer's vision of transformed human relations becomes a travesty. In the midst of *Love among the nations* he appears, clothed, while two naked Negresses fondle him. Thus was the 'earthly paradise' reduced.

He himself was incapable of full relationships. He married Hilda Carline when he was thirty-three. In 1935, he began a series of perverse nudes of Patricia Preece, sometimes including a self-portrait. These are redolent with oppressive sexual tension, but without trace of feeling in touch, composition or gesture. Hilda was divorced from Spencer in 1937, and he promptly married Preece. He invited his first wife to attend his honeymoon with his second, whereupon the latter (who was already established in an enduring lesbian relationship) accused him of adultery with the former, and declined to live with him.

He made repeated overtures to Hilda to remarry him; but she refused. He wrote her endless letters—some over 100 pages long—which were not inhibited by her death in 1950. Thus though Spencer celebrated good human relations as the realized essence of religion, he knew little about them. Even his affirmation of the sexual was born of frustration rather than fulfilment—and, in the paintings, this shows.

Perhaps not surprisingly, he often tried to revive his religious 'world-view.' Sometimes, in *The Christ in the wildnerness* series of 1939, or Southampton's *Resurrection*, of 1947, he almost succeeded. But the repulsive, comic-book character of such works as *The crucifixion* of 1958 indicate only the *desperateness* with which he sought to invest the old mythology with meaning and feeling again.

The psychiatrist, Anthony Storr, has recently suggested that there is a special link between utopianism and sexual perversion. Both involve transfiguring the world according to one's fantasies and wishes. When Spencer's 'earthly paradise' collapsed, he failed to find a secular equivalent for it. Had he been a socialist, or even someone more sympathetic to modernist art, would he have fared any better? We cannot say. As it was, he lapsed into a chaos of perverse fantasy.

<div align="right">1980</div>

AFTERMATH IN FRANCE

'Aftermath', the opening exhibition at the new Barbican Centre, surveyed French painting from the decade 1945–54. In effect, it is a development of the Centre Georges Pompidou's recent Paris-Paris exhibition—but one which focuses specifically on the response to World War II. 'The post-war theme of the exhibition,' wrote Henry Wrong, General Administrator of the Centre, 'is particularly relevant to the Barbican which itself rose like a phoenix from the ashes of World War II.' Be this as it may, the historic association between these tortured, anguished, and often helpless paintings and the plush, hotel-lobby, self-confidence of the Centre was not likely to be immediately apparent to the average viewer.

As I roamed through acres of carpeted foyer, I could not help reminiscing about how, as an eager young journalist writing for *City Press* ('The Voice of Honest Capitalism'), I had repeatedly defended the proposed arts centre against the baying, aldermanic philistines of Common Council who didn't want a penny wasted on the arts. (The City's miserable allocation to the Mermaid Theatre was, in those days, a contentious issue every year.)

Inevitably, in the lift going up to the eighth level gallery, I found myself wondering whether I had been right. It wasn't the eventual cost of £150m that bothered me: Durham or St Paul's cathedrals, or, come to that, the Parthenon must also have been expensive in their day. Rather, it was the unutterable tastelessness of the place. To have spent so much money on *this*. The Barbican Centre is part of the sixties fantasy that the arts ought to be *consumed*, an attitude which leads to a building which looks and feels like an endless department store restaurant. The gallery space is peculiarly ghastly: yet again, it was clearly designed by someone who believes that 'Art' somehow benefits if we allow our experience of it to be impinged upon by 'real' life. Thus the gallery is cut into by cavernous spaces allowing extraneous light, noise, and in-

formation to stream in from everywhere. When are gallery designers going to realize that pictures are best seen in stillness and silence? For all that, 'Aftermath' itself was an important exhibition. Germain Viatte was quite right when he wrote in the catalogue, 'Now, however, more than three decades after the 1940s, we can see this period in all its complexity as one of the first expressions of the crisis of "post-modernism".' Indeed, the problems raised by these works, and often enough their appearances, too, seemed almost eerily close to the concerns of the last five years, or so. But first, what is there to be seen?

The opening section covers the works of those who were already established 'masters' of Modernism before the war— Bonnard, Braque, Léger, Matisse, Picasso, Rouault. Whatever their subect matter, these artists were still able to be expressively optimistic through the forms they created: these often involved the resuscitation of disintegrated picture space with pronounced decorative elements. Of course, this was true of Matisse's now legendary paper cut-outs of the early fifties; but it applies equally to Léger's odd homage to Louis David, *Les Loisirs*, a picture whose brilliant, flat, two-dimensional forms depict bicycling workers, and others, having a good time beneath a cluster of doves. But perhaps the finest painting in the whole exhibition, for me, was Pierre Bonnard's *L'atelier aux mimosas*: this picture was begun in 1939, and finished the year after the war ended. It could almost be taken as a living testimony of Marcuse's belief that, art has its own dimension of truth, protest, and promise—a dimension constituted by aesthetic form. The quivering light in this Bonnard bears witness to art's capacity to create 'that other reality within the established one—the cosmos of hope.'

Another section covering 'Aspects of Realism', included Balthus, and the arid Social Realism of Fougeron; there was also plenty of existentially inspired work—the best, undoubtedly, being the painting of Giacometti, who emerged from the selection on show as resembling an angst-ridden William Coldstream. Also shown were Buffet's appallingly sentimental drawing-room equivalents: if ever emotion was unearned, it must be in the stereo-typed lines of his *Solitude-le buveur assis*, of 1948. Fautrier's hieroglyphics of pain provided a link with 'Primitivism and *art brut*', Dubuffet being densely represented—alongside a selection of work by his protegés

among the primitive and the insane. Finally, a section called 'The Frontiers of Identity' showed the way in which Artaud's anguished autoportraits melt into the limitless interior spaces of such neo-abstractionists as Bryen, Matta, Michaux, Mathieu and Wols.

What was to be made of this seemingly eclectic selection? Most of the art of this period was characterized by impotence. The men who made it often possessed an almost inordinate talent, yet they could only deliver a desperate art. Sometimes, they openly refused culture; more often it seems to manifest a longing to be part of its fabric (hence the repeated references to decorative and ornamental motifs). But, in either instance, this art remains isolated, and insistently peripheral.

These artists were compelled to look hither and thither for their means. Either they could hark back to the old academic orders of the past (sometimes proposing them in socialist fancy dress as a 'solution' for the future); or they might clutch at modes of working given by biology and innate process rather than history. (Hence the fascination with the art of children, the mentally sick, and 'primitives'.) Alternatively, they tried, like Giacommetti, to invent an iconography through an encounter with the bodily subject whom they regarded as the incarnation of mind. Or, like Fautrier and Dubuffet, they endeavoured to compel the brute *matière* of the pigments and stuffs they were using to become something beyond itself—to heighten its sensuousness until it tipped over into symbolism. Nonetheless, except for the experienced *maîtres* of an older generation, there seemed no escape from the tortured affirmation of individual subjectivity. *Authority* is conspicuously absent from all these works: Léger cannot even realize it through his flagrant appeal to Louis David.

It is not that these painters lack symptoms of true greatness; although they are effectively visually speechless, this seems to have little to do with their possession or lack of imagination and technical skills (although these, of course, vary widely.) Rather, talented and untalented seem unable to reach beyond themselves because there is no shared symbolic order to which they can appeal, and no commonly accepted *style* capable of furnishing them with a living, enabling, and yet resistant pictorial language. Early modernism had held out the promise of such a language, and, in the event, had failed to deliver.

All this, of course, will be perfectly familiar to anyone

involved in what is going on in contemporary art today. This is
the problem, and, substantially, these are the solutions we see
being pursued all around us—with equal confusion and
marginality. But the question this exhibition immediately
raises is, 'Why did 'post-Modernism' erupt with such desperate
violence in this decade, only to disappear from view again
almost for a quarter of a century?

The clue, I think, was to be found in the last section of the
exhibition, so aptly entitled, 'Frontiers of Identity'. There we
could see the emergence of a very narrow, but definitely new,
form of pictorial expression. Elsewhere, I have frequently
talked about the twin roots of expression in physiognomy, on
the one hand, and in somatic, rhythmical, and decorative
process on the other. Expression is rooted in the expressivity
of the subject depicted, or of the artist, as creative subject. In
the work of certain French painters, e.g. Henry Michaux,
however, we can see the literal disintegration of physiognomic
expression into abstractions, which articulate the whole
picture surface and become, in effect, representations of
internal space.

Now there is no reason to suppose that this extension of
expression could, on its own, have formed a route back to
culture for the individual artist. In many ways it is as
solipsistic as the other phenomena on show; however, it is a
matter of history how this interesting, if narrow, line of work
was transplanted to New York where it benefited from all the
cultural competitiveness with Paris. For across the Atlantic,
this existential, physiognomic abstraction reached its apoth-
eosis, and produced its major masterpieces, in abstract
expressionism—especially in the painting of Mark Rothko.

Again, the story of how it was culturally recuperated to
provide an improbable flag for an expansionist American
society has been told elsewhere. But with that recuperation,
this form of abstraction quickly became cut off from its roots
in affective life. It was trumpeted as a *formal device*, and thus
quickly degenerated into mannerism. Meanwhile, the problem
of style was itself 'solved' by this manoeuvre: with the advent
of an officially sponsored Late Modernism, the search became
not for the new language through which the artist might speak
articulately, but rather for the latest reductive innovation, or
fashion, in the formal means. Hence the historicist continuum
of styles characteristic of Late Modernism, which obscured the

crisis of 'post-Modernism', from which it had originally sprung.

Interestingly, 'Aftermath' was subtitled 'New Images of Man', apparently in homage to Peter Selz's exhibition of that name held at the Museum of Modern Art in New York in 1958. Like 'Aftermath', that exhibition included work by Appel, Dubuffet, Giacommetti, etc. It was intended as a challenge to the hegemony of an increasingly academic 'Tenth Street' abstract expressionism, then well established as the orthodoxy in New York, and rapidly being re-exported, through massive promotional exhibitions, throughout Europe. As a challenge of course 'New Images of Man' failed (despite its endorsement by the theologian Paul Tillich!) As we know, the motor of Late Modernism with its reductionist manipulation of devices and conventions, roared along until, sometime in the 1970s, it hit the wall at the end of the narrowing *cul-de-sac*. But the collapse of Late Modernism has cleared the horizon. We can now see that we are facing, in painting, almost exactly the same problems as those faced by these first 'post-Modernists' in their search for 'New Images of Man'. That is why 'Aftermath' was such an important exhibition. There seems little reason to suppose that whatever the road forward, physiognomic abstraction will provide the *only* solution again. Equally, it is hard to see how, this second time around, we will prove any more able to produce a style which both allows for individual expression and commands a significant degree of collective assent—over and above merely sectional interest. But it may be that the solution lies somewhere in the perceptual encounter with and symbolic transformation of natural and anatomical form.

1982

PATRICK HERON

Long Cadmium with Ceruleum in Violet (Boycott): July-November 1977 is the largest of a series of canvases Heron made for an exhibition at the University of Texas where he was Doty Lecturer in Fine Art for 1978; and it is, in fact, *very* large: 13 by 6½ feet, to be precise. Boycott comes into it, apparently, because just as Heron—radio playing in his studio—was about to begin a nine-hour stint of laying down the red background in oils, the batsman was walking up to the wicket to open the innings against Australia. All very English, and quite right, too. *Long Cadmium is* a rather lovely work. On the bottom left-hand side, there is an irregular circle of lighter red; above it, top-left, a flash of yellow. Towards the upper right-hand corner there is a cluster of large, cut-out-style shapes, often over-lapping each other, in blue, purple, red, green and brown. But all these forms float against a vast ocean of red. As might be expected from Heron, *Long Cadmium* offers a lot of intelligent, tightly-packed, 'painterly' incident if you push your nose up close against its surface, and a great humming sea of vibrating and receding colour as soon as you step away from it. But *Long Cadmium* is not just pleasant to look at. It also, as it were, delivers all that Heron promises in his writing about what he takes to be good painting. (His three E. William Doty lectures, published by the University of Texas as *The Colour of Colour*, give a résumé of his past and present thinking.)

And just *what* Heron takes to be good painting, let it be said, is a contentious matter. For, back in the 1950s, when he was also a practising art critic, Heron was locked into a heated polemic against John Berger. Heron was essentially arguing for 'The Autonomy of Art', which he tended to associate with the pursuit of abstraction, the work of certain St Ives painters, and (at that time) with a defence of the new work coming out of America. Berger then advocated a modified socialist realism; he emphasized 'social relevance' and subject matter, and reacted negatively to most abstract painting—especially that coming

from America. Heron thus told his Texas audience that, in 1955, he considered 'John Berger's Marxist criticism . . . the main threat to major painting in my country'.

And what did Heron himself think major painting should be like? Well, it seems, rather like *Long Cadmium*. For example, in 1953 Heron wrote that 'the secret of good painting . . . lies in its adjustment of an inescapable dualism'—that between the illusion of depth, and the physical reality of the flat picture-surface. 'Good painting', he claimed, 'creates an experience which contains both. It creates a sensation of voluminous spatial reality which is so intimately bound up with the flatnesses of the design at the surface that it may be said to exist only in terms of such pictorial flatness'. *Long Cadmium* is, of course, rooted in this dualism: it also clearly draws its strengths from that response and commitment to colour which led Heron to declare, in 1962: 'It is obvious that colour is now the *only* direction in which painting can travel. Painting has still a continent left to explore, in the direction of colour (and in no other direction)'.

Does the fact that *Long Cadmium* is an enjoyable painting mean that, in those debates, Heron was right and Berger wrong? I do not think so. Today—with the advantage of hindsight—I don't agree with what either of them was saying then. John Ruskin used to draw a distinction between what he called 'aesthesis' (or the response to sensuous pleasure) and 'theoria' (or the response to beauty of one's whole moral being). It must be emphasized that, for Ruskin, 'morals' meant much more than narrowly ethical considerations: the word for him embraced all that we would now identify under such categories as human emotions, 'structures of feeling', and the whole rich terrain of symbolic thought. Now Ruskin has been much derided for this distinction: but unless one is prepared to argue that the response we have to a beautiful red silk scarf, is in every significant respect equatable with our response to, say, the Sistine Chapel, then it must be admitted not just that Ruskin had a point, but that it was a very good one indeed.

Now it seems to me that painting like Patrick Heron's is in pursuit of pure 'aesthesis'. Indeed, that, I take it, is what Heron is trying to say when he writes such things as, 'concepts and also symbols, are the enemy of painting, which has as its unique domain the realm of pure visual sensation. Painting should start in that multi-coloured, and at first amorphous,

texture of coloured light which is what fills your vision, from
eyelid to eyelid, when you open your eyes. The finished
painting should also end in pure sensation of colour—having
passed into the realm of the conceptual in the process, and
come out again at the other side . . .' And so forth.
Ruskin himself took a dim view of pure 'aesthesis' (hence his
quarrel with Whistler). He said something about taking no
notice of the feelings of the beautiful which we share with
spiders and flies. But I cannot see that there is anything
morally, politically, or aesthetically wrong with a quest for an
art which gives pleasure through visual sensation alone.
Indeed, at a time when, culturally, we lack the sort of shared
symbolic order which religion once provided, good decorative
surfaces (which are as rare as they are desirable) are very often
of this kind. Heron is a good decorative painter—as the
successful application of his designs to wall hangings, and
carpets for the Cavendish hotel, bears witness.

But—whatever Heron says—this is *not* the 'only direction'
for painting; indeed, that language of pure form, enjoyable for
its own sake, is peculiarly difficult (and perhaps impossible) to
arrive at on the canvas surface. Because we are not spiders and
flies, all our sensations and experiences tend to be subject to
imaginative and symbolic transformations. The greatest art of
the past and the present has always recognized and made full
use of this fact.

Heron may think that I am thereby seeking to minimize the

Patrick Heron, *Long Cadmium with Ceruleum in Violet (Boycott):
July-November, 1977*, artist's collection

importance of those 'abstract' elements in all painting on which he places such emphasis. Not so. I firmly believe that the greatest painting is always rooted in a mastery of 'aesthesis': in other words, Giotto's blues were unrivalled in his time, but he offers us rather more than an unrivalled sense of blue. Indeed, his blues appear as good as they do, not just because of the physical sensations to which they give rise, but as a result of the affective (or symbolic) resonances which such blue has within the context of his painting.

More than once in the course of his Doty lectures, Heron reminded his Texan listeners that he was friendly with the late Herbert Read. He failed, however, to point out that it was Herbert Read who first suggested that the formal values which Clive Bell and Roger Fry (and it would seem Heron himself) expressly dissociate from symbolism—through such concepts as 'Significant Form'—might themselves be symbolic. And this of course explains why by no means all abstract painting need be as closely linked to 'aesthesis' to the exclusion of 'theoria' as Patrick Heron wants his to be. Rothko said that those who saw only the formal relationships and colour harmonies in his work were missing the point; he referred to a spiritual intention which many can confirm having experienced in front of the works themselves. But plenty of abstract artists have demanded of their viewers responses which were not limited to visual sensation alone, but which involved what Ruskin would have described as 'their whole moral being'. Even Heron (whatever he *says*) clearly rises above decorative sensation through the emotive power of works like *Long Cadmium*. It may be that he himself, however unwittingly, sometimes draws upon such a symbolism of form. And it is for this reason that, just as the social realist critics were wrong to over-emphasize manifest content and subject matter, so, too, Heron was wrong to insist that criticism should be solely formal, technical, and 'as descriptive of the visual facts as we can make it.' After all, Herbert Read's criticism was *never* like that . . .

1981

JENNIFER DURRANT

Jennifer Durrant is an uneven painter. Her contribution to the 1979 Hayward Annual was impressive: she emerged, decisively, as the most interesting of those artists promoted by *Artscribe*. But, when I saw her work at the Nichola Jacobs gallery in 1980, I was disappointed. She seemed to be dissipating her achievements in slurping self-indulgence. (Certainly, her co-exhibitor, Gary Wragg, did not help: his short-lived quest for true expressiveness seems to have been swallowed up in a mire of over-weening ambition.)

But at an exhibition at the Museum of Modern Art in Oxford in 1980, I remembered why Durrant had excited my interest in the first place. Only one work over-lapped with the

Jennifer Durrant, *Cloudland Painting*, 1980, artist's collection

Jacobs show, *Princess Painting* (1979/80), and it could be seen to much better advantage in this new context. Durrant exhibited five other large works in acrylic on cotton duck; one dated back to the autumn of 1977; another to 1978. The rest were made after her move to Oxford as artist-in-residence at Somerville College, in November 1979. (She also showed three small painted collages, none of which seemed of much significance to me.)

The 1977 painting simply illustrated what she is coming from: though competently executed, and eminently 'tasteful', it remained unimaginative—an example of bland, flat 'salon' abstraction. Her newer works were different. They showed immediately how Durrant contrasts in one important respect with the majority of Stockwell artists: she can draw. Admittedly she cannot use drawing satisfactorily as a way of constructing full-blooded forms in space: but she can design shapes and set them shifting and drifting through an illusion of pictorial depth; moreover, she can contain the whole within a strong and convincing unifying composition. She has evidently studied late Matisse to advantage; although she may perhaps have failed to realize that the reason the cut-outs (or some of them) are so effective is that they were nourished by all that previous drawing from the model.

Durrant's best new works are certainly good decoration. I do not mean that to be derogatory. The decorative can be a true quality; it is one which is in short supply. But is Durrant anything more than that? I think, at her best, she is.

One can certainly talk about the *content* of her work, or rather about the way in which content has become form. Her painting is clearly replenished by contact with nature. I am not just referring to the fact that her painting seems to teem with an imagery suggestive of the generative capacities of living organisms. Durrant also has a sense of *place*. (This may be one reason why her move from Stockwell to Oxford has proved so fruitful.) I get the sense that she spends long hours gazing at trees, rocks, animal and bird-life and indeed into the night sky. *After Midnight*, of autumn 1978, seems to allude to that favourite theme of painters and poets, the frailty of man when confronted with the infinity of the cosmos. This residue of natural forms in her work indicates that she has certain affinities with the peculiarly British tradition of Hitchens, Lanyon and Hilton—stronger than any of the younger artists

in the 1980 Hayward Annual. Durrant wants to affirm these underlying constants of lived experience.

This is not a question of my reading 'images in the fire.' A recent work, *Cloudland Painting* of April 1980 (which I have seen only in reproduction) makes use of images of a caged and free-flying birds. Of course, it would be silly to suggest that Durrant is interested in verisimilitude: her work is rather more concerned with 'inner' than with 'outer' experience. The symbolism of the birds surely does not need labouring. But this residue from perception is of critical importance. I believe that Durrant's work could usefully be discussed in terms of that symbolism *of form itself* which I have raised elsewhere; but the important point is that, in her successful paintings, these 'inner' and 'outer' elements are transfigured and transformed, brought into contact with decorative motifs, and welded through her compositional skills into an aesthetic unity, which seems whole and convincing. I was particularly impressed by *Spring Painting*, of March-July 1980, in which a form reminiscent of a sea-creature (a star-fish, sea-urchin, or polyp) is used to organize and hold the whole painting.

But, when all this has been said, I feel I must voice my reservations. The question of drawing remains: Durrant's attempts to construct forms in space remain weak, and this limits her expressive power. At times even her sense of design falters: one becomes aware of a certain looseness, a lack of *necessity*, of the capacity to convey the sense that her work is this way and no other. *Witch Painting*, of February-March 1980, suffered from both these faults, and, uniquely in the Oxford exhibition, reminded me of some of the very poor paintings by her which I have seen. I wonder why she insists upon such enormous *size*: the scale of some of her works would not be necessarily affected by a reduction in size, but they might gain in tautness of handling. And then also I must raise a question mark beside her imagination. Does that sense of *slightness* I still sometimes feel arise from the fact that she has not yet fully challenged all those conventions out of which she is working? But this may be carping. Durrant has shown she has the courage to do that upon which her imagery constantly insists: to change and to grow. One feels that the Oxford paintings are *transitional* works, and that she may be on the threshold of making a significant contribution to that great tradition of decorative-symbolic painting, which stretches, in

Western art, from Gauguin, through Bonnard, to Rothko and Natkin. (At times, she reminds me of the latter's great series of *Fieldmouse* paintings, of the early 1970s, none of which has ever been seen in this country.) There is no other British painter of her age, or younger, about whom I could so confidently risk such a judgement.

1980

ADRIAN BERG

I have known Adrian Berg's work for twelve years. I have often seen it in his studio, one-man shows and mixed exhibitions. But, although Berg's landscapes have always interested me, I have also found it difficult to reach a convincing judgement on what he is doing. When I saw Berg's restrospective at Rochdale, however, I realized I could think of no better landscape painter working in Britain today. One painting, in particular, *Gloucester Gate, Regent's Park, February, March, April, May and June 1977*, seemed to me an outstanding achievement: I would certainly wish to include it in my slender list of significant paintings produced in Britain in the 1970s. Here, I want to consider two related questions. Why did it take me so long to acknowledge the significance of Berg's contribution? And what are the material qualities of his work which allow me to affirm, today, that at his best he is a good painter?

Since the late 1960s, Berg has devoted much of his time to the scrutiny of the landscape visible from his window at Gloucester Gate: this is a Nash terrace overlooking Regent's Park. One reason I tended to distrust my positive responses to Berg's painting was personal. When I was beginning to write professionally about art, in 1968, I lived in a flat beneath his studio. The way Berg tells the story now, I met him on the stairs one day and said, 'I've just started writing for *Arts Review*'. He replied, 'Well, you can write about me'. Early in 1969, he had his third one-man show at Tooth's, his first consisting entirely of pictures of Gloucester Gate. The naive but enthusiastic feature I wrote on him was indeed my first article of more than a couple of hundred words on any artist.

Later, of course, I began to wonder. Was my interest just nostalgic? Did I respond to Berg's painting only because he had provided my initiation into criticism? Or was it because I, too, had lived close to that landscape and fallen beneath its spell? Few parts of London are as evocative as this section of

Regent's Park. There, in the middle of this modern city, you can watch the seasons coming and going and through all those infinitely subtle shifts in the nuance of leaf and sky echo whispers of the ghosts of England's aristocratic past, mingling now with the shouts of sportsmen, sounds of children playing, and the howls of wolves in the paddocks on the edge of the zoo. Here is nature, laid out by men, and transformed by successive waves of civilization. I came to relish everything specific to this landscape: the way in which those twigs curled on that particular day; the quality of light one summer evening; or that row of cold, naked trees in the snow. And yet I felt something in that place made it impossible for me to gaze at it objectively. It is so redolent with associations that the distinction between inner and outer spaces seems thrown into question. I know that I could not go there, now, in October, without remembering Hopkins' great poem:

> Margaret, are you grieving
> Over Goldengrove unleaving?
> Leaves like the things of man, you
> With your fresh thoughts care for, can you?

But it was not the Goldengrove that grieved her. 'It is Margaret you mourn for'. All this prevented a just assessment of Berg, because it made me wonder whether I would not respond to *any* image of this landscape (a post-card, a snap-shot) by recollecting such sentiments.

But other factors prevented me from seeing how good a painter he really is. In 1972, I began a review of Berg's exhibition of that year with a sermon on the death of painting. I wrote: 'From the physical restrictions of the stretchers and canvas, in an age when images can be instantaneously transmitted and destroyed in moments, to the elitist economic role of the finished product with all its intimate links to capital and big money investment, the limitations of the medium indicate to me that it is both obsolete and reactionary'. Only after I had made that speech could I bring myself to explain that Berg was an exemplar in painting's decadent twilight, and to talk about my enjoyment of his work.

How clogged with the visual ideology of contemporary monopoly capitalism we so-called 'left' critics were in those days. (And, judging by Philip Corrigan and Mark Nash's silly

'structuralist' outbursts against my critical approach, in *Art Monthly*, some of us, to our shame, still are.) Today, I would argue the opposite of what I wrote then. In his dogged, painterly exploration of his relationship to landscape, Berg, and not I, was the true radical in his way of seeing and representing the world. Despite my belief that I was adopting a 'left' or oppositional position, I was so deeply enmeshed in the prevalent ideology of perception and representation that I could not respond freely to the material qualities of his work.

But, looking back, what matters is that despite the fashionable 'modernist' blinkers through which I viewed his paintings, I was not so blind that I stopped them from reaching me and moving me. For this first exhibition at Tooth's in 1964, Berg provided some catalogue notes. He wrote, 'I am not

Adrian Berg, *Gloucester Gate, Regents Park, February, March, April, May, and June,* 1977, private collection

supposing this information will make a difference to how much
or little the pictures are enjoyed. As a painter I am sufficiently
conscious of the autonomy of pictures. The only problem one
seems to have when working is to make the painting look
better'. Today, I believe something similar about criticism.
One is really endlessly confronted with the same question,
'Does this painting look good, or not?' Like it (or not) the
answer can only be given in experience. All that follows is a
necessary tissue of rationalizations.

No doubt, there are those who will say that I only think Berg
is good because of the personal associations which I bring to
his work. Of course, there is no way I can *prove* they are wrong;
but what redeems my position from subjectivity is my
emphasis on the artist's *material* and *imaginative* skills. Some
of Berg's paintings I find weak; others superlative. I bring
similar associations to them all: these distinctions must be
rooted in something other than sentiment.

So how do I characterize Berg's skills? Firstly, I want to draw
attention to what Corrigan and Nash would no doubt dismiss
as mere 'craft'. In this respect, Berg is indeed a true painter.
One cannot repeat too often Bomberg's dictum that there is no
good painting without drawing. Berg is a fine draughtsman: his
early figure drawings of black men demonstrate that. But he
can also draw the natural forms of landscape well, and that is
even more difficult. You can tell a lot from the way a landscape
painter draws the branches on his trees, and Berg *never* falls
back on a stereo-type. I see Berg as belonging to a particular
empirical tradition of British painting which can be traced back
through Bomberg, the Slade, Constable and beyond into
eighteenth century landscape. It is not (as we shall see) that
Berg is in any sense a literalist; nonetheless, everything he does
is rooted in the evidence of his eyes, however much he chooses
to transform that evidence.

Secondly, at his best, Berg is a fine colourist. I have
commented elsewhere on how little the younger Stockwell
painters seem to know about colour even though (being unable
to draw) they choose to stake everything upon it. They should
look at Berg, or, better still, at the landscape he views every
day. Again, Berg does not simply transpose the colours that he
sees there. Indeed, sometimes he is so audacious that he fails, as
in a night scene of *Gloucester Lodge*, painted in 1977/9 which
went over the top into a sentimental, red glare. Nonetheless,

like his drawing, Berg's colour is constantly replenished
through his contact with nature: and this shows. He sees such
things as can never be dreamed of behind closed studio
doors: at his best, he invites camparison with Bonnard in this
respect.

But drawing and colour on their own do not make good
painting (though they certainly help). What counts is the
quality of a painter's *imagination*. Berg evidently does not
experience the primary and secondary processes as being in
some sort of necessary opposition. (See my article 'Salvador
Dali and Psychoanalysis' above.) In his work, critical and
analytic attention to the perceptual mechanisms through which
we apprehend the world serves and informs his imagina-
tive response to it. Again, it is interesting to contrast
Berg with many of the painters in the 1980 Hayward Annual,
so many of whom adhere to an infantile or regressive
conception of expression. Cézanne, Constable, and Poussin all
recognized the role which the primary processes played in
imaginative expression: today, however, there is a tendency to
dismiss all attention to cognitive, perceptual and 'scientific'
processes in painting as being (of all things) 'literary'. I am not,
of course, suggesting that Berg bears comparison with
Cézanne; nonetheless, his rare intelligence as a painter is
welcome.

Berg scrutinizes his sense impressions remorselessly: many
of his most successful canvases are concerned with the way in
which he sees the same landscape *through time*. Others
question his point of view, as an observer by creating
perspectives which could not 'really' be seen in a single gaze.
Hitherto, I had considered his experiments in this direction
much less convincing than the time-based works. But in 1978,
he produced a remarkable, large canvas, *Gloucester Gate,
Regents Park*, reproduced on the cover of his Rochdale
catalogue, which shows the familiar trees of the park in a
splayed-out perspective, encompassing the roofs and sky-line
of the city. Like *Gloucester Gate, Regents Park, February,
March, April, May and June* of 1977 (which can be seen as the
consummation and finest example of his time-based studies) it
represents a genuine extension of the conventions of landscape
painting, which challenges the way we see the world, and for
which there is no precedent in tradition.

But I do not wish to imply that Berg is merely concerned

with specialist or technical researches. In that catalogue text of
1964, he wrote, 'In European painting, the ideas of classical
mythology have informed classicism, the ideas of Christianity
religious painting. By the dialectical process described so well
by its philosophers out of these came romanticism, since when
the ideology informing painting, and not just in Europe, has
been scientism'. He turns to a 'scientific' empiricism, not for
its own sake, but in order to discover conventions through
which he can create works of symbolic significance, ordered
into aesthetically satisfying wholes.

Berg is evidently not just concerned with conveying to us his
experience of this particular landscape (even though the
specificities of his observations are vital to what he is doing).
He is concerned with the observer's relationship to physical
reality, in its totality—imaginative, and perceptual. It is no
accident that his father was a prominent psychoanalyst of the
British school, Charles Berg. And Berg combines the dual
emphasis on empiricism and the imaginative-symbolic order
which is so typical of that school. A major, early work, *Hymns
Ancient and Modern* of 1963/4, depicts sense impressions as
existing inside the head of a particular human subject,
enmeshed almost with the anatomy of his cerebral and nervous
systems. Since then, Berg has been repeatedly posing the
question as to whether it is possible to go beyond such
subjectivity, towards a more accurate account of the external
world: and, in the era when classical and religious mythologies
have collapsed, this can be seen as one of *the* central questions
of our time.

I have no doubt that Corrigan and Nash will be thinking,
'Well, all this talk about Berg's material skills, and the nature
of his imaginative vision is beside the point. What really
matters is that Berg and Fuller share similar ideologies. It isn't
just that, like Fuller, Berg comes from the English middle
classes and read English at Cambridge. They both respect
British empirical traditions, and share a relationship to the
British school of psychoanalysis. Fuller sees his own ideology
reflected back in Berg, and that is why he thinks he is good'.
But Corrigan and Nash are the sort of people who believe that
it is the dominant mode of production which causes men
and women to have a neurological system, and leads the leaves
to fall in October. They are beyond redemption. Meanwhile, it
is worth emphasizing that the sorts of insights which Berg has

expressed through painting about his (and our) relationship to the physical world, just could not have been achieved through photography, or indeed any of the new mechanical media, in which Corrigan and Nash (and those who think like them) have such *blind* faith.

1980

KEN KIFF

Ken Kiff is a painter close to my own sensibilities. Above all, however, I appreciate the primacy he gives to *imagination*. The imagination has suffered a terrible occlusion within much Late Modernist art (and also, tragically, within much Marxist aesthetics, even though Marx himself described imagination as 'that great faculty so largely contributing to the elevation of mankind.')

I agree with Kiff when he writes, 'A great deal of abstract and other painting that I see around me seems to me subjective in a helpless way. That helplessness suggests to me that realities inside oneself have not been accepted and I do not agree with trying to do nothing about it.' In contrast, it is hard not to be exulted by Kiff's work. At the level of *subject matter*, he presents us with an inner world, a subjective world, of that there can be no doubt. His images resemble those of dream and fantasy: houses do not necessarily obey the laws of gravity; zoological creatures are conjured from memories of the nursery rather than the visible world; monsters abound; many of the paintings have a brilliant iridescence like that one might expect in Oz, but not in South London, where Kiff lives.

But, like so much fantasy, this changeling world reverberates around a familiar core of givens. The psychoanalyst, Charles Rycroft, recently wrote, 'the range of things symbolized in dreams embraces all aspects of man's life-cycle.' He added that 'the study of dreams reveals that human beings are more preoccupied with their biological destiny than most of them realize.' Similarly, for all their transfigurations, Kiff's paintings are immersed in what he describes as the 'banal' or 'everyday.'

However, I am not identifying subject matter with imagination; when the moon scratches its head in a Kiff painting, or a man rides naked on a giraffe against the background of a luminous blue sky that is 'fancy'. Coleridge held that fancy is 'no other than a mode of memory emancipated from the order of time and space' and 'must receive all its materials ready made

from the law of association.' But imagination recreates in order to say something new, to build a new whole. Kiff's imagination makes itself felt through his ability to constitute a world through his pictures, a world which comprises (with exceptions we will come to in a moment) an aesthetic unity, or autonomous reality within the existing one. As Marcuse puts it in *The Aesthetic Dimension*, 'Inwardness and subjectivity may well become the inner and outer space for the subversion of experience, for the emergence of another universe.' It is just such 'another universe' that Kiff offers through a long series of paintings, begun in 1971, which relate to his experience of psychoanalysis.

Dreams can be either fanciful, or imaginative, or both. But I do not want to give the impression that Kiff is a fancifully imaginative dreamer, *tout court*. He is first and foremost, and this needs emphasizing, a *painter*. The painter creates something of value through an expressive, material process—not through detached reverie. The matter upon which Kiff works is of the greatest importance in these paintings. Part of it is that which is given by the tradition of painting. It is not difficult to see where Kiff has been looking, or what he has been taking. A

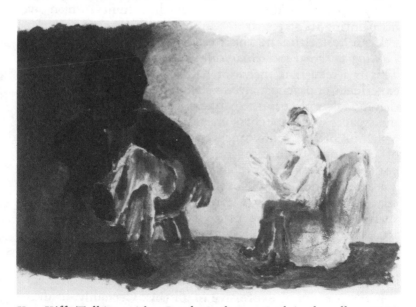

Ken Kiff, *Talking with a Psychoanalyst; a crack in the yellow*, 1972, Nichola Jacobs Gallery, London

face in a bunch of flowers recalls Redon; many fabulous elements and devices hint at Chagall; there is an intensity of hue which recalls Bonnard. Kiff also shows that he has absorbed himself in the ethics of early Modernism. The Cubists *consciously* restructured picture space, and invented a new visual grammar. But Klee learned this as a 'natural' language with which he could write his own 'poetry'. I am not, evidently, claiming that Kiff is of Klee's stature: but his indebtedness to Modernism is of a similar kind. It provides him with an 'enabling' yet 'resistant' pictorial language, in and through which he can work.

But beyond the materiality of that which he inherits from tradition, there is that of the substances and techniques upon which he works. At times, you may detect a deceptive coarseness or apparent casualness in the way Kiff handles paint. But, for all that, he is an artist who is fascinated by the nature of the material process through which the painted image is constituted on the canvas. Kiff's world was not *given* in subjective reverie. Rather, he made it real through a process of imaginative work upon matter (conventional, traditional and physical.) Only in this way could he bring about the expressive transformation, and establish the aesthetic unity, which gives his painting its strength.

I can best elaborate this by talking about a specific work: *Talking with a Psychoanalyst: A Crack in the Yellow, No 3*. This is a recurrent theme of Kiff's. As anyone who has had experience of psychoanalysis will know, the space within which therapy takes place is distinctive. Every day, the analysand fills this space with thoughts, images, and ideas including many which, in other circumstances, would not be allowed any sort of conscious realization in the world. The analyst does not appear to react affectively to all this. And yet, of course, he *is* a 'real person', with whom the analysand is engaged in a real relationship (of sorts) in a real room. More than that, the analysis can only take place if both parties agree to the acceptance of certain rules and conventions: as the analysand soon discovers, the space of therapy is not free. It therefore takes on a peculiarly transitional or intermediate quality which belongs neither to 'inner' nor to 'outer'.

Kiff's painting is expressive of all this. Certainly, he draws upon classical expression to realize his image. Though painted with a lively crudeness, the physiognomies and gestures of the

two figures appear accurate. The analyst is at once a huge and shadowy figure, slumped into a pose of attentive receptivity. We expect him to utter an oracular, toad-like croak. The analysand is engaged in special pleading, his elbow pivoting upon his knee.

But all the devices and elements of the painting are called in the service of expression. For example, much of the visual interest of the picture comes from the way in which the yellow is modulated across the surface, reaching a crescendo of brilliance on the right-hand-side. But this is also expressive of the way in which everything that fills the space seems to be a literal emanation from the analysand. The scale of the two figures, evidently, underlines this: the analyst has been transformed by the analysand's projections. He is of enormous size, and bathed in murky menace. Similarly, the pictures do not extend on three-sides to the framing-edge. The border is allowed to penetrate into the image through a column of whiteness, reaching to the back of the analysand's head. This seems to imply that the whole background could wither away and dissolve, and we would be left only with blankness, and the seated figure of the analysand—who is, of course, a portrait of the artist himself. This then is a picture in which content has become form; and form content. It is not possible to separate the two. More than that, it is not clear in this painting whether Kiff is using the devices of painting to tell us something about the space within which psychoanalysis takes place, or, as it were, invoking the literal image of the psychoanalytic setting to emphasize a significant parallel with the painter's depicted world . . . or both. Certainly, in this masterful little painting, it is as if many of the conventions, devices, and techniques of recent Late Modernist painting (with all its preoccupations about scale, 'crossing the surface', the framing edge, etc.) had been re-invested with the emotional energies and significances from which they first sprang.

Interestingly, the first time I saw Kiff's work, I was reminded of a book by the psychoanalyst, Marion Milner, *On Not Being Able to Paint*. This, I think, is the most intelligent text yet written by an analyst on painting. In it, Milner describes her attempt to get over her inability to paint— despite a virtuoso ability in drawing from the object. She found that in order to paint imaginatively satisfying pictures she had to abandon the conventions of firm outline and focused

perspective, and to seek a way of drawing which involved mixing herself up more in the object she sought to depict. Similarly, she discovered the risk of engulfment implicit in the exciting use of colour, rather than line. Later, another psychoanalyst, D. W. Winnicott was to learn much from Milner's observations on the inter-play between the surfaces of two jugs when he came to formulate his pivotal psychoanalytic concept of a primary 'potential space' between the mother and the child. In the potential space, the child both began to perceive, and also playfully denied the perception, of the otherness and objectivity of the mother, as separate from the self. Winnicott, in my view convincingly, posits the experience of this 'potential space' as the psychological precursor of satisfaction in cultural pursuits.

Work of this kind led to a revaluation of the 'primary processes', or, put another way, to the discovery that iconic and non-discursive thought, and the 'negative capability' characteristic of imaginative activity, were not (as the first Freudians had believed) 'regressive' or 'infantile'. Rather, as Milner put it, the facts of art compelled analysts to realize that the imaginative was, in effect, a complementary mode of mental functioning, present from birth, and throughout life, in all those who lived creatively and relatively happily. The analysts came to acknowledge all this by attending to the facts of art; but, in the Late Modernist era, 'primary process' thinking—the imaginative, and the iconic—has tended to be devalued within art itself. (Hence the vogue for 'conceptualism' and ideological reductions of aesthetics.) Paradoxically, in his personal attempt to assert their value again, Kiff now appeals directly to the facts and conventions of psychoanalysis . . . But, of course, one sees this in the *way* he paints as much as in *what* he paints. As he himself has written, 'the charting of subjective and objective may occur in every brush stroke, and in all the multiple functions of the brush-stroke.'

I cannot, however, finish without a criticism. Kiff is an uneven painter. In his best work we feel that imaginative labour has acted upon materials, leading to the creation of a new reality, an aesthetic unity, on the picture surface. But there are others which fail to convince us, that fall apart. The two largest paintings in this exhibition do not work. One depicts a fantastic vista, filled with drifting images and animals. But it is as if the artist was so uncertain of his other reality, here, that he

had to insert an intermediate phase between it and us in the form of a painted hand clumsily drawing back a curtain. What is *established* through the forms of the smaller works has to be spelled out here through a literal device. Similarly, another painting, *Two Faces*, just loses itself in passages of obsessive handling, and rigid, but unrelated forms. One suspects in both these pictures the presence of intractable elements from Kiff's inner world which just have not been successfully worked into the new unity of the painting. Perhaps, too, single 'master-pieces' create particular difficulties for Kiff because they may seem to contradict the more continuous form of unity which comes from the open-ended series . . . Only if his analysis proves to be terminable, rather than interminable, will he (perhaps) prove able to achieve the completeness, otherness, and finished-character of a successful large work.

<div align="right">1980</div>

RICHARD HAMILTON

We all make mistakes. In 1969, as a very young and rather glib cub critic, I went to see Richard Hamilton among the helium balloons in his Highgate home. When the interview was over, Hamilton offered to take me back to the station in his Porsche. I should have realized when the push-button switch operating the garage doors failed to work that the man who Lawrence Alloway called a 'knowing consumer' was a sham. I didn't, however, and the glowing profile I subsequently wrote of him for *Harper's Bazaar* was certainly among the silliest of the many silly things I wrote at that time. Already, by the time of the Tate retrospective the following year, I had my doubts. But it was Hamilton's Serpentine Gallery show of 1975 that made me realize just what a whore of an artist he was.

The exhibition consisted largely of preciously contrived images of flowers, sea-scapes, and forest 'glades' defiled by representations of turds, toilet tissue and defecating women. To say that it 'did dirt on life' (in Leavis' well-known phrase) would be to give it too much importance. It was just silly and nasty. Indeed, when I saw this work I realized that Hamilton had just been the Bouguereau of the sixties as the ubiquitous Burgin was of the seventies. In fact, that is to insult Bouguereau who was a technically superior artist to either Hamilton or Burgin: furthermore, his masturbatory, phallic vision seems to me at least preferable to Hamilton's crabbed little anal corner-shop imagination.

Perhaps it is not surprising that the Peter Fuller who wrote for glossy magazines saw something in this sick poseur. Today, however, I have come to recognize that the value of art resides in *expression* which is compounded of several different elements. Expression requires an imaginative human subject, an artist, who works upon and transforms the given materials of a specific medium (in the term 'materials' I include both the traditional conventions or language of the medium, and the physical stuff, ie paint, or canvas or whatever) to constitute a

new aesthetic whole. Only in this way can the artist hope to
create another reality within the existing one or to participate
in what Marcuse calls 'the cosmos of hope'. Today, this means
providing an alternative vision of experience and the world to
that spewed out within the mega-visual tradition of advertising,
posters, colour supplements, glamour photography, etc.

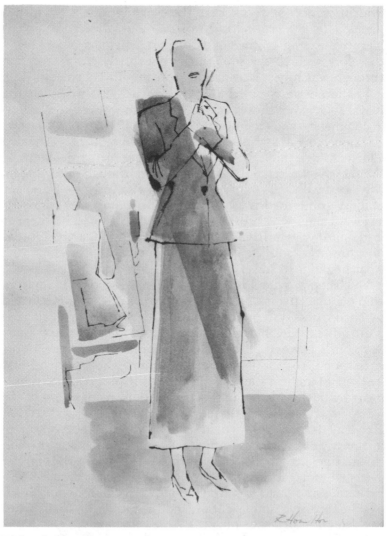

Richard Hamilton, *Fashion Drawing*, 1947, Anthony d'Offay
Gallery, London

Hamilton abandoned or prostituted every constituent element of expression. He therefore ended up treading shit. His 1975 exhibition, with its mountainous turds in sea-scapes, showed that as an artist he was washed-up, or at least flushed out. It was thus perhaps to be expected that his first London showing for some time should contain so many bits and pieces of juvenilia dating from the days before his decadence was too evident. I do not think that these exhibitions are worth a detailed review. Hamilton, however, provides an excellent 'negative exemplar' for any young artist setting out today: I therefore wish to say something about the strange inversion through which he succeeded in reducing his art to crap.

Hamilton was trained as a Fine Artist. He attended the Royal Academy Schools and then went to work (like Warhol) in commercial and technical art. Between 1941 and 1945 he was an engineering draughtsman at EMI. He subsequently attended a life class in fashion drawing run by *Vogue* magazine. Some of the sketches he made then are preserved (though one wonders why) in the d'Offay exhibition, which also includes a number of illustrations for Joyce's *Ulysses*. For the most part, these are awkward and immature, but they do show that if he had kept at it Hamilton might have developed into a serious artist. He did not, however, and the rest of the works at d'Offay's indicate what he did instead.

Duchamp provided almost an obsessive focus for Hamilton, who became effectively a Dada mannerist. He grew fascinated by chance and systematic formulae. Many of the paintings at d'Offay's reflect this preoccupation. In the words of Anne Seymour's hagiographic catalogue introduction, these works correspond to the 'mechanical resources of science' and 'express Hamilton's interest in physically programmed movement by both artist and spectator, and his recognition of the work of art as being the result of a systematic, ritualized activity'. I, however, would argue that this abdication of imaginative activity, and simultaneous abandonment of traditional fine art skills—this 'ruthless following through of systems', and 'programmed involvement'—was a decisive, self-castrating step that Hamilton took towards the relinquishment of his expressive potentialities, and the reduction of his art to the depiction of heaps of shit.

In effect, he was handing over the creative process to structures outside of himself: he was denying himself as a

potentially creative subject. Once he did this, there was no way in which he could hope consciously to constitute that 'other reality' on the canvas. Inevitably, his work became increasingly reflective of the prevailing ideology. Hamilton once insisted, 'I've always been an old style artist, a Fine Artist in the commonly accepted sense'. But he could also say, 'Somehow it didn't seem necessary to hold on to that older tradition of direct contact with the world. Magazines, or any visual intermediary, could as well provide a stimulus'. (See *Studio International*, March 1969.) Thus, while claiming to be a traditional Fine Artist, he repudiated imaginative engagement with experience of the world, and developed a practice which involved the proliferation of visual lies immediately comparable to those of the mega-visual tradition. And so in an exposition of his painting *She*, Hamilton stressed that irony had no place in his work, 'except in so far as irony is part of the ad man's repertoire'.

Those who relinquish the imaginative component in expression inevitably end up reducing art to the status of ideology (or advertising). This was to happen again and again in Late Modernism—for example in the work of Warhol, Stella, Victor Burgin, Mary Kelly, Willatts, etc. All such artists devalue the affective, subjective, emotive aspects of art. Hamilton was no exception. His works have that glazed, obsessive, necrophiliac feel that can only be communicated by someone who is dissociated from his feelings and frightened of his own inner world. Predictably, like latter day conceptualists, Hamilton has also gone on record denigrating the role of feeling in art, and characterizing it as a 100 per cent intellectual or cognitive activity. (See his interview with Victor Willing in *Studio International*, September 1966.)

One can see just by glancing at Hamilton's Pop paintings that he can only look at the world through the spectacles of someone who has been 'dehumanized' by the mega-visual tradition of monopoly capitalism. The 'relationship of woman and appliance is a fundamental theme of our culture', he writes. And it is a relationship which, for example, he simply reproduces uncritically. His theory (such as it is) reflects his practice. Thus he writes, 'It is the *Playboy* of the month pull-out pin-up which provides us with the closest contemporary equivalent of the odalisque in painting. . . . Social comment is left to comic strip and TV. . . . If the artist is not to lose much

of his ancient purpose he may have to plunder the popular arts to recover the imagery which is his rightful inheritance'. (When he writes of 'popular' of course, Hamilton in fact means 'mega-visual': it is characteristic of his shallowness of vision and insight that he should attempt to pass the two as being the same.) Note that Hamilton speaks of plundering the mass media, not of providing an alternative to them.

How did he manage to justify this sort of prostitution of Fine Art to himself? Characteristically, he rationalized his sell-out to monopoly capitalist visual ideology as an attack on bourgeois values. He therefore dismissed the honourable tradition of imaginative bohemian dissent within the fine arts as 'anachronic in the atmosphere of conspicuous consumption generated by art rackets'. 'Pop-Fine-Art', however, he defended as 'a profession of approbation of mass culture, therefore also anti-artistic'. Pop Art, he said, 'upholds a respect for the culture of the masses'—as if a Y-Front advertisement, or whatever, could legitimately be so described! And so he attempted to maintain a veneer of radicalism over the unappealing, bug-eyed spectacles through which he made art. Victor Burgin does much the same today. They both keep implying that uncritical submission of oneself to the anaesthetic, mega-visual ideology of contemporary corporate capitalism represents a brave transcendence of bourgeois imaginative or 'subjective' modes.

The technical aspects of Hamilton's work reflect his disingenuously ambivalent position. He is for ever flirting with photography, the fashion magazine, and the techniques of mass production and reproduction of imagery: but he knows that to embrace them fully would be to relinquish his claim to being a traditional 'Fine Artist'. He thus also pokes and picks at the traditional techniques—drawing and painting—which might have enabled him to constitute that other aesthetic reality within the existing one, if he had fully embraced them.

Perhaps we should not be surprised that this obsessive compromise eventually collapsed: Hamilton, however, proved quite unable to break-through to an alternative, imaginative vision. He simply regressed in a way which is characteristic of his psychological type: he began to manifest what he himself has described as 'a complusion to defile' certain classical genres of the old fine art tradition. Thus he painted turds on flower pictures, sea-scapes, landscapes, nudes, etc.

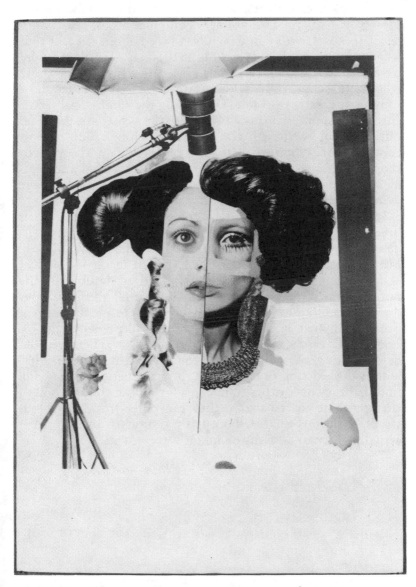

Richard Hamilton, *Fashion Plate*, *(Cosmetic study X)*, 1969

Hamilton, having thereby reduced himself to complete visual bankruptcy, then saw fit to come out in defence of the most decadent art of his younger contemporaries. He wrote a letter to *Art Monthly* in which he whined about the fact that whereas pornographers of what I call the 'mega-visual tradition' were permitted to depict 'gaping glycerine-coated cunts' those who were subsidized by the state were required to show somewhat greater restraint. Dismissing the commercial sector entirely, Hamilton maintained that 'the visual arts have no outlet at all without Arts Council backing'. But he was concerned only about the effects of censorship on 'the work of the younger artists, those who are not likely to get a second-hand Tampax show at the Marlborough, whose used diapers won't be snapped up by Waddington'.

It is not surprising that Hamilton should equate the artist's 'freedom' with the extent of his licence for formless self-debasement. He speaks out in favour of the 'right' of Late Modernist artists to abandon their specific material practices —drawing, painting and sculpture—and to wallow in the pornography of despair at the State's expense. Meanwhile, his own ignominious career exemplifies the way in which the great promise implicit in the early modernist movement—in, for example, Cézanne, Gauguin and Van Gogh—was betrayed and defiled. But those who seek to construct that 'other reality' within the existing one through their aesthetic practice will find that they have other things to worry about than the size of the 'glycerine-coated cunts' they can pilfer from the mega-visual tradition, or Marlborough's refusal to exhibit their actual menstrual detritus or infant's excrement.

1980

WHO CHICAGO?

Karl Wirsum, *Armpits*, 1963, Artist's collection

Armpits was painted in 1963 by Karl Wirsum, one of the original members of Chicago's 'Hairy Who' group. (This was the first of a series of 'flip' and 'funky' art movements which proliferated in the mid-western city during the 1960s and 1970s.) *Armpits* formed part of an exhibition, 'Who Chicago?', organized by Sunderland Arts Centre: the painting depicts a woman with her arms raised in a way which reveals that to which the title of the painting refers. The under-arm hair is represented by real fur, stuck on to the picture surface. What is there to say about a work as tacky as this?

Firstly, that there is nothing about it which suggests that the man who made it possesses anything but the most pedestrian imagination. *Armpits* is as silly and depressing as a felt-tip caricature of a woman's body scrawled on a lavatory wall. It is, of course, perfectly possible to paint good pictures which draw upon primitive aggressive fantasies about women: Rouault and Soutine have shown that. But if you want to see just how shallow and inauthentic *Armpits* is, you only have to contrast it with *Woman I*, which Willem De Kooning made in New York in 1950–52.

In each painting, the subject matter is very much the same. But a gulf divides them. Wirsum just wants us to snigger. But De Kooning evokes deeper, more complex, and significant responses: the skin of his painting is redolent with a magnificent, primal terror. Evidently, there is a moral judgement to be made between these two works: but this is also necessarily *aesthetic*, too. The difference between the pictures is inseparably bound up with the way in which each has been made. In the De Kooning, emotion has been worked through and literally *expressed* in the creation of innovative and convincing pictorial forms. Indeed, it might be said that the formal complexity of this picture redeems the rage of its content, an observation that in no way contradicts De Kooning's assertion that he was not interested in 'abstracting', or taking things out, or 'reducing painting to design, form, line and colour.' Rather, it confirms the approach to painting he professed when he dismissed 'all this silly talk' about the components of the picture, and insisted that the *woman* 'was the thing I wanted to get hold of.' In this particular way, through these specific forms, De Kooning succeeded in 'getting hold' of his experience of the woman, and transforming it into a picture.

By contrast, Wirsum's is a sentimental work, by which I mean that the emotions to which it alludes have not been earned in the working through of the pictorial forms. There is a sentimentality of violence as well as of more saccharine emotions. Wirsum has little grasp upon the material processes of painting: on the evidence of *Armpits*, he cannot draw, has no colour sense whatever, no touch, and compositional skills of a lower order than the comic book designers whose work he pillages for his forms and representational devices. Character- istically, he has to resort to collaging elements of the 'real'

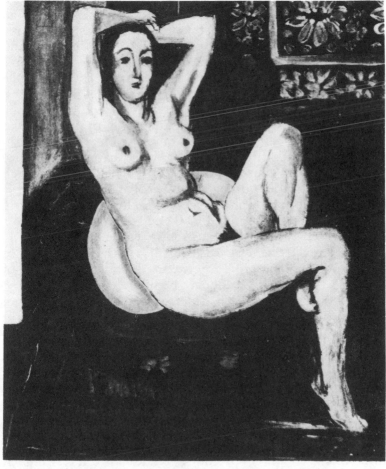

Henri Matisse, *Nu au coussin bleu*, 1924, private collection

world onto his surfaces to achieve effects he is incapable of realizing within the illusion of the picture space. Indeed, the fur tufts show just how far Wirsum is from knowing *anything* about aesthetic transformation: there is, for example, a fine painting by Henri Matisse in which the black patch in the pit of an odalisque's raised arm becomes a formal and emotional pivot which at once fuses the figure with the decorative pattern on the wall-paper, in the background, and simultaneously signifies her specificity, individuality, and separateness. . . . But a cheap sensationalist like Wirsum can reveal nothing of such things to us; he is stuck with his fetishistic clumps.

Now some might think that I have already spent too much time sniffing at *Armpits*: it was, after all, only one in an exhibition of getting on for two hundred works, illustrating three waves of so-called Chicago 'Imagist' art in the 1960s and 1970s. But *Armpits* was emblematic of the show: Wirsum's 'Hairy Who' colleagues included James Falconer, who, in the happily brief period in which he made pictures, managed to produce some of the worst I have ever seen in a public exhibition; Art Green, whose finest quality is his slickness; and Jim Nutt, super-star of the group of whose *Wow* of 1968 it can at least be said that the arm-pit has been shaved. The 'Hairy Who' was later joined by the 'Non-Plussed Some', which included the sterile pornographer, Ed Paschke, whose art is merely a symptom of his perverse pathology. These, in turn, were soon supplemented by the 'False Image' group, the best of whom was the glorified cartoonist, Roger Brown.

Take Paschke: he deals with sex, but without any sense of eroticism. His pictures are executed under the aegis of Thanatos: they are bereft of play, humour, hope, or sensuality. Paschke offers only the cold, depersonalized, closet fantasies of masturbation and perversion. He leaves the viewer feeling as empty and unrequited as if he had leafed through *Knave* or *Penthouse* magazines. Again, touch is even more decisive than subject matter: Paschke's sickly sheens of paint make Allen Jones seem like a truly sensitive painter. Leavis would have taken one glance at Paschke and said that he did 'dirt on life'; and he would have been right.

John Ruskin once wrote that 'the first universal character-istic of all great art is Tenderness,' which, for him, was 'in the make of the creature.' Of course, tenderness can reveal itself through form, which is why paintings as brutal as De

Kooning's, Rouault's, of Soutine's women can still be tender.
But the work of Paschke and his colleagues lacks any quality
even resembling tenderness in form or content. There are just
two exceptions to this: a few, just a few, of the recent Jim
Nutt's, and some of the water-colours by Gladys Nilsson, his
wife. Nilsson is the only painter of any promise—and it is no
more than that—in this show: she at least manifests some
of the rudiments of imaginative and material skill, though as
soon as you put her work beside, say, the best of Edward
Burra you realize what a very long way she still has to go.
Chicago Imagism is without any hint of greatness too: it is
an art of degradation, banality, perversion, and formless
despair.

Why was a show like this imported into Britain? The
organizer, Tony Knipe of Sunderland Arts Centre, seems to
have come round to recognizing that although American art
has been over-exposed in Britain since the last war, until
recently institutional and critical attention has tended to focus
on a very narrow seam of 'Late Modernist' art. The 'official'
account of American art history (especially that version of it
intended for export) left out a great deal, for example the work
of many regionalists, populists and realists. Now I welcome,
and have indeed myself argued for, the shift towards a wider
perspective; but it must also be said that for a few years now,
even 'official', institutional art thinking has itself turned to
promoting the idea of the need to look beyond the main-
stream. This has led to some interesting, re-evaluative
exhibitions and to a more generous conception of which
American exhibitions ought to be seen in Europe. Examples of
this shift in thinking include Milton Brown's exemplary
precursors of American Modernism exhibition at the Hayward
a few years back; the recent Wyeth show at the Royal
Academy; and the Arts Council's Hopper exhibition in 1981.
The idea of a 'mainstream', legitimized by reference to a self-
evolving continuum of styles may at last be passing out of art-
institutional fashion. Indeed, it is already becoming necessary
to insist that not everything which was previously left out of
account is now worth celebrating.

'Chicago Who?' brought home to me that this shift in
thinking had left one problem untouched: the inability or
incapacity of those employed within the institutions of art to
make credible and convincing aesthetic judgements. To use a

James Falconer, Untitled, 1966, Collection Jim Nutt and Gladys Nilsoon

Ed Paschke, *Nueva Yorka*, 1971, private collection

little bit of jargon: whereas once the institutions appealed to the 'diachronic' continuum, as a way of evading such judgements, they are now seeking a 'synchronic' substitute; or, to put it in plain metaphor, whereas the art bureaucrats once let the arrow of *avant-garde* style make all their choices for them, they are now leaving everything to an ever widening net. As a matter of fact, there is quite a bit to be said for a net rather than an arrow approach; I am certainly not objecting to it as such. Nonetheless, neither the net, nor anything else, ought to be allowed to displace aesthetic judgement. If it does, one simply ends up with the same mistakes in new forms: whereas formerly we were subjected to vanguardist offal art (like André's bricks, Mary Kelly's diaper liners, P. Orridge's pornographic pictures, and Cosi Fanni Tutti's sanitary towels) we are now beginning to be subjected to provincial offal art, like 'Chicago Who?'

Thus it was just not good enough for Tony Knipe to plead that his exhibition offered 'a unique opportunity for a British audience to evaluate the present situation.' I want to know, specifically, what Knipe judged to be the qualities of, say, *Armpits*, or Paschke's paintings. Why are such things worth attending to—not as documentation, forensic specimens, art history, or sociology—but as *paintings*? If Knipe replies, 'That is for the critics and the public to decide: it is my job to bring forward whatever happens to be going on,' then, I would suggest, he has got himself into the 'synchronic' equivalent of the position the Arts Council, the British Council, and the ICA took when they committed themselves to the silliest and nastiest *avant-garde* work just because it happened to be what was thrown up by the arrow at that time. If, however, Knipe replies that he chose to exhibit *Armpits*, and Paschke, etc., because he judged them to be good works, them, I am afraid, his competence as an organizer of exhibitions of painting can legitimately be called into question. Snooker.

Of course, this is unfair to Tony Knipe. He was only doing what other art administrators do every day; indeed, Knipe found plenty of willing collaborators all over the British Isles, eager to give wall space and public money for his exhibition. ('Who Chicago?' was shown in London, Sunderland, Edinburgh and Belfast.) It must also be admitted that the exhibition catalogue did contain an introductory essay, some critical studies, and notes on each of the contributors; but these were

so full of misinformation and misjudgements that they amounted to little more than a tissue of promotional deceits. What, for example, should be done with poor Dennis Adrian, 'a recognized authority on contemporary art' (or so the catalogue tells us) who believes that Paschke's paintings are characterized by 'luscious technique', 'singing colour', and 'a brilliant, inventive and compositional ability,' and that the artist himself is engaged in 'a quite serious meta-physical examination of the meaning and significance of many kinds of images?' Indeed, Adrian even goes so far as to compare Nutt's ham-fisted obscenities with 'Persian manuscript paintings',

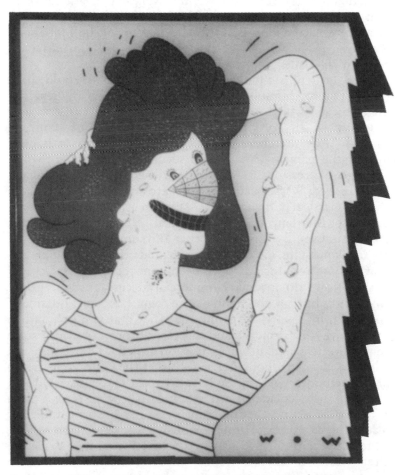

Jim Nutt, *Wow*, 1968, collection Mr. and Mrs. Karl Wirsum

and claims that they are 'concerned with the very basis of creative power and experience.'

But Victor Musgrave's introductory essay was worse still: it contained much which was simply not true. For example, he consistently depicted the 'Chicago Imagists' as 'a tiny band' struggling heroically against 'the chauvinistic, bureaucratic compulsion to project easily identifiable, non-controversial movements'. Musgrave said that the 'Chicago Imagists' have created 'a gutsy, socially-functioning, rule-breaking art of their own.' (What does that mean?) He described the British Arts Council as having been too sleepy, lazy and bureaucratic to have recognized the 'inspirational' and 'revelatory' character of an 'outsider' orientated art which made an 'all-out assault on prevailing cultural norms.' Only the director of the Sunderland Arts Centre, however, had the 'enterprise' and 'initiative' to bring such challenging work over, etc., etc.

Well, a few simple facts which Musgrave could have established for himself if he had bothered to do any research into Chicago art before writing his essay. Firstly, there was not much 'new' or 'original' about the tail-end of 'Chicago Imagism' exhibited here. The 'Hairy Who', and so forth, were merely the parasitic, mannerist successors of that authentic Chicago expressionism which flourished between 1945 and 1963. Indeed, Wirsum and Paschke, etc., have a similar relation to this 'classical' Chicago expressionism as, say, Jules Olitski, or Brice Marden, have to classical New York Abstract Expressionism. By this I mean that Wirsum and Paschke, etc., are really just safe, latter-day stylists (and not very good ones at that) whose reputations have been concocted by dealers and critics. Now I do not hold commercial success, as such, against any artist, but, in the light of the 'tiny band' of 'outsiders' approach, it is worth stressing that the 'Hairy Who', and so forth, have been cynically and successfully promoted ever since they were featured in an exhibition called, 'Don Baum Sez Chicago Needs Famous Artists', held at the Chicago Museum of Contemporary Art in 1969. As early as 1973, Gladys Nilsson received the accolade of a one-woman show at New York's Whitney Museum; the following year, her husband took her place there. Almost simultaneously, an exhibition called, 'Made in Chicago', was featured at the Bienal de Sao Paulo, after which it toured South America before coming to Washington. The truth is that the 'Hairy Who' and their

successors were an immediately identifiable movement: they were also an almost instant commercial and cultural success, receiving infinitely more attention than they deserved. As ever, where there is muck, there is brass. The current price for a small painting by Nutt is $10,000; by Nilsson, $8,000; by Paschke $20,000. All this means that the British Arts Council, far from being unaware of latter-day 'Chicago Imagism', knew very well about this commercial extravaganza. Indeed, just for once, the Arts Council deserves to be roundly congratulated for *not* having imported this unadventurous and dispiriting American rubbish, despite all the indecent hyping it was getting. You can, if you wish, believe *Arts North*'s front page story that 'Who Chicago?' was a 'scoop' for Sunderland: but I would suggest it is the kind of scoop you get by reaching to the bottom of the barrel.

My point that the work in 'Chicago Who?' is just unadventurous commercial mannerism can easily be demonstrated if you contrast *Armpits* of 1963 with two works produced in the city ten years before: Leon Golub's *Thwarted*, and Robert Natkin's *Monster Painting*. These paintings manifest the same sharp frontality of imagery, the same focus upon a single figure within a shallow picture space, and the same pervasive sense of psychological aggression. And yet, whatever the faults of *Thwarted* and *Monster Painting*, a gulf divides them from the inauthentic slovenliness of *Armpits*. And the pity of it is, of course, that a good, original and varied exhibition of art which originated in Chicago could, so easily, have been brought to Britain. Why wasn't it? Well, in the course of his introduction Victor Musgrave claimed that 'certain European-style artists from Chicago, being "safe" have succeeded in getting some attention from critics in London'. Later, it emerges that one such artist that Musgrave has in mind is Golub. Perhaps I should declare an interest: I am the critic who has given Golub the attention over here. (Indeed, Musgrave may well also have had Natkin in mind, since I have written a number of articles about him, and subjected his work to detailed analysis in the last chapter of *Art and Psychoanalysis*. My book about Natkin was published in 1981 by Abrams Books in New York.) When I read this talk about good, erstwhile Chicago painters being 'safe', and so forth, I realized the depth of the bad faith that went into the promotion of 'Chicago Who?'

Golub, after all, must be one of the least 'safe' of the major painters working in the West today. He is barely known in this country, and has not had an exhibition here since his ICA show in 1957. But all that is beside the point: Golub is a painter of strength and complexity. He is one of the few artists grappling with history painting, trying to produce hard and resilient pictures of power and conflict. (Indeed, aesthetically, he is almost the polar opposite of Natkin, who has concentrated upon sensuous abstractions, vibrant evocations of internal space, resonant with intimate nuance and feeling: I can think of no more delicate and subtle colourist than Natkin.) Now it would truly have been a 'scoop' if Sunderland had managed to organize an exhibition which showed the roots and more recent development of Chicago painters of this stature. But this would have required both more thorough research, and more discriminating judgement, than Knipe and his associates seem capable of.

I have written elsewhere about the roots and achievements of serious Chicago painters. (See, for example, the essay on Golub in *Beyond the Crisis in Art*.) Here, I just wish to

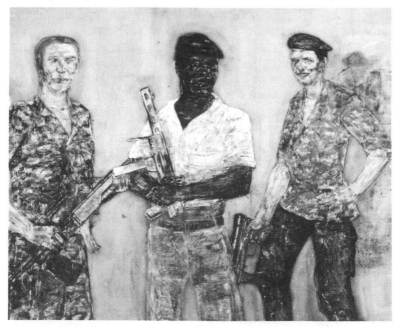

Leon Golub, *Mercenaries (I)*, 1979, Artist's collection

give some intimation of what the exhibition might have
been.

Despite what is said in the 'Chicago Who?' catalogue,
Chicago 'Imagist' painting first began to make its presence felt
in the city, through what became known as 'The Monster
Roster', in 1946. Prominent in this movement were the
painters Leon Golub, George Cohen, and the sculptor, Cosmo
Campoli. A number of more 'classical' surrealists were also
associated with them. During the 1950s, this group became the
dominant force among Chicago artists: they tended to reject
the French influences of Chicago Art Institute's magnificent
Post-Impressionist collection, to value German Expression-
ism, 'primitive' and psychotic art, the decorative and 'ethnic'
art to be seen in Chicago's Field Museum, Surrealism, and—in
Golub's case at least—fragmented classical sculpture. Their
work was an intense, but indelibly Chicagoan, variety of
expressionism: all of these artists struggled to give expression
to their experience of suffering and alienation. Their painting
relates to their moment of history: many of the senior
'Monster Roster' painters had experience of the Second World
War; it can also be seen as a reaction to aspects of their
architecturally depersonalizing and brutalized city. Carl

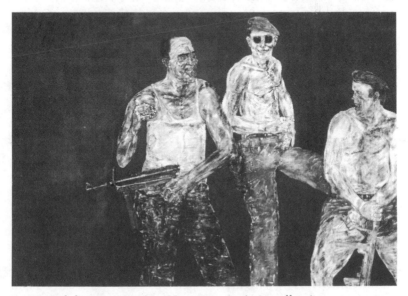

Leon Golub, *Mercenaries (II)*, 1979, Artist's collection

Sandburg once described Chicago as a good place for a poet to get his head knocked. In a recent interview, Leon Golub said that these artists wanted 'to get a raw, natural, primitivist, therefore basic— which relates to psychoanalysis too—notion of how reality is seen, not so much on the surface of things but in terms of instinct, urges, action, violence, myth.' In 1954, however, Golub published a locally influential text, 'A Critique of Abstract Expressionism'. He complained that it was 'non-referential and diffuse', criticized 'the unfettered brush— discursive, improvisatory technique—motion, motion organization, and an activized surface.' Golub was also doubtful about the expressionistic side of Abstract Expressionism, which he described in terms of 'violence, subliminal contents —the explosion of self.' Lawrence Alloway once perceptively remarked that many of these criticisms of Abstract Expressionism contain 'unmistakable' references to Golub's own work, which, at that time, had much in common with the first phase of Abstract Expressionism, especially, perhaps, with De Kooning.

This was manifest not just in Golub's concern with myth, psychoanalysis, symbolization, the unconscious, etc., but also formally, in his shallow picture space, the frontality of his images and his concern for the integrity of the picture surface. But the critical difference between Golub and the New York artists was Golub's absolute *determination* to find a way in which his practice as a painter could relate immediately, consciously and critically (though without compromising itself) to historical experience. I believe that what Golub was attempting in Chicago in the 1950s, was as ambitious and significant as that which was being attempted by any painter anywhere in America: he was trying to wrench the new 'space' and aesthetic of early Abstract Expressionism in a way which might make history painting of stature possible again. Golub had indeed perceived the true character of the crisis of marginalization which confronted (and still confronts) the Fine Artist; he chose to fight a war of almost single-handed resistance.

The first group of 'Monster Roster' artists was later joined by a younger generation: these included Barnes, Halkin, Hunt, Petlin, and Statsinger. Of these, perhaps only Petlin can be said to have consciously attempted to find the solution to that

problem with which Golub had grappled; for the work of this generation already begins to look more conspicuously derivative, privatized, and obsessive in its preoccupations. But by the late 1950s, Abstract Expressionism in New York was visibly degenerating into a shallow formalism. Golub, and a number of the Chicago artists associated with him, were selected for the significant 'New Images of Man' exhibition which Peter Selz organized at the Museum of Modern Art in New York. Golub hoped that, through this show, Chicago painters would be able to emerge at the forefront of a movement to bring art back to concern itself with a wider range of experience than just the experience of art itself, once more. Perhaps not surprisingly, much of the work at the Museum of Modern Art was more eloquent of the *difficulties* which Fine Artists faced when they made this attempt than of anything else. In any event, the art establishment had committed itself to the banalties of the arrow, i.e. to Late Modernism. As Schjeldahl writes, 'the show's cool reception, from all accounts, considerably dampened the spirits of the Chicago art world, perhaps speeding the departure of its members.'

After 1959, the work of the Chicago school quickly degenerated. Most of the leading practitioners of the first two generations left the city. What happened then was that which was inflicted upon us at Sunderland: a sort of cellophane-packaged decadence, in which the great enterprise of the earlier generation was watered down into a poster-style, which owed a lot to East Coast pop and a preoccupation with sexual nastiness: i.e. 'Hairy Who' was the same sort of betrayal of Chicago art, as 'Post-Painterly Abstraction' was of New York Abstract Expressionism. It was a salon art, a dealer's art. . . .

As for Golub himself, he came to New York. Perhaps he never succeeded fully in his attempt to metamorphose Abstract Expressionism into the new realism; but if he failed, his failure is on the scale of a Pollock or a De Kooning. It has to do with the enormity of that which he attempted. In 1968, Golub defined his position: 'I am trying to record certain things about power and stress, about this world of giganticism and automatic controls that we live in, but I'm trying to do it through an existential statement of where man finds himself in terms of these kinds of stress. . . . I'm painting citizens of our society, but I'm painting them through certain kinds of

experience which have affected them. I can describe some of them—Dachau, Vietnam, automatized war, I would even say such a phrase as Imperial America, in a way.'

Throughout the sixties, Golub worked on a series of enormous paintings of raw, struggling men which he calls his 'Gigantomachies'. They are stark, disturbing paintings, quite unlike any others I have seen in either Britain or America. Indeed, I believe them to be among the most compelling, difficult, and implacable pictures to have been painted anywhere in the last twenty years. More recently, Golub has been producing a number of related works which retain the 'up-front' American picture-space, but incorporate many more elements from a traditional expressive practice, based on physiognomy and specific bodily detail and posture. In these hard, uncompromising works Golub comes closer than at any point in his career to realizing his goal of major history paintings which deal with the themes of the human experience of power and control. If Sunderland had really wanted to show us some good, original, and yet disturbing art from outside the American *avant-garde* mainstream, it would have done much better to have brought a Golub exhibition over. But this would have required true courage: and this is not to be expected of those who dismiss work of Golub's stature as being 'safe', while turning to Playboy Enterprises for a subsidy to bring over a group of third rate pornographic plagiarists.

1981

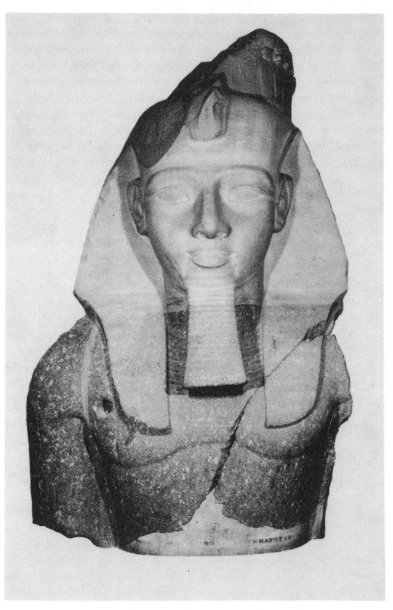

Head of Ramesses II, Egyptian, 19th Dynasty, British Museum, London

III SCULPTORS

STRANGE ARTS OF ANCIENT EGYPT

Ramesses II has gazed out between his cobra diadem and his huge false beard for more than three millennia. His colossal granite head is among the most celebrated of all the works in the British Museum. Today he stares across a succession of stone monuments stretching back to predynastic times in the museum's new exhibition of its Egyptian sculptures. Behind his immense back are ranged works from later and lesser dynasties when Egyptian civilization was increasingly corroded by decadence.

Ramesses is a fitting pivot for the Egyptian rooms. He was a powerful monarch who tried to arrest the decline of Egyptian civilization. Even in classical times he was regarded as an archetypal Egyptian potentate. The sculptures of him exude an unchallengeable, kindly authority. A warrior who repelled the invading Hittites, Ramesses devoted the remainder of his long reign to monumental building feats.

These were spectacular. In Nubia, he erected a rock-hewn temple adorned with four sixty foot seated statues of himself. At the Ramesseum, his mortuary temple, are broken fragments of a 1,000 ton portrait statue. Granite colossi stamped with his idealized likeness were erected throughout his kingdom, and verses lauding his feats in battle were inscribed on his temple walls.

In the new exhibition, Ramesses rules over a chronological display of Pharoahs' heads and fists, crouching baboons, giant scarabs, and animal-headed figures. The previous set-up was laid out almost half a century ago. Today's is a great improvement: the vast sculptures can be viewed from raised platforms; they are beautifully lit; and they have been given the space they need for their monumentality to work upon us. Smaller objects are also convincingly displayed in catacomb-like side galleries which emphasize the association between Egyptian art and the tomb.

One is jolted into thinking about these ancient works again.

No one could deny their strangeness. No umbilical cord of cultural history connects us with these relics of the Pharoahs as we are linked with, say, the classical fragments in nearby rooms. Indeed, there is much about the public art of ancient Egypt which seems not just mysterious, but implacable and antipathetic.

Our modern art museums, with their succession of styles, indicate the premium we have come to place on innovation and development in art. But the Egyptian sculptures in the British Museum, spanning more than 3,000 years, seem inhibited by some hushing sense of stasis.

Today, we tend to assume, too, that art ought in some way to be expressive either of the individuality of its subject, or of the maker of the work. But this is barely true of Egyptian art. Certainly, the Pharoahs are personified: but they are seen as embodiments of divine essences rather than as human subjects. Though their particular features are often portrayed, these appear as no more than incidental appurtenances—which is why a ruler felt so little compunction about expunging his predecessor's name from existing statues and inserting his own.

We tend to suspect the momumental in art. Yet Egyptian art is relentlessly monumental. Much of it is funereal. The sculptures were often hewn from the hardest stones. Their stupendous scale, too, reflects a preoccupation with the defiance of the ravages of time and merely human frailties. Indeed, the Egyptian craftsmen seemed intent upon creating a kind of frozen, stone eternity, another world more 'real' and 'material' than the existing one, fabricated from the strange hypostasis of impenetrable beliefs about gods, kings and everlasting life in granite and schist.

Egyptian work first became widely known in Europe following Napoleon's Egyptian campaign of 1798, and it is not surprising that it tended to be treated more as a freakish curiosity than as great art. A trustee of the British Museum wrote to one of the donors of the statue of Ramesses in 1817 explaining why it could not be exhibited 'among the works of fine art' and denigrating all things Egyptian in contrast with the Greek.

John Ruskin later argued that Egyptian arts were 'altogether opposed to modern habits of thought and action.' He tried to show how the forms of Egyptian sculptures reflected the

subjection of those who made them in contrast to the forms of Christian Gothic, which, in its ornamental variety, 'recognized the individual value of every soul.' Egyptian sculptures, Ruskin said, were 'evidently executed under absolute authorities, physical and mental, such as cannot at present exist.' Thus he contrasted the conventionality, linearity and frontality of Egyptian work with 'the glory of Gothic architecture' in which 'every jot and tittle, every point and niche . . . affords room, fuel and focus for individual fire.'

So Ruskin conjured up a spectacle of an old Egyptian builder, with a couple of thousand men—'mud-bred, onion-eating creatures'—whom he set to work 'like so many ants' on the temple sculptures. The imagination of such slaves, Ruskin claimed, was not involved in their work: the builder was simply making use of their toil to realize his great design. He could teach them only such things as 'to draw long eyes and straight noses' and 'to copy accurately certain well-defined lines.' Then, having mapped out those lines so there could be no possibility of error, the builder would set his 2,000 men to work upon the sculptures 'with a will, and so many onions a day.'

Whether this picture is historically accurate or not, it vividly indicates where Egyptian art diverges from post-romantic conceptions of artistic activity. And yet, we have to account for the uneasy sense of *familiarity* we get from these works. In part, of course, this may be just because we have got used to ancient Egyptian art as part of the furniture of our own culture. Scholars, cartoonists, exhibition organizers and horror-movie makers have all familiarized us with sphinxes, Pharoahs, pyramids and mummies. But I believe this familiarity derives from something deeper than this.

Ruskin was right in seeing Egyptian art as totalitarian—that is, as reflecting 'absolute authorities'—but wrong in assuming such authorities were a thing of the past. This century we have seen striking parallels for the monumental *art officiel* of Ramesses II in Stalin's Russia, Mao's China and Hitler's Germany.

Hitler, too, dreamed of a Reich that would defy time to last 1,000 years. He sought an art which would dispense with 'inner experience' and aspire to timeless values through an impersonal devotion to the spirit of the German people, which was somehow inextricably bound up with his personal power,

and often his personal likeness. Albert Speer, the greatest Nazi builder, taught that monuments should express timelessness and eternity, and should be made of massive, permanent and natural materials.

'Small everyday needs have changed over the millennia,' Speer wrote, 'and they will continue to change. But the great cultural documents of humanity, built of granite and marble, have remained unchanged over the millennia.' They alone, Speer argued, constituted a stable element in the rush of all other phenomena. With which, we may assume, the builders for Ramesses II would have concurred.

And yet Egyptian art may feel familiar to us (in a way it could not for Ruskin) for reasons still closer to home. Although the 'subjected' Egyptian craftsman may be far removed from our conception of the 'free' artist, he could not be said to be without parallel in our own culture. Indeed, Ruskin's picture of 2,000 men carrying out uncreative, mechanical labour according to someone else's designs is not an unfamiliar one. And the architecture, if not the art, of the modern movement reflects a suppression of imaginative and creative work in our own time. A city like Chicago, whose skyscrapers vied in height and scale as monuments to competing corporate powers, seems to have a lot in common with the aesthetic ethics of the Pharoahs.

Indeed, modernist architecture might be said to have taken Egyptian suppression of the 'focus for individual fire' one stage further, with the elimination of all ornamental features, standardization, and the subjection of every detail utterly to the designer-architect's control. Or, as Mies van der Rohe, the mightiest of Chicago architects once put it, 'The individual is losing significance; his destiny is no longer what interests us. The decisive achievements in all fields are impersonal and their authors are for the most part unknown. They are part of the trend of our time towards anonymity.'

And yet it is not only a sense of familiarity I derive from the strange arts of ancient Egypt. I certainly would not agree with Roger Fry when he writes that, of the Egyptian things in the British Museum, the lion of Amenophis is the only one in which he can find some aesthetic significance. I find many of the Egyptian sculptures aesthetically pleasurable in a way in which the architecture of Speer, or Mies van der Rohe (though all too familiar) never can be. Indeed, the more that one looks

at Egyptian sculpture, the more one comes to realize that its suppression of individuality was less absolute than Ruskin supposed.

Henry Moore has written about his admiration for a small, grey granite figure of an official from the late twelfth dynasty, about 1800 BC, now in the British Museum. Cloaked figures were conventional: the type was perhaps intended to save laborious work in blocking out all the limbs every time. But Moore points out how the sculptor used the cloak to show the body form, and by making one side fuller than the other gave it a feeling of movement, 'as if the wearer had just pulled it closer around him.' Moore also explains how he likes the way the hand creeps out like a ghost from the material.

Now convention could never teach a sculptor how to realize such things convincingly in stone. They can only be born of sculptural imagination. And the best Egyptian sculptors, however subjected they may have been, still found the space to make something of that which had been made of them. And, ironically, what they made was almost certainly the reverse of what the Pharoahs intended. In front of the statue of Ramesses II—now bearing the ignominious inscription, 'Presented by H. Salt Esq and J. J. Burckhardt Esq, 1817'—we think only about how wrong Speer and Co were.

The great cultural documents of humanity, even when made of granite, have not remained unchanged over the millennia. Indeed, Ramesses II inspired Shelley's poem: 'Look on my works, ye Mighty, and despair.' But in front of the small granite statue of the official we realize how, Speer notwithstanding, the everyday needs and potentialities of human beings have retained a relative constancy across cultures, and through history. And, in the way the craftsman found the appropriate form for the sweep of the official's cloak we may detect that promise of a future freedom (implicit in all good art) which ought to have been enough to disturb the archaic smile on the face of Ramesses.

1982

LEE GRANDJEAN & GLYNN WILLIAMS

It was fortunate that at the time of the Whitechapel Gallery's important survey of British sculpture in the twentieth century Lee Grandjean and Glynn Williams were exhibiting at the Yorkshire Sculpture Park at Bretton Hall, Wakefield. I believe the formal garden outside Bretton Hall housed two of the most promising sculptures seen in Britain for twenty years.

These are Grandjean's *Woman and Children: Flame*, 1981 and Williams's *Squatting, Holding, Looking*, 1981. They are intensely unfashionable: they are carved, rather than 'constructed', and they have been made out of elm and hard, white Ancaster stone respectively. Moreover they make unequivocal use of one of sculpture's most 'traditional' images: a mother and her children. Though they are certainly flawed pieces, I am confident that they point towards the emergence of sculpture from the stultifying decadence of the last quarter of a century.

Many of those concerned about British sculpture have been watching what has been going on in and around Wimbledon School of Art (where Glynn Williams heads the sculpture department) for some time. In recent years, the 'Wimbledon sculptors' have elaborated through their sculptures a thoroughgoing critique of the reductionist tendencies in recent Modernism. They rejected the historicist assumption that sculpture could only develop by the progressive renunciation of everything specifically sculptural.

These Wimbledon sculptors raised again the issue of *imagination* in sculpture by accepting, as Grandjean has recently put it, 'that the freedom, the hope of sculpture is that it can order a new reality through the transformation of material'. They also demonstrated the continuing expressive potentialities of traditional techniques (especially carving) and materials (like wood and stone). Consistently, they pointed to the necessarily limited 'language' of sculpture, given by a

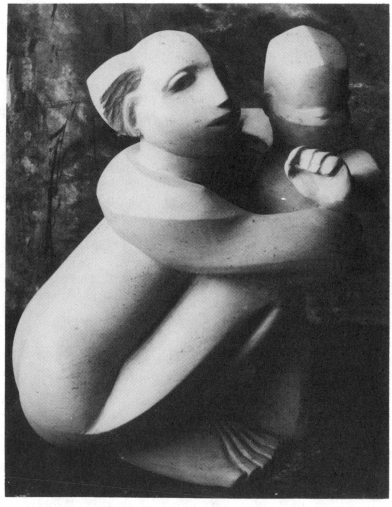

Glynn Williams, *Study for Squatting, Holding, Looking*, 1981,
Anthony Blond Gallery, London

tradition established in the earliest human civilizations, and reminded us that sculpture is a practice whose 'problematic' has not changed fundamentally since the Sumerian times. In a cultural climate seemingly addicted to transience and changes of style, this was salutary. Yet there has often been something ambiguous in the work coming out of Wimbledon. For all their yearning for true expression, the sculptures themselves have sometimes looked like the stirring of roots and limbs in some primordial sludge. But whatever its faults, this new exhibition has clarity: it concerns itself frontally with the question of explicit subject matter, and the necessary relation of all good sculpture to the human body.

Of course, there has been plenty of sound and fury in British sculpture in recent years; but, by and large, it has signified nothing. Elsewhere (see *New Society*, September 24 1981) I have argued that, since the early 1960s, the sculptural tradition has been betrayed by those who ought to have been tending it. Henry Moore was right when he said, in 1962, 'We're getting to a state in which everything is allowed and everybody is about as good as everybody else. When anything and everything is allowed both artists and public are going to get bored'. Moore added, 'Someone will have to take up the challenge of what has been done before. You've got to be ready to break the rules but not to throw them all over unthinkingly'. He explained that great art comes from great human beings who are never satisfied 'with change that's made for change's sake'.

Since Anthony Caro's change of style at the beginning of the 1960s, we have seen enough of unthinking rejection of sculpture's fundamental elements. But Grandjean and Williams are at last facing up to 'the challenge of what has been done before', just as Moore himself did when, in the 1920s, he steeped himself in the 'primitive' sculpture in the British Museum.

Why has it taken so long for anyone else to respond to that challenge? In part, it is because in all that passed for sculpture—from Caro's *Twenty-Four Hours* to the antics of his pupils, Gilbert, George & Co.—Moore's sculptural standards were simply lost sight of. With the passage of a few more years, the tragi-comedy of British 'sculpture' since the early 1960s will be quietly forgotten. A great many St Martin's-inspired 'constructions' in industrial steel are already under wraps awaiting the Last Judgement.

But why did we have to go through this sorry episode? I have tried to give some of the reasons elsewhere. (See especially my article, 'Where Was the Art of the Seventies?' in *Beyond the Crisis in Art,* 1980.) However, there is one factor to which I have hitherto given insufficient attention: the achievement of Henry Moore himself.

Through his best sculptures, Moore has made a major contribution to Western culture. His achievement was the greater in that it was realized in times hardly propitious for good sculpture. Such quality does not always serve as an inspiration to others. As a young sculptor, Moore saw Michelangelo's work for the first time in Italy. 'I saw he had such ability', Moore explained later, 'that beside him any sculptor must feel as a miler would knowing someone had once run a three-minute mile'. But at least Moore could console himself with the thought that Michelangelo had worked four centuries ago.

What happened in the early 1960s was, in one sense at least, the indignant revolt of the Lilliputians. Between 1951 and 1953, Moore employed as an assistant a figurative sculptor of moderate ability: Anthony Caro. Anyone who has studied, say, Caro's *Woman Waking Up* of 1956, now in the Arts Council Collection, will realize something of Caro's predicament in the 1950s. Caro was already in his thirties, but he had not even begun to achieve Moore's expressive mastery over the human figure. The shadow of Moore must have stretched endlessly in front. But instead of stuggling on, Caro decided (in the words of Michael Fried, one of his many American protagonists) to make sculptures which rejected 'almost everything that Moore's stand for'.

What did Moore stand for? He was a sculptor of such range and ability that it is possible to say that he stood for sculpture itself. 'Rodin', Moore has said, 'of course knew what sculpture is: he once said that sculpture is the science of the bump and the hollow'. The twin roots of this art form are carving and modelling: to use Adrian Stoke's terminology, I believe that Moore is a fine carver 'in the modelling mode'.

Few men have had a better grasp on the formal aspect of sculpture than Moore. Certainly, no one living today can touch him for what he calls 'complete cylindrical realization' or 'full spatial richness' which, at the formal level, remains the greatest expressive potentiality of good sculpture. And yet

Moore was far too big an artist ever to be content with displays of skill, or formal ingenuity, for their own sake. Purely abstract sculpture, he explained in 1960, seemed to him an activity that would be better fulfilled in some other art. For Moore, the human figure was always at the root of his sculptural transformation; when he extended beyond it, it was into the rich world of natural forms, such as bones, shells, pebbles.

He saw this 'humanist-organicist' dimension as being a necessary component of good sculpture. He once said that a 'synthetic culture' (i.e. one that cut itself off from such 'natural' roots) was, at best, 'false and impermanent'. That is why he emphasized drawing from life and from nature as necessary activities for sculptors. And in all this he showed himself to be in full continuity with, as Matthew Arnold might have said, the best that has been thought and done in sculpture.

But for Moore all this—the mastery of sculptural techniques, the manipulation of forms in space, the attendance to the wealth of natural forms—was only the means to an end. 'I do not think', he once said, 'any real or deeply moving art can be purely for art's sake'. The bringing of a work to its final

Anthony Caro, *Pompadour*, 1963, Kröller-Muller Musem, Otterlo

conclusion, for Moore, necessarily 'involves one's whole psychological make-up and whatever one can draw upon and make use of from the sum total of one's human and form experience'.

I do not want to project Moore beyond criticism. I believe there was truth in John Berger's once notorious essay of the late 1950s on Moore in which he pointed out that in some of his work there was a tendency for the artist's imagination to disappear, and the material to take over. But I think Moore himself recognized this. Throughout the 1950s (perhaps perceiving what was likely to happen within the sculptural tradition) Moore stressed that in the past he had over-exaggerated the argument from 'truth to materials'. 'Rigid adherence to the doctrine', he said, 'results in the domination of the sculpture by the material. The sculptor ought to be the master of his material. Only, not a cruel master'. Nonetheless, a question mark must still hang over Moore's later works, which can show a slackness in carving, and repetitiveness of imagination, that would have been inconceivable in the pre-war years. At times, too, Moore has tended towards over-production. And he has also been tempted towards a more than occasional over inflation of scale.

Although *some* of Moore's sculptures descend towards the condition of objects, his work as a whole offers a vision of enduring aspects of human experience. But, precisely because he is no woolly idealist, Moore fully realized that he had to hold fast to those elements of experience which, relatively speaking, remain constant. Hence his emphasis upon the human figure in its natural landscape. 'For me', Moore said in 1962, 'sculpture is based on and remains close to the human figure . . . If it were only a matter of making a pleasurable relationship between forms, sculpture would lose, for me, its fundamental importance. It would become too easy'.

I have written often enough about Caro's 'false' revolution in sculpture, about his rejection of carving, modelling, mass, volume, imagination, natural form, 'tactile values' and, indeed, 'image' of any kind, in short, of everything that characterizes sculpture as an art form and makes it worthwhile. But as Moore himself said in 1961 (just a year after his former assistant's dramatic change of style), 'a second-rater can't turn himself into a first rater by changing his medium or his style. He'd still have the same sensitivity, the same vision of form,

the same human quality, and those are things that make him good or bad, first-rate or second-rate'.

All that came after, was taking what Moore himself called the 'easy' option: the arrangement of 'pleasant shapes and colours in a pleasing combination'. And yet, and yet . . . As I have argued before, Caro must be acclaimed as the King among the Pygmies. His work is transparently superior to that of his legion of followers. Why is this? Fried said that Caro's sculptures rejected *almost* everything that Moore's stand for. That diminutive residue of Moore in Caro's work is, I believe, responsible for such sculptural qualities as it has. In the 'Abstract' section of the first part of the Whitechapel's British sculpture show, there was a tiny sculpture by Moore (who was, unfortunately, not particularly well represented in the exhibition) from the Tate Gallery. This work hovers on the threshold of full abstraction: it consists of a number of disparate yet related elements which nonetheless evoke the sense of a single reclining figure. It is a slight though not unattractive piece in which the image does seem to be tantalizingly close to disappearing into the material altogether. Look carefully at this little work and then consider again, say, Caro's much vaunted *Pompadour* of 1963. Of course, the materials, techniques and style have changed completely. *Pompadour* has none of Moore's sense of tactile quality, or of full 'cylindrical' realization. It appears to flaunt the 'synthetic culture' of 1960s. And yet the comparison renders Caro's secret self-evident: there is something about *Pompadour* which we cannot dismiss as being 'false and impermanent'; and that something had already been realized by Moore. It is the capacity to take the human body, abstract it, and split it up into bits, in sculpture, without losing it altogether, so that the finished work has a sense of aesthetic unity deriving from this relationship to the whole body.

Caro has described how Clement Greenberg helped him find his new stylistic clothes. (Greenberg, incidentally, showed a regrettable lapse of taste in his blindness to Moore's greatness.) But such *content* as Caro's new work had derived from something which he isolated in Moore's work, flattened out, and wrote large.

Unfortunately Caro neglected to advise his students to study Moore. Many thus failed to notice the origins of Caro's residual sculptural qualities, and assumed they had something

to do with the drastic, reductive 'innovations' of style which he had initiated. Many younger sculptors reproduced the trappings of Caro's style. They thus produced sculptures which were nothing more than exercises in style, inferior, by far, to Caro's. Others assumed that they could 'progress' in sculpture by treating Caro as he himself had treated Moore: i.e. by throwing out the little that was truly sculptural that he had retained in his work. Hence all the foolishness and anti-art activities so prevalent among Caro's students at St Martin's (and else-where) in the late 1960s and 1970s.

The result of all this was a period of unparalleled decadence in British sculpture. If Caro had had the humility to recognize Moore's greatness, he could have done much more to ensure the continuity of the sculptural tradition. Instead, we reached an absurd situation in which, though Moore's reputation was forever growing, it actually became necessary to *defend* him in art schools. But the poor quality of all that has been produced by those who rejected what Moore stood for speaks for itself. And this, I believe, is the significance of what has been going on in and around Wimbledon School of Art.

I am not suggesting that Lee Grandjean and Glynn Williams are necessarily of the calibre of Moore. That is not the point. But Grandjean and Williams have seen that there can be no

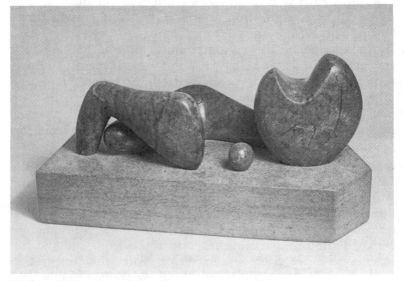

Henry Moore, *Four-piece Composition (Reclining Figure)*, 1934, Tate Gallery, London

evasion of what Moore stood for if good sculpture is to survive. In his catalogue statement, Grandjean said that an important part in what gives a work of art enduring value concerns the nature of its relationship to elements of experience which do not change, or rather which change at such a slow rate that they may effectively be regarded as constants. Of all the arts, sculpture relies most heavily upon such elements. Its roots are to be found in the physical and tactile qualities of materials, the effects of gravity, the world of natural form, and the enduring skills and representations of the human body itself.

It cannot, of course, just be a question of a return to traditional techniques, materials and imagery. The quality of *sculptural imagination* is also involved: Grandjean rightly affirmed the full tradition of sculpture; he spoke of the continuing need for 'the most rigorous formal criticism'. But he also affirmed, 'the challenge of something to say, to tell. Of sculpture facing the world instead of itself'. In short, he affirmed what Moore stood for . . .

Grandjean showed three recent works: two are reclining figures, and the third, and most achieved, *Woman and Children: Flame* 1981, is an upright based upon the forms of a mother with two children. (Moore's recurrent themes, one recalls, were the reclining figure and mother-and-child.) But Grandjean demonstrates that recuperation of the fully sculptural does not necessarily mean retrogression. Though a mother-child study, *Flame*, evokes a mood closer to the *Laocoon* than to Moore's serene Northampton *Madonna*. But at the formal level, too, Grandjean is original: the way in which he has made his works is fully his own; indeed, it implies a critical *dialogue* with Moore. At first glance his reclining figures appear to be 'constructed' in wood. In fact they have been carved from a single trunk of elm. Grandjean seems to be retaining something of the 'look' of construction because he wants to make use of 'part-to-part' relationships in articulating his figures while enjoying all the advantages of full carving. In short, he wants to create living spaces *within* the figures without resorting to the device of punching a hole from one side to the other. For all that, these remain tentative beginnings: I believe that the contradiction between the 'construction' he has come from and the full carving he is practising will have to be more fully resolved in the future. Grandjean also needs to eschew a certain 'symbolical' vagueness in his forms; before one can work through and

beyond the particularities of figure sculpture, one needs to have mastered them entirely. This is only possible through continuous study of the body and of natural form.

Williams, too, shares Grandjean's interest in part-to-part relationships within the figure. (Again, this seems to be the positive legacy of his erstwhile, and otherwise wasteful, involvement in the sculptural betrayal of the last twenty years.) Yet, formally, Williams's solution is more convincing. He at least had the advantage of a 'traditional' training in sculpture.

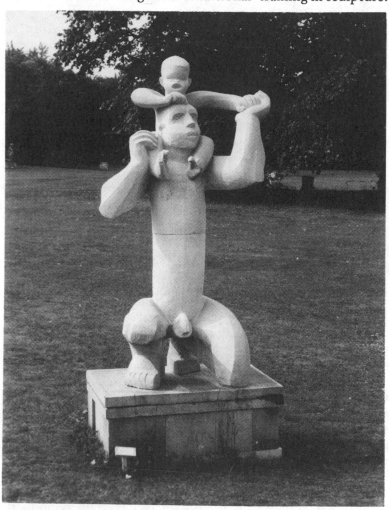

Glynn Williams, *Lifting, Carrying, Protecting,* 1981, private collection

(As early as the 1940s, Moore spoke of the value of 'an academic grounding' as the basis for later achievement in sculpture.) Williams is also a virtuoso carver who can make the working of stone seem seductively easy. But he has drawn upon Gothic and African traditions (without in any way imitating them) so that he can 'structure' his figures in a way which has not previously been seen in British figurative work. It is interesting to contrast his sculpture, *Lifting, Carrying, Protecting* of 1981, of a man shouldering his son with Moore's massive *Mother and Child* of 1925, shown in his first one-man show, but now in Manchester City Art Gallery. In Williams's work, each part is allowed an independent life, but because all the parts are closely related, the whole has sculptural unity. Williams's weakness is currently the inverse of Grandjean's. His mastery of the rudiments of the figure is such that he can convincingly handle it sculpturally, rather than anatomically. Yet, at the moment, his images are little more than vividly expressive of human activities. They do not fully engage our emotions.

Interestingly, Williams regrets the passing of 'given Subject Matter' which was so well-known and well-worked that 'to make fresh sculpture the only thing left to use was the activity inside the image'. And this, indeed, is a central problem for sculptors working outside the framework of a religious iconography, which connects them immediately with shared, affective and symbolic beliefs. Such subject matter as the mother and child, however, endures. The problem is to evade ambiguous 'Surrealism' (or the indulgence of private fantasy) on the one hand; and a pedestrian academic commitment to given appearances on the other. Moore, however, demonstrated that there was a third route: good sculpture could offer us a transformed vision of ourselves in our world, and in nature. Grandjean and Williams have not yet fully succeeded; but the great promise implicit in their exhibition was that (even if on a more modest scale) this may be done again, done differently, and yet done well.

1981

IV ACADEMIES

THE ARTS COUNCIL COLLECTION

In 1942, CEMA, the war-time Council for the Encouragement of Music and the Arts, bought works for a touring exhibition of modern British painting. When the Arts Council was set up in 1946, these acquisitions formed the nucleus of its collection, which now comprises some 5,000 items. (A catalogue is available.) Initially, purchasing was carried out with chronological exhibitions (e.g. 'New Painting 58–61' in mind.) During the 1970s, however, the Council invited individuals to purchase around a theme, (e.g. Boshier's 'Lives', Fuchs's 'Languages', Causey's 'Nature as Material').

The Council's policy of appointing different purchasers each year is, I am convinced, a good one. It is a way in which the individual judgement necessary to aesthetic discrimination could be preserved without permitting an undemocratic accretion of power within the purchasing institution. Nonetheless, I think that recent acquisitions have suffered through the choice of purchasers, and the brief which they have been given. The qualities of a work are constituted neither by its position in art history, nor by its style, nor yet its subject matter. The thematic selections of recent years indicate that the Council has failed to appoint purchasers with a true critical intelligence in painting and sculpture. This fatal refusal of the 'aesthetic dimension' is accentuated by the decision in the early 1970s to start adding photographs to the collection, and cataloguing them as if they could be *equated* with paintings and sculpture, on the grounds that they are also 'images'.

If some works which ought never to have been purchased found their way into the collection on 'stylistic' or 'thematic' grounds, others, which ought to be represented, have been excluded for similar reasons. A policy which permits the acquisition of inconsequential, anaesthetic items by Nigel Hall, Stephen Willats and Victor Burgin, and which yet excludes *anything* by painters of the stature of John Ward, Peter Greenham, and Bernard Dunstan, cannot be regarded as

perfect. Nonetheless, despite the self-evident lacunae, I think that the Council's collection gives an insight into post-war British art as good as any, and I want to use the recent exhibition of a selection of some 400 items from it, at the Hayward Gallery, as an opportunity for some self-critical stock-taking. It is now more than three years since I published 'The Crisis in British Art' (see *Art Monthly*, nos 8 & 9). That article began by asking the question, 'What has gone wrong with the visual arts in Britain in the 1970s?' I was worried (with good reason) about the absence of significant art in the decade within which I was growing up as a critic. I tried to analyse the decadence of the 1970s in the light of what had happened since the second world war. And so I was concerned with exactly the terrain covered by the Arts Council collection.

In 1977, I argued that, for historical reasons, the British Fine Art tradition emerged belatedly and remained weak. In the twentieth century, it was threatened by the growth of what I call a 'mega-visual tradition'; i.e. all the means and processes for producing and reproducing images, from modern advertising to television, which proliferate under monopoly capitalism. Thus the artist lost his cultural centrality and social function, and the great traditional media—painting, sculpture and drawing—fell into decline. I felt that British art was further vitiated by American hegemony in the 1960s, and thinned out by the recession of the 1970s.

In general, this analysis still seems sound. The collection reveals just how few works of stature or quality were originated in the 1970s. Nonetheless, I can now see that my criticisms were, to some extent, contaminated by the disease they sought to expose. Today, I hardly need reminding that the qualities of a good painting are not constituted wholly within ideology. But, three years ago, I failed to grasp fully the implications of the fact that painting, sculpture and drawing differ from mechanical media in that they are (before anything else) material processes involving, although differentially, imaginative and physical human work and *biological processes*. This weakness in my theory of course corresponded to a weakness in the prevailing art practice: at that time, one encountered little good, new painting or sculpture that transcended ideology.

Even then, of course, I retained and expressed a notion of *what painting and sculpture might be*. But a residue of 'leftist' modernist idealism caused me to underestimate the

concrete, aesthetic achievements of an indigenous, oppositional tradition of painting which had consistently set its face against the prevailing decadence. This is one reason why I missed the point of Ron Kitaj's purchase exhibition for the Arts Council collection in 1976, 'The Human Clay'. I accused Kitaj of trying to 're-invoke the visual conventions of an earlier historical moment': I failed to recognize that in *all* historical moments, men and women are made of 'Human Clay'. Kitaj was attempting to root aesthetics in that 'relative constant' of human experience, the body, with its not unlimited potentialities, as a means of escaping from the ideological vicissitudes of late modernism. Today, I still do not accept Kitaj's anti-abstractionist bias. (As I have shown elsewhere, the expressiveness of abstract art can be rooted in somatic experience too.) Although 'The Human Clay' *was* certainly uneven, I recognize that my earlier polemic against his position was over-historicist, and I retract it.

Indeed, in the year's since 1977, I have come to put a higher and higher estimate on the work of a number of artists whom Kitaj has also championed. (What a pity, incidentally, that the only painting by Kitaj himself in the Arts Council collection is such a feeble work. He is a very uneven painter: *Screenplay* is of little merit. Whoever selected it must lack a good eye.) Auerbach's Hayward exhibition, in 1978; Kossoff's show at Fischer Fine Art in 1979; Creffield's 1980 shows; and the exhibition of late Bombergs at the Whitechapel impressed upon me just how solid the achievements of these artists are. My 1977 article failed to discuss them at all: this was an omission for which I can plead nothing better than in-excusable ignorance.

But the exceptional qualities of the late Bomberg paintings were brought home to me vividly at the Hayward again. I have tried to analyse the peculiar power of these works elsewhere. (See *Beyond the Crisis in Art*). Here, I can proffer only value judgements. Bomberg's *Self Portrait (David)* of 1937 struck me as easily the best painting in the unimpressive 'Thirties' exhibition at the Hayward in 1979. How good it was to see it again! His tautly sensuous painting, *Trendrine, Cornwall*, of 1947, was not only in my view the finest single work on show from the Arts Council's collection: it also demonstrated just how much better a painter Bomberg was than either Pollock or De Kooning in the mid-1940s. In the late

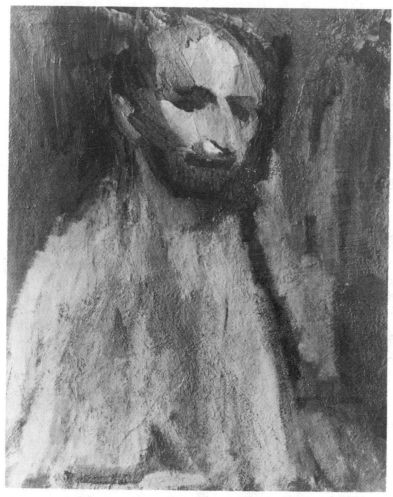

David Bomberg, *Self-Portrait*, 1937, Arts Council Collection, London

Bomberg, we encounter a truly major artist of a still-unsung indigenous tradition: but the scale of his achievement has hitherto been obscured through a perverse infatuation of the British art world with American late modernist modes. Indeed, the Arts Council collection confirms that the impact of 'The New American Painting', first shown at the Tate in 1959, was like a dose of anaesthesia rather than an innovation. (Berger, incidentally, was the only critic of the day who had a good enough eye to perceive this.) By this time, Abstract Expressionism in America had already gone through its metamorphosis from living struggle into dead ideology. And so it came about that a stars-and-stripes spangled screen was drawn over the authentic example offered by the late Bomberg, his finest pupils, and other lesser but equally dogged British practitioners.

You could see this clearly at the Hayward. All you had to do was to compare two consecutive sections of the collection. One contained works made by British artists immediately *before* the invasion; the other displayed works by younger painters and sculptors influenced by it. Now I should be clear about what I am saying here. Evidently, not everything in the earlier section was of even quality. Kossoff's *Building Site, Victoria Street* of 1961 seemed to me a muddy and confused painting in terms of touch, colour, space and composition. What a contrast with the adjacent *Seated Nude* which he painted just two years later! Similarly, I was not convinced by Auerbach's *Primrose Hill* of 1959—though his drawing *Head of Brigid*, of 1973/4 (hung in the drawing section) was truly consummate, the work of someone who had really mastered that difficult medium.

But the point about the works in this section was that in them one could feel the struggle, often pursued through *radical* aesthetic means (no one had ever previously applied paint like Auerbach and Kossoff), towards a genuine expression: sometimes this coalesced into a convincing picture. (For example, within its own terms, I found it hard to fault Sheila Fell's landscape with figure, *Woman in the Snow*, of 1955). Sometimes the artist failed. But in almost all of this work, I felt the urgency of an authentic imaginative quest and perceived the concrete evidence of it in the material handling of paint substance and pictorial conventions. Even the failures were often interesting. Thus, although Kossoff's *Building Site* did

not work, with the advantages of hindsight I could perceive in it rudiments of his masterpieces of the 1970s, his paintings and drawings of a children's swimming bath and of the outside of Kilburn underground station.

How different the 'feel' of this section was from that just up the ramp. Appropriately, Denny called one of his paintings of 1963 *Bland*. I grant he can match his colours as well as a competent interior designer, but he lacks touch and imagination. Rothko had many imitators: none possessed his acuteness of eye, mastery of painterly means, or, above all, his affective sensitivity and psychological courage. Denny is a plastic Rothko. But, weak and ineffectual as Denny's work is, it is perhaps unfair to single him out. There was not one good, or even interesting, painting in this section by Cohen, Hoyland, Stephenson or anyone else. It served merely to illustrate the shabbiness and opportunism of 'Situation' artists. They were stylists, borrowing the 'look' of American art. But a duck-arse hairstyle did not turn Cliff Richard into Elvis Presley: these painters were never Pollocks, Rothkos, or De Koonings either. Twenty years on, the tattiness and inauthenticity of their plagiarism is clear for all to see.

One artist interestingly spans both sections: the sculptor, Anthony Caro. He was almost destroyed by trans-Atlantic influence as the contrast between his 'before' and 'after' sculptures demonstrates. Caro's *Woman Waking Up* of 1956 is an arresting if not quite achieved little work. It shows a woman lying on her back. Her slightly arching upper torso is roughly parallel to a flat, supporting plane; her right hip, however, swivels over towards her left side. The body is structured expressively, rather than on the basis of anatomy or perception alone. The sculpture depicts that moment of dawning consciousness and muscular awareness in which one emerges from sleep. The mouth is a slouching slit. The head is small, stuffed into the shoulders: the arms seem to spring directly from the great, flattened breasts.

Sculpturally, there is quite a lot wrong with the figure. Its two halves pivot around the narrow waist but are not brought into a unity through a continuous movement. There is slack work in the handling of the right leg, feet and left arm. The expressive distortions—like the lop-sided swelling of the right side of the chest—are not always convincing. Nor does the figure work equally well all the way round: it is much better

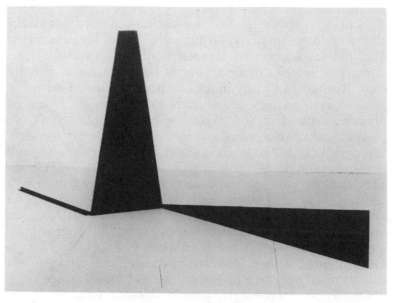

Anthony Caro, *Slow Movement*, 1965, Arts Council Collection, London

seen from over the back of the hips from where its formal weaknesses are less visible. There is also a rhetorical, even theatrical element in the piece which seems to be an attempt at compensating for its sculptural deficiences. But when all this has been said, *Woman Waking Up* is clearly an authentic and sculpturally imaginative work, created by a sculptor of evident potential.

However, Caro's *Slow Movement*, up the ramp, illustrates how that potential was squandered. *Slow Movement* is a placement, or arrangement, of three flat, painted steel elements. (a trapezoid, a triangle, and an angle iron.) The emergent sculptural imagination of the earlier piece has been stifled: the search for authentic expression using the haptic and volumetric skills peculiar to sculpture has just been abandoned. Certainly, a

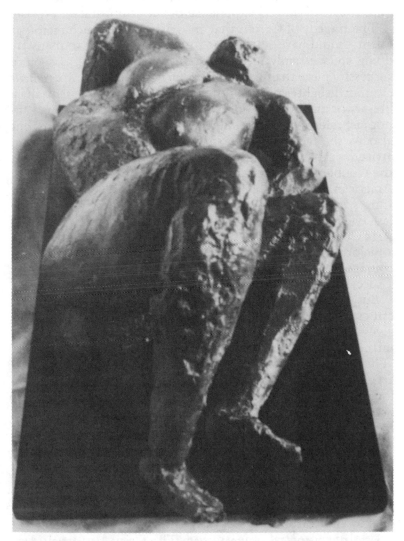

Anthony Caro, *Woman Waking Up*, 1956, Arts Council Collection, London

residue of Caro's earlier project survives. (Compare the way the triangle meets the trapezoid with the figure's pivotal waist.) This is why Caro is so much better than those who followed him: they had *no* real experience of the sculptural enterprise. The tragedy of Caro is that an artist with so much incipient talent should have settled for so little and misled so many by doing so. Certainly, *Slow Movement* can be read as a more successful piece than *Woman Waking Up*; but *Slow Movement* is a much slighter piece. In the end, of course, it is essentially a literary or mannerist exercise rather than a true sculpture. I am not just referring to its relinquishment of sculptural means, but also to the fact that it is so evidently based on ideological attitudes rather than a genuine expressive struggle—but this is the trouble with so much British art that became seduced by American modes in the late 1950s and early 1960s. Enough of Caro's earlier project shows through in his best work of the last twenty years (see, for example, the 1975 piece also in the Arts Council collection) to indicate that he could still become a major sculptor if he summoned up the aesthetic and moral courage to break with the ideology which helped to render him a successful late modernist salon artist twenty years ago.

But it is unlikely that Caro will oblige. Like many artists and critics of his generation, he does not seem to understand what gives rise to quality in art. In 1964, David Thompson introduced an exhibition of 'New Generation' artists saying, 'They are starting their careers in a boom-period for modern art. British art in particular has suddenly woken up out of a long provincial doze, is seriously entering the international lists and winning prestige for itself'. Even today that debasement of British art which occurred in the late 1950s and 1960s is still defended by those lacking in aesthetic sensibilities in these terms. But Caro, I would suggest, was more deeply asleep in *Slow Movement* than *Woman Waking Up*: meanwhile, in the midst of their so-called 'provincial doze', late Bomberg, Kossoff, Auerbach, Creffield, etc. were producing works of true quality and stature.

I do not want to suggest that 'The Crisis of British Art' simply originated in the imitation of American styles and theories. It also had much to do with the tendency of art to become seduced by the ideology of the mega-visual tradition, and thereby to relinquish the particular expressive capacities of the painter and sculptor. In many of my recent articles and

lectures, I have tried to sketch out what I believe those particular expressive capacities to be. Evidently, I cannot rehearse all those arguments again here. Suffice to say that I emphasize that painting and sculpture are specific *material practices*. Good painting, for example, involves a peculiar combination of imaginative and physical work (on both materials and conventions, given by tradition.) When a painter is successful, this leads to the constitution of a new aesthetic whole. I have argued that, in the present social context, the true qualities (and indeed the radical potential) of a painting are literally expressed through these material practices. The point I am making can be vividly demonstrated if one considers the Arts Council's selection of 'Pop Art'.

A work like Hockney's *We Two Boys Together Clinging*, of 1961, has real qualities. One can perceive the imaginative and physical work of the artist, his *expressiveness*, and identify this with the transformation of his physical and conventional materials. But contrast this with Patrick Caulfield's *Artist's Studio* of 1964. It is not just that Caulfield copied so much from Lichtenstein. Nor is it just that Caulfield's world view is boring and bland: the way in which he realizes it in paint, through a mechanical filling in between the lines with luminous, matt colours, shows that he has no resistance to offer to the ideology of the mega-visual tradition. Like Robyn Denny, he has neither touch nor imagination. It is absurd that we should be asked to look with reverence in the Hayward Gallery at a painting as bad as *Artist's Studio*. It is the sort of work one would not be surprised to see in a beach night-club in Benidorm, on the Costa Brava—and even there it would not merit a second glance.

But the collection confirms that the problem with the 1970s was not so much that they rejected the values of the previous decade, but rather developed in a disastrous continuity with them. Caro was the albeit reluctant father of those who abandoned sculptural means altogether; Hamilton sired Burgin, and the silliness of conceptualism. Just as Caro's early work gives us some intimation of *what might have been*, so, too, does Hamilton's sensitive drawing of himself, aged sixteen, hint at what he might have become. Instead, of course, Hamilton chose to relinquish the painter's means and to toy with the images and techniques of the mega-visual tradition. His *Portrait of Hugh Gaitskell as a Famous Monster of*

Filmland would long ago have been forgotten if it had been, say, an illustration accompanying an article in a colour magazine. Hamilton's sensibility became merely reflective of the 'media landscape' which fascinated him: as an artist, he seems to have died in late adolescence. But there are not, of course, even flickerings of 'what might have been' in the wholly anaesthetic offering of Victor Burgin and his colleagues.

There is no doubt that, in the 1970s, the Arts Council acquired some unconscionable rubbish, which will soon be put under wraps for ever. Very little of the work Richard Cork bought in 1972/3 (under the rubric 'Beyond Painting and Sculpture') seemed worth any one's while getting out for this selective exhibition. Yet it is only eight years since Cork bought these things. The trouble is that the Council does not seem to learn from its mistakes.

Rudi Fuchs was specially imported to purchase for the collection in 1977/8. The results of his efforts were shown in an exhibition last year, 'Languages', which consisted entirely of specimens of structured ideology: i.e. 'conceptual' and related works. In the catalogue, Fuchs wrote 'Because a painting is Art before it is anything else (for example the image of a tree on a hill) it has become impossible to use painting objectively—as a neutral medium'. He then goes on to say that photographs and texts are 'closer to the real thing they portray than a painting—provided of course, the photograph and the text are unadorned and plainly descriptive'. The straight photograph and plain text, he says, are 'almost reality itself'. Predictably, he adds, 'Look at this art as if it were television; read it as if it were a newspaper'.

On the evidence of this text, Fuchs lacks even an inkling of the nature of art and what is worth preserving in the experience of it. He actually *wants* 'neutral media'. He does not understand the imaginative work of the artist, or the way in which he creates a transitional reality, neither objective nor subjective, through transforming his physical and conventional materials into a new and convincing whole. In short, Fuchs seems to lack even the most elementary insight into everything that I mean by *aesthetic*.

This is no small matter. 'Renunciation of the aesthetic form', wrote Marcuse, 'is abdication of responsibility. It deprives art of the very form in which it can create that other reality within the established one—the cosmos of hope'. But

Fuchs actively wishes to serve us up with an 'art' which can be looked at as if it were television, or read like a newspaper! If the Dutch want such a man to run one of their leading modern art museums, that seems largely a matter for the Dutch. But why was Fuchs invited to Britain to purchase for the Arts Council?

The Council still has not learned what a disaster it was in the early 1960s when art administrators started all that talk about waking up from 'a long provincial doze' and entering 'the international lists'. The decision to invite Fuchs shows just how entrenched that sort of thinking still is. The historian, Edward Thompson, has recently argued that the true vandals of British laws, customs, and liberties in the 1970s were 'not the raging revolutionaries of the "extreme Left" but Lord Hailsham, Mr Silkin, the judges in their ermine, the peers of the realm', and so forth. Similarly, I am often convinced that the true vandals and philistines are habitués of 105 Piccadilly: it is for those of us who are dubbed the 'extremists', to uphold value and quality in art. Perhaps this is not surprising. As Marcuse pointed out, the aesthetic and subjective aspects of art constitute 'an antagonistic force in capitalist society'.

1980

HAYWARD ANNUAL 1979

The Arts Council began to organize 'Hayward Annuals' in 1977: the series is intended to 'present a cumulative picture of British art as it develops'. The selectors are changed annually. The Hayward Annual 1979 was really five separately chosen shows in one. It was the best of the annuals so far: it even contained a whispered *promise*.

I want to look back: the 1977 show was abysmal, the very nadir of British Late Modernism. The works shown were those of the exhausted painters of the 1960s and their epigones. Even at their zenith these artists could do no better than produce epiphenomena of economic affluence and US cultural hegemony. But to parade all this in the late 1970s was like dragging out the tattered props of last season's carnival in a bleak mid-winter. The exhibition was not enhanced by the addition of a few more recent tacky conceptualists, although four of the exhibiting artists—Auerbach, Buckley, Hockney and Kitaj—each showed at least some interesting work.

The 1978 annual, selected by a group of women artists, was, if anything, even more inept. It was intended to 'bring to the attention of the public the quality of the work of women artists in Britain in the context of a mixed show'. Some of Elizabeth Frink's sculptures seemed to me to be good, though that was hardly a discovery. There was little else worth looking at.

It was in the face of the transparent decadence of British art in the 1970s (clearly reflected in the first two annuals) that a vigorous critical sociology of art developed. Writers such as Andrew Brighton and myself were compelled by history to develop in this way given the absence (at least within the cultural 'mainstream') of much art which was more than a sociological phenomenon. We were forced to give priority to the question of where art had gone and to examine the history and professional structures of the Fine Art tradition. We attended to the mediations through which a work acquired value for its particular public. Andrew Brighton emphasized

the continuance of submerged traditions of popular painting
which persisted outside the institutions and discourse of
modernism. I focused upon the *kenosis*, or self-emptying,
which manifested itself within the Late Modernist tradition
itself. Critical sociology of art was valuable and necessary: it
has not yet been completed, and yet it was not, in itself,
criticism of art.

The sonorous Protestant theologian, Karl Barth, used to
draw a sharp distinction between 'religion' (of which he was
contemptuous) and 'revelation', the alleged manifestation of
divine transcendence within the world through the person of
'The Christ', by which he purported to be awed. Now I am a
philosophical materialist. I have no truck with religious ideas:
what I am about to write is a metaphor, and only a metaphor.
However it seems to me that over the last decade it is as if we
had focused upon the 'religion' of art—its institutions and its
ideology—not because we were blind to 'revelation' but
because it was absent (or more or less absent) at this moment in
art's history.

The problems of left criticism have, as it were, been too
easily shelved for us by the process of history itself. During the
decade of an 'absent generation' and the cultural degeneracy of
the Fine Art tradition the question of quality could be evaded:
one grey monochrome is rarely better or worse than another.
Indeed, in the 1960s and 1970s, the debate about value became
debased: we saw how the eye of an 'arbitrary' taste could
become locked into the socket of the art market, and the art
institutions there become blinded with ideology and self-
interest, while yet purporting to swivel only in response to
quality. But these are not good enough reasons for indefinitely
shirking the question of value ourselves.

In his book, *Ways of Seeing*, John Berger distinguished
between masterpieces and the tradition within which they
arose. However, he has recently made this self-criticism: 'the
immense theoretical weakness of my own book is that I do not
make clear what relation exists between what I call "the
exception" (the genius) and the normative tradition. It is at this
point that work needs to be done'. I agree, but this 'theoretical
weakness' (which is not so much Berger's as that of left
criticism itself) runs deeper than an explanation of the
relationship of 'genius' to tradition. Works of art are much
more uneven than that: there are often 'moments of genius'

imbedded with the most pedestrian and conventional of works. But at these points, the crucial points, talk of 'sociology of art', 'visual ideology' or historical reductionism of any kind rarely helps.

I believe neither that the problem of aesthetics is soluble into that of ideology, nor that it is insoluble. Trotsky, thinking about the aesthetic pleasure which can be derived from reading the *Divine Comedy*, 'a medieval Italian book', explained this by 'the fact that in class society, in spite of all its changeability, there are certain common features.' The elaboration of a materialist theory of aesthetics for the territory of the visual is a major task for the left in the future: such a theory will have to include, indeed to *emphasize*, these 'biological' elements of experience which remain, effectively, 'common features' from one culture and from one class to another. In the meantime, I cannot use the absence or crudeness of such a theory as an excuse for denying that certain improbable works (with which, 'ideologically', I might be quite out of sympathy) are now beginning to appear in the British art scene which have the capacity to move me. When that begins to happen, it becomes necessary to respond as a *critic* again, and to offer the kinds of judgement which, since Leibnitz, have been recognized as being based upon a knowledge which is clear but not distinct, that is to say not rational, and not scientific.

Let me hasten to add that the 1979 Hayward Annual seemed to me no more than a confused and contradictory symptom. Nothing has yet been won. It was rather as if an autistic child whom one had been attending had at last lifted his head only to utter some fragmented and indecipherable half-syllable. But even such a gesture as that excites a hope and conveys a promise out of all proportion to its significance as realized achievement. The exhibition, which I am not inclined to reduce entirely to sociology, was an exhibition where some works, at least, seemed to be breaking out of their informing 'visual ideologies'. An exhibition where, perhaps, those 'moments of becoming' which I have been ridiculed for speaking of before may have been seen to be coming into being.

The five loosely labelled component categories of the exhibition are 'painting from life', 'abstract painting', 'formal sculpture', 'artists using photographs' and 'mixed media events'. I want to deal briefly with each.

'Painting from life' consists of the work of six artists chosen

by one of them (Paul Chowdhury). Now it is easy to be critical of the *style* which dominates this section. Chowdhury's selection looks like an attempt to revive an ebbing current of English painting on the crest of the present swell towards 'realism', i.e. in this instance, pedantic naturalism. Most of these artists have links with the Slade's tradition of 'objective' empiricism and particularly with that peculiarly obsessive manifestation of it embodied in the art and pedagogy of Sir William Coldstream. This tendency has its roots deep in the vicissitudes of the British national conjuncture, and in the peculiar complexion of the British ruling-class. Here I do not wish to engage in an analysis of the style: despite their affinities, these paintings are not a homogenous mass. Indeed the section is so uneven that one can only suspect that Chowdhury (who is certainly in the better half) sometimes allowed mere stylistic camaraderie to cloud his judgement.

Let me first clear the ground of that work which fails. At forty-seven, Euan Uglow is on his way to becoming an elder statesman of the continuing Slade tradition. This is hard to understand. His paintings here are much more frigidly formalist than anything to be seen in the adjacent 'abstract painting' room. In works like *The Diagonal*, Uglow decathects and depersonalizes the figures whom he paints. To a greater extent even than Pearlstein he degrades them by using them as excuses for compositional exercises. He is so divorced from his feelings that he has not yet proved able to exhibit a good painting. Uglow, at least, has the exactitude of a skilled mortician. By contrast, Norman Norris is a silly and sentimental artist who uses the trademarks of measured Slade drawing as decorative devices. In a catalogue statement he writes that he hopes to discover a better way of coping with the problem his drawing method has left him with. 'For this to happen', he adds, 'my whole approach will have to change'. This, at least, is true. In the meantime, it would be far better if he was spared the embarrassment of further public exposure.

Patrick Symons studied with the Euston Road painters; he is the oldest painter in this section, and his optic is also the most resolutely conservative. But, despite its extreme conventionality, his painting is remarkable for the amateurish fussiness and uncertainty it exhibits even after all these years. A painting like *Cellist Practising* is all askew in its space: walls fail to meet, they float into each other and collide. Certain objects appear

weightless. Such things cannot just be dismissed as in-
competence: Symons is nothing if not a professional. I suspect
that the distortions and lacunae within his work are themselves
symptoms of the unease which he feels about his apparently
complacent yet historically anachronistic mode of being-
within and representing the world. Symons' bizarre spatial
disjunctures mean that he is to this tradition what a frankly
psychotic artist like Richard Dadd was to Victorian academic
art.

So much for the curios. There is really little comparison
between them and work of the stature of Leon Kossoff's:
Kossoff is, as I have argued elsewhere, perhaps *the* finest of post
Second World War British painters. He springs out of a
specific conjuncture—that of post-war expressionism and a
Bomberg-derived variant of English empiricism—a conjunc-
ture which enabled him partially to resolve, or at least to
evade, those contradictions which destroyed Jackson Pollock
as both a man and a painter. (I have no doubt that Kossoff will
prove a far more durable painter than Pollock.) But Kossoff
transcended the conjuncture which formed him: his work
never degenerated into mannerism. *Outside Kilburn Under-
ground for Rosalind, Indian Summer* is, in my view, one of the
best British paintings of this decade.

As for Volley and Chowdhury themselves, they are the
youngest artists in this section: their work intrigues me. In
Chowdhury, the lack of confidence in Slade epistemology is
not just a repressed symptom. It openly becomes the subject
matter of the paintings: if we do not represent the other in this
way, Chowdhury implies, how are we to represent him or her at
all? He exhibits eight striking images of the same model, Mimi.
His vision is one in which, like Munch's, the figure seems
forever about to unlock and unleash itself and to permeate the
whole picture space. (Chowdhury has realized how outline can
be a prison of conventionality.) In his work subjectivity is
visibly acknowledged: it flows like an intruder into the Slade
tradition where it threatens (though it never succeeds) to
swamp the measured empirical method. The only point of
fixity, the only constant in these 'variations on a theme' is the
repeated triangle of the woman's sex. Both in affective tone
and in their rigorous frontality these paintings reminded me of
Rothko's 'absent presences'—though Chowdhury is not yet as
good a painter as Rothko. In Chowdhury the fleshly presence

of the figure is palpable, but its very solidity is of a kind which—particularly in *Mimi Against a White Wall*—seems to struggle against dissolution.

Volley is a 'painterly' painter: he is at the opposite extreme from Uglow. In his work the threat of loss is perhaps even more urgent than in Chowdhury's. Over and over again, Volley paints himself, faceless and insubstantial, reflected in a mirror in his white studio. Looking at his paintings I was reminded of how Berger once compared Pollock to 'a man brought up from birth in a white cell so that he has never seen anything except the growth of his own body', a man who, despite his talent, 'in desperation . . . made his theme the impossibility of finding a theme'. Volley, too, knows that cell, but the empirical residue to which he clings redeems him from utter solipsism. He is potentially a good painter.

The 'abstract painters' in this exhibition were chosen by James Faure Walker who also opted to exhibit his own work: again, the five painters chosen have much in common stylistically, though the range of levels is almost equally varied. These are all artists who have been, in some way or another, associated with the magazine *Artscribe*, of which Faure Walker is editor. *Artscribe* emerged some three years ago as a shabby art and satire magazine. It benefited from the mismanagement and bad editing of *Studio International*, once the leading British modern art journal, which has been progressively destroyed since the departure of Peter Townsend in 1975. (There have been no issues since November 1978.) Around issue seven, *Artscribe* mortgaged its soul to a leading London art dealer, which precipitated it into a premature and ill-deserved prominence.

Artscribe claimed that it was written by artists, for artists: it was, in fact, written by some artists for some other artists, often the same as those who wrote it, or were written about in it. Unfortunately, the regular *Artscribe* writers have been consistent only in their slovenliness and muddledness; the magazine has never come to terms with the decadence of the decade. It has, by and large, contented itself with cheery exhortations to painters and sculptors to 'play up, play up and play the game'.

Despite denials to the contrary its stance has been consistently formalist. Recently, Ben Jones, an editor of *Artscribe*, organized an exhibition—revealingly called 'Style in the

70s'—which he felt to be 'confined to painting and sculpture that was uncompromisingly abstract—the vehicle for pure plastic expression both in intention and execution.' Much of the critical writing in *Artscribe* has shown a meandering obsession with the mere contingencies of art, a narcissistic preoccupation with style and conventional gymnastics. This has been combined with an almost overweening ambition on the part of the editors to package and sell the work of themselves and their friends, the art of the generation that never was, the painters who were inculcated with the dogmas of Late Modernism when Late Modernism itself had dried up. Indeed, there are times when *Artscribe* reads like something produced by a group of English public school-boys who are upset because, after trying so hard and doing so well, they have not been awarded their house colours. It is noticeable that all the 'ragging' and pellet flicking of the first issues has gone: now readers are beleaguered with anal-straining responsibility, and upper sixth moralizing . . . but *Artscribe* has yet to notice that there are no more modernist colours. The school itself has tumbled to the ground.

Now this might be felt to be a wretched milieu within which to work and paint, and by and large, I suspect it is. 'Style in the 70s' is, as one might expect, a display of visual ideology. Oh yes, most of the artists are trying to break a few school rules, to arrest reductionism, to re-insert a touch of illusion here, to threaten 'the integrity of the picture surface' there—but most of it is *style*, 'maximal not minimal': its eye is on just one more room in the Tate. But—and this is important—it is *necessarily* style which refuses the old art-historicist momentum: there was no further reduction which could be perpetrated. The very uncertainty of its direction has ruptured the linear progress of modernism: within the resulting disjuncture, some artists— not many, but some—are looking for value in the relationship to experience rather than to what David Sweet, a leading *Artscribe* ideologist, once called 'a plenary ideology developed inside the object tradition of Western Art'.

Take the five artists in the Hayward show; again, it is easy enough to clear the ground. Bill Henderson and Bruce Russell are mere opportunists, slick operators who are slipping back a bit of indeterminate illusionism into pedantic, dull formalist paintings. Faure Walker himself is certainly better than that. His paintings are pretty enough. He works with a confetti of

coloured gestures seemingly dragged by some aesthetic-electric static force flat against the undersurface of an imaginary glass picture plane. The range of colours he is capable of articulating is disconcertingly narrow, and his adjustments of hue are often wooden and mechanical—as if he was working from a chart rather than allowing his eye to respond to his emotions. Nonetheless the results are vaguely—very vaguely—reminiscent of lily pools, Monet, roseate landscapes, Guston and autumnal evenings. Faure Walker is without the raucous inauthenticity of either a Russell or a Henderson.

The remaining two painters in this group—Jennifer Durrant and Gary Wragg—are much better. They are not formalists: just compare their work with Uglow's, for example, to establish that. I do not get the feeling that, in their work, they are stylistic opportunists or tacticians. They have no truck with the punkish brashness of those who want to be acclaimed as the new trendies in abstraction. In fact, I do not see their work as being abstract in any but the most literal sense at all: they are concerned with producing powerful works which can speak vividly of lived experience.

Wragg's large, crowded paintings present the viewer with a shifting swell of lines, marks, and patches of colour: his works are illusive and allusive. Looking, you become entangled in them and drawn through a wide range of affects in a single painting. 'Step by step, stage by stage, I like the image of the expression—a sea of feeling', he wrote in the catalogue. He seems to be going back to Abstract Expressionism not to pillage the style—though one is sometimes aware of echoes of De Kooning's figures, 'dislimned and indistinct as water is in water'—so much as in an attempt to find a way of expressing his feelings, hopes, fears and experiences through painting. His work is still often chaotic and disjunctured: he still has to find himself in that sea. But *Morningnight* of 1978 is almost a fully achieved painting. His energy and his commitment are not to contingencies of style, but to the real possibilities of painting. He is potentially a good artist.

The look of Durrant's work is quite different. Her paintings are immediately decorative. They hark back—sometimes a little too fashionably—to Matisse. A formalist critic recently wrote of her work, that it has 'no truck with pseudo-symbolism or half baked mysticism. The only magic involved comes from

what is happening up front on the canvas, from what you see. There is nothing hidden or veiled, nor any allusions that you need to know about'. If that were true, then the paintings would be nothing but decoration, i.e. pleasures for the eye. I am certain, however, that these paintings are redolent with affective symbols—not just in their evocative iconography, but, more significantly, through all the paradoxes of exclusion, and engulfment with which their spatial organizations present us. Now there is an indulgent looseness about some of her works: she must become stricter with herself; paintings like *Surprise Lake Painting, February–March 1979* seem weak and unresolved. However, I think that already in her best work she is a good painter: she is raising again the problem of a particular usage of the decorative, where it is employed as something which transcends itself to speak of other orders of experience —a usage which some thought had been left for dead on Rothko's studio floor, with the artist himself.

Durrant and Wragg manifest a *necessary* openness. Like Chowdhury and Volley, they are *conservative* in the sense that they revive or preserve certain traditional conventions of painting. But they are all prepared to put them together in new ways in order to speak clearly of something beyond painting itself. Levi-Strauss once explained how the limitation of the *bricoleur*—who uses bits and pieces, remnants and fragments that come to hand—is that he can never transcend the constitutive set from which the elements he is using originally came. All these artists are, of necessity, *bricoleurs*: Levi Strauss has been shown to be wrong before, and I hope they will prove him so again.

Something similar is also happening in the best British sculpture: you can see it most clearly at the Hayward in Katherine Gili where the debased conventions of welded steel have taken on board a new (or rather an old) voluminousness, and seem to be struggling towards expressiveness: imagery is flooding back. Such work seems on the threshold of a real encounter with subject matter once more. Quite a new kind of figuration may yet burst out from this improbable source.

The other two sections in the Hayward Annual, 'artists using photographs' and 'mixed media events' seemed to me irrelevant to that flickering, that *possible* awakening within the Fine Art tradition. The 'mixed media events' were a waste of time and space. The fact that a pitiful pornographer like P.

Orridge continues to receive patronage and exposure for his activities merely demonstrates the degree to which questions of value and quality which I began by raising have been travestied and betrayed during this decade by those in art institutions who have invoked them most frequently.

There is just a chance that we may be coming out of a long night. Immediately after the last war some artists—most notably Leon Kossoff and Frank Auerbach—produced powerful paintings in which they forced the ailing conventions of the medium in such a way that they endeavoured to speak meaningfully of their experience; as a result, they produced good works. Some younger artists—just a few—now seem to be going back to that point again, and endeavouring to set out from there once more. They cannot, of course, evade the problem of the historic crisis of the medium. Whether they will be able to make the decisive leap from subjective to historical vision also yet remains to be seen.

But if what one is now just beginning to see does indeed develop then, with a profound sense of relief, I will shift further away from 'sociology of art' (which is what work like P. Orridge demands, if it demands anything more than indifference) towards the experience offered by particular works, and the general problems of aesthetics which such experiences raise. I hope that I will not be alone on the left in doing so. The desire to displace the work by an account of the work (which I have never shared) can only have any legitimacy when the work itself is so debased and degenerate that there is no residue left within it strong enough to work upon the viewer or critic, when, in short, it is incapable of producing an aesthetic effect.

<div align="right">1979</div>

HAYWARD ANNUAL 1980

I begin to feel like Diderot. The Annuals of 1977, 1978, 1979, 1980. For these are certainly the salons of our time. The first thing to be said about the 1980 Hayward Annual where John Hoyland was the selector, is how good it was to have an exhibition of *painting* (with a few sculptures thrown in). I am a critic of *painting, drawing* and *sculpture*. When I went into the Hayward, I responded, at once to the look, feel and smell of the show. (I even enjoyed the rich aroma of fresh oils streaming out of Michael Bennett's *Blue Lagoon*.) Minimal, conceptual, theoretical art, and their derivatives have not made the slightest aesthetic contribution. Hoyland conceded nothing to the junk art that traces descent from Duchamp. In this sense, his selection was a relief and a pleasure. He deserves to be congratulated.

But as soon as this has been said, the questions crowd in. What sort of paintings did Hoyland choose? How good are they? How are we to assess his contribution aesthetically and culturally? Hoyland 'situated' his selection with an 'introductory section' which included work by painters from Matthew Smith to John Walker. But this section made sense. In general, Hoyland picked from those painters who emerged in Britain in the 1940s and 1950s—pre-'Situation' artists who were unaffected by the invasion of American Late Modernist anaesthetics. In many cases, they were represented by recent works, so the section as a whole amounted to the visual argument that there is a significant, neglected, British tradition which has been continuously producing genuinely expressive work over several decades.

I share this view and acknowledge that my earlier texts on British art gave insufficient weight to it. (See my self-criticisms in 'The Arts Council Collection', (p. 162). But I inflect my assessment of the achievements of this tradition differently from Hoyland. The striking fact, for me, about the paintings in the introductory section was not just that the best of them

were so much better than anything that followed, but that they were so *conservatively* conceived. The artists belonging to this redeeming strand in British art tended to be respecters of traditional skills, like touch, composition, and—here's the rub—*drawing*. The majority of them were even concerned with the painter's traditional categories: i.e. figures (Smith, Auerbach, Hilton) and still lives (Scott). In fact, only one such category was entirely absent from Hoyland's choice—history painting. Nonetheless, it is possible to say that, in some sense, *landscape* was the key for all these artists. Of course, that is evidently true of Lanyon and Hitchens. How lovely the former's *Untitled (Autumn)*, of 1964, looked in this context! But when Scott floats his still life shapes across cool blue expanses, or ochre fields; or when Hilton draws figures which ebb and flow without definite boundaries, like tidal rivers, one feels the strong affinities of their art, too, not just with 'objects' in the world, but with a notion of external environment, or *place*. Of course, none of these painters was intent upon verisimilitude of appearance or perceived space. Rather, they made use of perceptions and affective imaginings, which, through the material skills of painting itself, they sought to weld into new worlds, or aesthetic wholes. These can be 'explained' neither in terms of their connections with 'inner' nor 'outer' reality, nor yet in those of painterly forms alone, but only through the way in which all these elements are fused together. Successful examples, chosen by Hoyland, included Hitchens' fine *Folded Stream* of the early 1940s, and Walker's impressive *Daintree I* of 1980. (Walker's painting gets better all the time: he is probably the best of the younger, British 'non-figurative' painters.)

Now Hoyland certainly selected some intriguing and beautiful works from this tradition, but his choice, both in terms of the sorts of works he picked from those he did include, and the painters whom he left out altogether, tended to imply that the radical or progressive aspect of their work was their *abandonment* of traditional skills, practices and genres. Thus Hoyland chose not to represent the late painting of Bomberg which is greater than anything achieved by Lanyon or Hitchens. But Bomberg remained doggedly committed to a sense of place, to the meeting point of 'inner' and 'outer', to seeking the 'spirit in the mass'. Hoyland also selected from Hilton works which most closely approached 'pure abstrac-

tion', which had moved furthest from figure and landscape. Similarly, he picked Auerbach (who is indeed a good painter) but not Kossoff, who is better still. But Kossoff is one of the few living British artists in relation to whose work the category of *history painting* can meaningfully be raised. Unlike Hoyland, I do not think it was the fact that any of the artists in this tradition moved away from traditional skills and genres which made their work powerful and good; that strength rather derived from the way in which they transformed their materials, both physical and conventional (i.e. as given by the tradition of painting).

This may seem like hair-splitting; but the importance of this difference of emphasis is made manifest when one moves on to the main section of the 1980 Annual. Here, it seems, Hoyland pointed not just to a continuity with the past, but to the emergence of a *new tradition*, differing from the older one in the radicalness of its abstraction. Certainly, the distinction was not just one of age, since several of the painters in the main section are older than some of those in the introductory section. Now I think that many of the 'main section' artists are indeed trying to produce genuinely expressive, 'non-figurative' works. Moreover, I believe that, as artists like Rothko and Natkin have demonstrated, this can still be done. I would go further. Many (but not all) of those whom Hoyland chose were not like, say, so many of the abstractionists exhibited in 'Style in the Seventies', preoccupied with the ideology of art, that is with 'style' or 'look' for its own sake. They were clearly seeking a genuine expressiveness, which they failed to find. But why?

Let us look, for a moment, at the works in the main section for which there was something positive to be said. Among those which impressed me most was Albert Irvin's *Boadicea*, with its consummate sense of colour and scale, and its vibrant expanses of red hanging above and behind a bar of green. Comparisons between music and painting are rarely just: but I feel that Irvin (at his best) expresses emotion through shape and colour in a way comparable with music. Nonetheless, he achieves his effects through an almost classical knowledge of painterly composition. (I do not understand, however, how a painter capable of *Boadicea* could have let pictures as bad as *Severus* and *Orlando* out of his studio.) Gillian Ayres has become a much more consistent painter than Irvin: I like her work better every time that I see it. Everything about her

recent canvases, from their densely packed over-painterliness, to the surface touches of gilded tinting, suggests an attempt to quash the transience of life with an over-full hedonism, to turn even mere 'images', into the evasive, and affectively sensitive, flesh, for ever. I relish her opulent materiality, and appreciate the despair, the *horror vacui*, of which it is born. Again, I was intrigued (though not convinced) by Terry Setch's hard, crowded, anaesthetic surfaces: these were resilient and unconceding, almost to the point of ugliness. And yet they redeemed themselves in a way I cannot explain, this side of a critical threshold. But Irvin is fifty-six; Ayres fifty; Setch forty-four; what they have achieved (though limited) is rooted in traditional painterly pursuits. (I would not mind wagering that, at some point, all three were good draughtsmen, or women.) Above all, they know intuitively that to be significant and successful, a painting cannot be just 'marks on the canvas', but, through the materiality of its forms, must constitute a symbol, if not of perceived reality, then of our affective life.

But most of the rest of the main section was thin indeed. It saddens me that I can only re-affirm an earlier judgement on Geoff Rigden. He is an infantilist, someone who daubs and squelches gobbets of colour in the hope that they will evoke *some* emotion in others. It is necessary to remind such 'artists' that even Jackson Pollock was a technical master, and a great draughtsman, who lost neither his touch nor his control in his lavender mists. Similarly, I could see nothing at all worth looking at in those squeeged expanses of dredged colour, allowing for *no* illusion of space, shovelled up by Fred Pollock. One might have thought that a redeeming aspect of enfeebled painting of this low calibre would have been its sense of *colour*: but neither Rigden, Pollock, Fielding, James, Tonkin, nor Whishaw seem to have any natural or acquired sense of nuance in this respect. Yet it is hard to see what else could be claimed for their art, certainly not drawing: of the younger artists, only Mali Morris showed the slightest aptitude in this direction, and in her case it is more a question of competent design than of true draughtswomanship.

There were, of course, some works that were better than others. Clyde Hopkins is a painter of promise, his *Untitled (A.F)* of 1980 had something of that sense of the sublime which I have tried to analyse elsewhere. It *reminded* me of how good abstract painting of this kind can be, even though itself it fell

short. But I felt Hopkins had made some attempt to work through and express his emotions, not just to allude to them. But, as *Untitled/Sturm* of 1979 indicates, he is a careless painter. The canvas size contradicts the scale of his imagery, over and over again: his painting falls apart at the periphery, so that the necessary sense of aesthetic wholeness eludes him. Jeffrey Dellow has certainly come on a bit since I saw his work last year at Stockwell: but then he had plenty of room for improvement. And I cannot get over a sense of rhetoric and inauthenticity, of over-weening careerist ambitions, based on the slenderest of material and imaginative skills, which pervades not only his large canvases but those of so many even worse painters in the exhibition.

Why was there such a marked generational gap in this exhibition? Well, in a recent interview, Hoyland himself kept on and on saying that you can only produce a really good painting when you are old. 'We're not expecting to find absolutes in all these paintings. You only find that in a few great artists at the end of their life. You're not going to find it in a thirty-two-year-old . . . To get everything happening and coming at once, it seems only to happen with older artists, with *much* older artists . . .' and so on, and so forth. Hoyland's explanation may comfort him as he himself leaves middle-age behind, having never fully realized his indubitable potential as a painter, but it is not good enough. 'A thirty-two-year-old': the choice of age could not have been more unfortunate, since Seurat (who surely came nearer to producing 'absolutes' than most) was precisely thirty-two when he died. Hoyland must also have reflected on the fact that Auerbach, included in his exhibition, produced many truly major works long before he was thirty. I believe that we must look for explanations which are more profound than age alone. And they are not hard to come by.

Many of the younger artists failed because they were contaminated by post-'Situation' ideology: that is by the belief that expressiveness can only be achieved through renunciation and reductionism. They err because they have been taught to eschew imagination, drawing, illusion, and the use of any expressive elements derived from perception. The earlier tradition in Britain, represented in the 'introductory section' never made these mistakes, (although Heron, of course, was among those who later betrayed it in a peculiarly British way).

Nor, for that matter, did painters like Rothko or Natkin in America, both of whose art is rooted in physiognomy. This could not be said however of the younger painters chosen by Hoyland. One of the sillier pronouncements recently from the Stockwell Depot (with which many of them are associated) was Gouk's observation that 'drawing is . . . the bane of British painting'. In so far as British painting has had strengths, drawing has been prominent among them. Bomberg was right: there is no good painting without drawing. The trouble is that Rigden, Fred Pollock, and Co. espouse a child-like notion of expression (as a *natural* activity), and cling to it as a model for adult art activity. But one reason why Hoyland himself (who, be it said, was modest enough not to find it necessary to exhibit any work of his own) is so much better than his South London protegés is that *his* expression is rooted in classical skills; one reason why he has never achieved as much as he might have done as a painter is that he was, in the prime of his development (but *after* he had learned to draw) seduced by the anaesthetic short-cuts seemingly offered by American mannerist abstraction.

I am not however referring to a merely 'technical' matter, one which could be put right by a few evening classes in drawing (though these would not go amiss). I believe that although these artists are in pursuit of 'the aesthetic dimension', they misunderstand what it is. In the catalogue, Timothy Hilton announces of Stockwell-style painting 'This is aestheticism'. And Hoyland, too, implies something similar when, in the interview referred to earlier, he says that he does not think that figurative painting is 'what painting is about'.

In such talk, aesthetics are reduced to the fashionable, institutional style of the moment: and yet it is in the nature of the realized aesthetic dimension that it is always at odds with the visual ideology of its time. Like Hilton, I would say that I, too, am committed to 'aestheticism' but my view of what this means is at once more generous and more radical than his. I believe that those old categories, the 'beautiful' and the 'sublime', as the two contrasting but related modes of the aesthetic, are still of great relevance to painting. (I have elaborated this at some length in the last chapter of my book, *Art and Psychoanalysis*.) I see *good* abstract painting as being an extreme manifestation of the 'sublime' mode, and I value it greatly. It is very much to my 'taste'. But, having said this, I

must add that one or other end of the aesthetic continuum tends to be in or out of fashion, as a result of the vicissitudes of style, culture and history. When an aesthetic mode is 'in fashion' it tends to be banalized and reduced into mannerisms. Think of all those white marble sculptures of Venus, shown in nineteenth century salons, whose makers sincerely believed they had produced works of transcendent 'beauty'.

But the 'aesthetic dimension' cannot be validated by an appeal exclusively to either of its modes, nor yet by an appeal to *style*. The roots of aesthetics, I am convinced, lie in 'relative constants' of our experience, or rather in the way in which the artist expresses those constants through his original handling of the physical and conventional materials of his medium, and brings them into a new and convincing whole. (In this sense, of course, the painters in Hoyland's introductory section were fully engaged in the aesthetic quest.) I think that works of great aesthetic strength could still be painted in either the 'beautiful' or the 'sublime' mode. But the sublime is now an institutional fashion, as the 1980 Hayward Annual confirms. Its essential characteristics (which are in fact rooted in 'relative constants' of human being) have been ascribed to a process of formal reductionism, which is assumed to have about it an inevitable historicist motion. (This is what I mean by post 'Situation' anaesthetics.)

All this makes it harder than ever (though it is *not* impossible) to make successful works in this mode. Many of the painters at the Hayward, however, were like those nineteenth century Venus-makers. They *think* they are producing 'pure sublime', whereas in fact they are slaves of fashion, mannerism and ideology. Hoyland himself has spoken of a lack of 'whole-heartedness' in much of this painting. To truly achieve the aesthetic dimension, these painters will have to dig deeper into their own bodily and affective experience, and to replenish their expressive skills in the richness of the older tradition.

1980

A NEW SPIRIT IN PAINTING?

Over at Burlington House, home of the Royal Academy, the trumpets sounded and *A New Spirit in Painting* was proclaimed. Hugh Casson, President of the Royal Academy, wrote that the massive exhibition of 145 large pictures was 'a clear and cogent statement about the state of painting today.' He even compared the show with Roger Fry's famous *Post-Impressionism* exhibition at the Grafton Galleries, seventy years ago, when Cézanne, Van Gogh and Gauguin were introduced to a sceptical British public.

Three organizers chose the recent work of thirty-eight artists from Britain, Europe and North America. The exhibition ranged freely across the generations: there are very late works by Picasso; by Matta, the Chilean surrealist; and five recent paintings by De Kooning, the last survivor of the 'classical' generation of American abstract expressionists. But there were also works by Germans and Italians in their thirties and forties which have been but little seen outside their home countries. Everything in the exhibition, however, was painted during the last ten years. It was a crusading exercise intended to give the lie to recent rumours about the health of painting and to demonstrate that 'great painting is being produced today.'

In the catalogue, the organizers argued that the existence of such work has been obscured by a 'one-track' reading of art history, biased in favour of a succession of recent styles in American art. A catalogue essay brushed aside the view that painting has been rendered obsolete by photography, and affirmed the enduring possibilities of the traditional medium. Imagination, individuality and subjectivity were celebrated; the exhibition, we were told, presented a position in art which conspicuously asserted traditional values—such as individual creativity, accountability, and quality; but 'for all its apparent conservatism the art on show there was, in the true sense, progressive.'

At the level of rhetoric, this is splendid stuff. Indeed,

for some time now, I have been arguing much the same against the orthodoxies of the institutionalized, salon 'avant garde,' and the social reductionists of the left alike. The more that I was exposed to the thin diet of reductionist modernism, the more I came to realize that my views about painting were radically conservative, though not, I hope, reactionary.

So perhaps it was not surprising that I found some things in the exhibition to admire. For example, I have long thought that Frank Auerbach was among the best living British painters. He combines a close, empirical observation of the external world with a vividly imaginative expressionism: the two elements are brought into unity in his successful paintings because he is a master not only of drawing, but also of that lusciously thick impasto with which he paints. The *Head of JYM* characteristically combines the fathering-forth of the beauty of past change with an accuracy of observation, and a taut economy of scale which most of the other exhibited artists would have benefited by studying.

Similarly, although I think that a lot of Ron Kitaj's painting falls short, I am equally certain that his *If not, not* is among the few really good pictures produced in Britain during the last decade. The painting is frankly utopian: it is like a dream of a world transformed. I was moved by this picture when I first saw it in 1976, and I have lived with a reproduction of it for some time. As in all good painting, form and content are virtually indistinguishable.

The picture is effective because Kitaj has managed to bring his extraordinarily inventive powers as a draughtsman and colourist into a convincingly unified composition, through which he is able to realize that 'other world' (the 'subject' of his painting) on canvas. It may, however, be indicative of the faulty taste of the organizers of this exhibition that *If not, not*, though entered in the catalogue, was withdrawn from the show sometime between the press view and the opening of the exhibition to the public, although a great deal of unconscionable rubbish was left hanging there.

There were some other works which I found interesting. Like John Berger, I once believed that Picasso's best pictures belonged to his cubist phase, and that what came later was essentially a falling off. Picasso, Berger argued so convincingly, became the prisoner of his own virtuosity—an *artiste* in search of a subject. But the four paintings shown—all produced

within two years of his death in 1972—impressed me deeply. *Young Bather with Sand Shovel*, for example, was more expressive, and pictorially impressive, than many of Picasso's cubist works. I also respected Lucien Freud's portraits of his mother, which rely upon the expressiveness of carefully perceived physiognomy; and the sensuousness, complexity, and compactness of Howard Hodgkin's abstractions. Hockney's new paintings, though better than most exhibited here, are much less achieved than either his earlier pictures, or the beautiful drawings which he exhibited recently at the Tate.

But could such things be said to amount to 'a new spirit in painting'? Well, hardly. Few of the good works in this exhibition are informed by freshly conjured genie. Recent art history has certainly over-estimated the importance of stylistic innovation; but it did not thereby obscure from view much worth seeing that is on show here.

After all, Hockney cannot be said to have been hiding his lights beneath a bushel; nor did Picasso's talents pass unnoticed during his lifetime. If the spirit of painting lives on in this exhibition it cannot be said to have been born anew. On the other hand, a great deal of the work here is not just bad: it is also in no way compatible with the verbal rhetoric of the catalogue, which emphasizes the specific physical processes involved in painting and the possibilities for imaginative expression to which these give rise.

Take the work of Andy Warhol. Instead of using his eyes to look at reality, and his imagination to transform what he saw, Warhol simply picked up ready-made images (like can labels, dollar bills, glamour photographs, and so on) from commercial art. He turned these into 'paintings' by the use of mechanical reproductive means, like silk-screening and photo-based techniques. Some paint was occasionally added, usually by Warhol's assistants. He thus not only debased the significance of the artist's particular vision (in both senses of that word), but ensured that there could be no relationship between his imagination, and the concrete working of his forms in paint. Since a Warhol painting owes so little to his imagination, touch, draughtsmanship, colour or compositional skills, any residue of aesthetic effect to which it gives rise can only be fortuitous: a matter of chance, or the ideological assumptions of the viewer. Warhol is thus the antithesis of a fine painter like Auerbach, who conserves and employs all those expressive

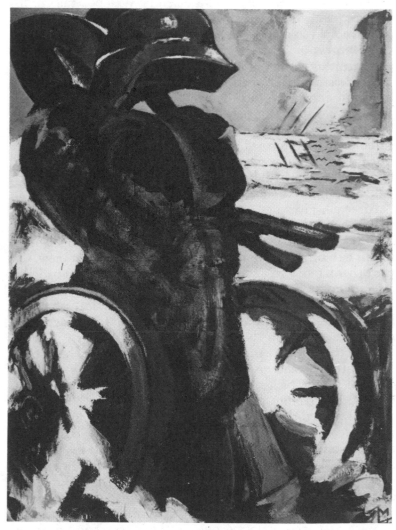

Markus Lüpertz, *Black-Red-Gold*, 1974, private collection

potentialities peculiar to painting which Warhol jettisoned. Warhol's work, for me, is style unredeemed by an iota of expressivity; he is fundamentally inauthentic. Indeed, he epitomizes what has gone wrong with painting in the last twenty-five years; one might have expected the heralds of any 'new spirit' to begin by rejecting him.

But instead, the Academy show includes some even more reductionist work, by the American, Brice Marden, who juxtaposes dead rectangles of flat colour; and Alan Charlton, an over-exposed British painter whose unsubtle grey mono-chromes have long symbolized for me the wall at the end of the late modernist cul-de-sac. In Charlton's work even the vestiges of the painter's imaginative and material powers have been relinquished: he is an artist who has nothing to say, and no way of saying it either.

At first sight, much of the work by younger European painters—in particular by certain Germans—seems rather different. Pictures by Baselitz and Lüpertz, for example, look as if they want to be thought of as being 'expressionist.' But as soon as you attend to them, you realize they are every bit as mannerist as Charlton's or Marden's. Their scale has been inflated out of all proportion to their content as if to say to the Americans, 'Look! We can do it bigger still!' But there is more excuse for oceanic size in a work whose effects depend upon colour rather than drawing; the drawing of these Germans, however, gives them away.

Just compare their loose and vapid lines with the sort of truly expressive handling you find in, say, Auerbach. The difference is that Baselitz and Lüpertz are just 'expressionistic' —i.e. the look of their paintings is derived from copying the *style* of European expressionism. There is little in their paintings which they have seen, felt or created for themselves. That is why they have to resort to all sorts of desperate devices—like hanging pictures the size of cricket pitches upside down, or repeating the same image over and over again—in order to try and attract attention. But they end up in a mire of murky rhetoric, producing wall-paper versions of the German art of half a century ago.

The elevation of these varieties of empty rubbish at the Royal Academy is as predictable as it is saddening. But *The Story of Modern Art* notwithstanding, quality in art is not a question of style, 'expressionistic' or otherwise. It remains a

matter of debate as to whether truly great painting can be produced in a society in which mechanical means of reproducing images are ubiquitous; traditional crafts have decayed utterly; and the shared symbolic order characteristic of a dominant religion has collapsed. But good painting certainly remains possible: it has much to do with a certain quality of imagination and the development to the point of mastery of the material skills specific to the practice of this art. Those skills include drawing (which can only be learned in the first instance from the figure and the object) and colour—which must be sought in nature.

Expression in painting, thus understood, is not reducible to historical circumstances but is rather a material process, incorporating certain significant biological elements which draw their strength from 'relatively constant' aspects of human experience. Late Modernism's reductive pursuit of next season's style, or the contents of the next room in the Museum of Modern Art, involved the relinquishment of all the constituent elements of painterly expression. This exhibition does not reject this trajectory: rather, it tries to associate a 'new spirit' in painting with this old vandalism, and some of its most sterile products. Worse still, it repeatedly mistakes expressionistic mannerism for true expression. But, after all, what else is one to expect from an academy . . . ?

<div align="right">1981</div>

V ARTS AND CRAFTS

PAINTING AND WEAVING IN AFRICA

'Art from Africa', an exhibition at the Commonwealth
Institute, contained works which originated from all over the
continent, from the west African nations, from Zaire, Ethiopia,
Zimbabwe, Tanzania and South Africa. For the most part
these were not examples of the traditional, tribal art of the sort
that influenced *Les Demoiselles d'Avignon* and so much early
Modernism. The oldest date back about thirty years; most are
from the 1960s or 1970s. They were made by Africans who
were affected by the massive migrations of the last quarter of a
century from the villages and countryside to the towns.

What was their work like? Before describing it, I want to
emphasize the limitations of the exhibition. In the catalogue,
Michael Manley stressed that the show was compiled 'mainly
from works in private collections and that these collections
have been assembled almost entirely by Europeans'. Moreover,
the exhibition conditions were hardly fair to the artists
concerned. Of the 400 works listed and numbered in the
unillustrated catalogue, only about half could actually be seen
on the walls. It was not just that many had been wrenched out
of the casual contexts for which they were intended; a good few
were in urgent need of restoration and repair. If recent African
art was worth showing at all, it deserved better.

Nonetheless, after taking these factors into account, I think
it is possible to say something about current African art on the
basis of the exhibition. The work varied, of course, from
region to region and from artist to artist. But, with the
exception of a handful of sculptures, almost all the works on
show were paintings on a rectangular support—board, paper,
or canvas. This, in itself, was significant. Although body
ornamentation, decoration of the outside walls with pattern
and pigments, earth-drawings, and the colouring of carved
masks were common in traditional African arts, this sort of
purely pictorial activity was almost unknown.

The new African painting seemed to be derived from various

distinct roots. Much of it appeared to be directly or indirectly influenced by European Fine Art teaching and practice. For example, there are some artists who receive the commissions of their Governments for new, independent universities and other public buildings; whose work is exhibited outside Africa, in one-man shows; and who become teachers in the emergent African 'Fine Art' system. Their work often exhibits a 'sophisticated' acquaintance with European and American art, and art educational techniques, but attempts to combine this with some mythological content specific to Africa. One can see this in the work of Bruce Onobrakpeya, head of the art department in St Gregory's College Lagos, who produces abstracted works based on Urhobo mythology and legends. The catalogue informed us that Onobrakpeya had 'mastered European methods of creative art and made full use of them as an African artist'. Another example is Ibrahim el Salahi, who studied at the Slade in London, where he spent a lot of time in the British Museum looking at Islamic art. Returning to his native Sudan, Ibrahim (who has exhibited widely in Europe and America) began to produce works which resemble Dubuffet's *art brut*, modified with embellishments from Islamic calligraphy. Such artists are 'professionals' in the sense that we use that word. However, in the exhibition, one also saw the influence of more traditional modes of European art: for example, a struggle towards naturalism, and a reaching out for modes of drawing which assume an imaginary picture space with representations of objects situated within it. This sort of work is often very awkward, and not in any way which can easily be related to expressive intention. For example, two Ghanaian portraits in oil on plywood attributed to 'Almighty God Art Works Anthony Akoto' were exhibited: these looked very much like weak examples of the sort of thing one sees in British amateur art exhibitions up and down the country.

Just as important as European and American Fine Art, however, is the immediate influence of African urban life itself. Many of the paintings manifested the influence of imported 'mega-visual' techniques especially those of the comic strip and poster advertisement. Others showed indifference to Western Fine Art and 'mega-visual' modes, and endeavoured to invent a pictorial language from scratch, capable of expressing the artist's experience of a modern city: such paintings tend to

resemble comparable work made 'outside of tradition' in, say, America or Britain. They were often among the most vivid and immediately 'appealing' works on show.

Another source was clearly the soil of traditional art activities: most of the established African professionals made some sort of reference to these. A few works in the exhibition—for example, those from Ethiopia—were more heavily dependent on traditional art than that. But Ethiopia is a special case: for centuries, the Coptic Church fostered a pictorical tradition. This persists, although today it deals with secular as well as religious subject matter. Of course, much recent African painting involves the blending of two or more of the modes I have mentioned. For example, in Dar es Salaam, a group of painters emerged in 1970, known as 'Tinga Tinga': they use the brilliant colours of car lacquer on slabs of masonite of uniform size; but the works they thus produce are not so much indigenous pop art as stylized pattern-pictures of animal and bush-life, reminiscent of traditional styles.

Many of the burgeoning African cities have given rise to an efflorescence of 'Street Art'. For example, small shops and businesses use painters to produce their promotional material. A section of the exhibition was taken up with scruffy examples of the boards from African barbers' shops on which different hairstyles—'Beatles', 'Police', 'Baby Face', 'Rocky', etc.—were sketchily illustrated. 'Street Art', however, is more extensive than this: it manifests itself in ways which are less readily exportable to chic European drawing rooms, in murals, decorated buses, trucks and cars. These often combine traditional patterns with Christian, American movie, and comic book imagery.

How are we to evaluate this new African art? For the most part, the exhibition was favourably received in the British press. Characteristically, in an extended feature on the show in the *Sunday Times Magazine*, Basil Davidson declared that the notion of Africa's arts being 'dead' was only another facet of a familiar Eurocentric mythology about the 'Dark Continent'. He went on to argue that the arts in Africa 'are in a period of remarkable ebullience at many levels of conception and purpose'. Although he agreed that very little traditional art was being made anywhere in Africa, he wrote, 'Visitors to the exhibition will receive a unique introduction to the huge release of self-expression which has accompanied the end of

foreign rule and now accompanies the joys and sorrows of transition to independence'.

Everything would have been so much easier if one could have just endorsed such an affirmation, but I think that if we took the works at the Commonwealth Institute as being in any way representative, then it is necessary to admit that African art is, if not dead, then at least catastrophically enfeebled. Ten years ago, Jean Laude wrote, 'When traditional African societies began to disintegrate, owing to their colonial status and to a prolonged contact with certain aspects of Western civilization, the arts entered a period of irreversible decadence'. Nothing I saw at the Commonwealth Institute inclined me to believe that the end of colonial rule had anywhere reversed that which Laude called 'irreversible'.

The artists in the Commonwealth Institute were all working on the margins of their respective cultures: this was true of those new 'professionals' who receive government commissions, and borrow their styles from Europe and their sentiments from a vanished African past. It was also true of the displaced villagers, who look to bill-boards for inspiration, and scratch around car repair shops for materials. It was even true of the 'traditional' sculptors, turning out ornaments for mantle-pieces in Palm Springs, and of those genuine 'primitives' trying to concoct a way of painting for themselves as it were from scratch. All are engaged in a desperate search for a shared symbolic order; most can only approximate through clinging to traditional forms, or through a kind of unconvincing bricolage of irreconcilable elements (e.g. Slade drawing + Islamic calligraphy + *art brut*.) Significantly, although the majority of the artists opted for the same material process (i.e. pictorial painting), it could not be said that any one of them showed a real mastery of it.

The point is best demonstrated by contrasting the world exhibited at the Commonwealth Institute with traditional, or tribal, African art. Within any given tribe, the arts all intimately related to each other, and together arose within a space which was neither wholly personal nor yet wholly social, but rather constituted a third term between the two. As Denise Paulme points out in her fascinating essay on 'Adornment and Nudity in Tropical Africa', African art involved the exteriorization of psychological and physical needs (which are by definition strictly personal) in ways which transformed

them into collective experience, collective exaltation. In African art, however, those transformations tended to remain peculiarly *physical*: it is singularly free of both the monstrous, and the idealized; its soil is always, in a particularly immediate sense, the *human body*.

Traditional African art, however, ranged between two expressive poles: on the one hand, it gave rise to free-standing sculpture, which is rooted in the separateness of the created object, its autonomy, and otherness. (As Leiris and Delange say in their book on *African Art*, for the traditional African sculptor the statue *constituted* a self-contained 'mythical reality'.) On the other hand were the decorative and ceremonial arts which, to a greater degree than their equivalents in Europe, remained intimately and indelibly fused in with the actual bodies of those whom they adorned, or who participated in them. The mask mediates between these two modes, bridging between the ornamental transformations of bodily adornment and the separate identity of free-standing sculpture. (Its role might be said to parallel that of architecture within the traditional European aesthetic: architecture functioned as both the site of ornament, and a framework for sculpture.) The traditional African arts thus provided a symbolic terrain for the communal expression of that which is intractably personal; under such circumstances, the material practices involved at either end of the African expressive continuum tended to thrive.

The greatest achievements were probably sculptural. Leiris and Delange argue that African sculpture alone resolved the fundamental problem of expression of volume, mass and its spatial relation to its environment. They point out how much Western sculpture is on the wrong road, because of its use of a 'more or less descriptive techniques, a "pictorial substitute", tending towards an arrangement of surfaces rather than a real organization of masses'. (As I have often argued elsewhere, Caro and his disciples epitomize this failing.) They then point out how the traditional sculptors' grasp of structural composition (as opposed to the arrangement of surfaces) allowed them to 'manipulate volumes in a way that immediately produces a three-dimensional quality'.

Interestingly, the work of the handful of contemporary sculptors at the Commonwealth Institute tended to be a mannerist version of traditional sculpture, i.e. these sculptors

drew upon the styles and forms of their sculptural traditions without necessarily working them through expressively. Many, like the Makonde, now exist by servicing the airport lounge market. Nonetheless, such work, though far below that of the best traditional artists, remains more impressive than almost any of the new painting: the reason is quite simply the richness of the traditions upon which the sculptor can draw. There is, however, *no* tradition of an art based on *depicted space* in Africa.

But the achievements of the traditional African craftsmen in the decorative modes were also considerable: compare the African textiles on show in the exhibition at the Museum of Mankind with the painting at the Commonwealth Institute. The variety of hand-woven textiles and the richness of the indigenous traditions is remarkable. At the Museum one could see a range of cloths in wool, raffia, silk, and cotton fibre, decorated through dyeing, stencilling, embroidering, patching and appliqué. Some of these were of exceptional beauty, for example, the cotton textiles of the Ashanti, from Ghana, the animal-pattern cloths of the Ibo, from Nigeria, or the Yomba's indigo-dyed textiles, painted free-hand with starch.

Today, of course, hand-woven textile manufacture has almost (but not quite) dried up in Africa. As a result of cheap imports, no one now has to spin or weave for any basic domestic necessity. Textiles are still produced for the tourist market, where quality tends to degenerate quickly: some are still hand-woven to a high quality for prestige or ritual purposes. But eventually, the traditional textiles will probably disappear altogether. At one level, this may be no matter for regret: hand-weaving is a repetitive and relatively sterile activity (though arguably less so than operating a mechanical loom). Nonetheless, I believe that we delude ourselves if we conflate such social transformations into aesthetic judgements: the collapse of the traditional African arts; the decadence of the specific material practices (e.g. sculpture and textiles) through which they were realized; and their replacement by a bastardized brand of European painting on the margins of African social life, represent a momentous aesthetic loss.

How then can some commentators claim this loss as a sort of renaissance in the African arts? We live in a culture in which the shared symbolic order has disappeared. Moreover, the material

practice of the ornamental and decorative arts has been destroyed (or at best rendered residual) by the rise of mechanization. The aesthetic, in both those modes which characterized the traditional African arts, has been progressively squeezed out of life and has been compelled to retreat to an illusory world on the picture surface, or behind the picture plane. Though culturally marginal, it flickers there as another reality within the existing one, a sign of what has been lost, or what may yet be to gain. Perhaps those who believe that African arts are currently 'ebullient' are so 'Euro-centric' that they consider that our culture, too, is currently aesthetically healthy.

1981

THE MAKER'S EYE

One of the most surprising cultural developments of recent years has been the 'craft revival'. I remember how, as recently as 1968, 'craft' was commonly used as a term of abuse within art critical circles. The mechanically and the mass reproduced were celebrated. But, these days, the laminated silk-screen star is undoubtedly waning. Who makes multiples now? Studio pottery, furniture making, hand-woven textiles, and jewellery, however, have all gone through something of a renaissance in recent years. The extension of the Crafts Council's gallery at a time when most institutions dependent on public funding are cutting back is a symbol of this efflorescence. Appropriately, the inaugural exhibition in the new space was a wide-ranging survey of the crafts, 'The Maker's Eye'.

Fourteen leading craftsmen and women were each invited to make a selection of work; their choices were presented as separate sections of the exhibition. By and large, selectors confined themselves to their own practice: potters chose potters, and jewellers jewellers. Each section, too, was indelibly stamped by the taste of the individual who chose it. Inevitably, quality was uneven between one section and another, and sometimes within a given section. But the exhibition gave a good introduction to the sort of thing that is currently being done by our best craftsmen.

The selections which impressed me most were both chosen by well-known figures within their respective fields: Michael Cardew, the potter, and David Kindersley, the typographer. Cardew, of course, was once a pupil of the legendary Bernard Leach, and his choice was predictable in that it included work by both Leach and his son David, Katherine Pleydell-Bouverie, Clive Bowen, and Cardew himself. Cardew was evidently seeking to illustrate his belief that those 'who produce useful pots today are raising questions which are just as crucial, and as central to our universal predicament, as those raised by any artist in any medium at any other time'. Whether or not this

was established, Cardew's own pots, for example, demonstrate
how, even in this century, a utilitarian object can be enthused
with an aesthetic, even a *spiritual* dimension.
Kindersley, too, connects with one of the great twentieth-
century traditions of British craft. He was once apprenticed to
Eric Gill, and is himself a typographer of genius. Kindersley's
selection showed his preference for lettering which is both
'functional and human'. He chose work by Banks and Miles,
for the Post Office, as an example. I agree with him, too, when
he makes a plea for space for the craftsman rather than the
designer in modern typography.

I also enjoyed Enid Marx's idiosyncratic and provocative
selection (including a nineteenth-century Punch and Judy
doorstop in hand-painted cast iron) and the simple but
workmanlike objects brought forward by Alan Peters: his own
stool and a rug by Roger Oates were outstanding.

Other selections I found much less satisfactory. Much of the
work chosen by Connie Stevenson, a knitter—including
Beverley Bull's shoulderbag in anodized aluminium jelly
moulds—owed more to the silliness and flippancies of passing
fashion than to anything I would encompass under the term
'craft'. Unfortunately the furniture selected by Eric de
Graaff—from a sub-standard, reproduction Mackintosh table
to stools by the appalling Floris van den Broecke—looked
suspiciously like his own. Unfortunately, because he is one of
those designers who has turned modernist functionalism into a
stylistic mannerism: he produced rectilinear chairs for machine
-like men with square buttocks. (Indeed, Eric de Graaff
exemplifies Kindersley's dictum that functionalism does not
function when the human dimension is ignored.) Michael
Brennand-Wood's selection of textiles also demonstrated little
to me except that when the ethic of modernist self-questioning
is embroidered into fabric to produce warps about woofs and
woofs about warps all that is worthwhile in weaving, and
creative textile making, is quickly destroyed.

Nonetheless, the exhibition, overall, bore witness to an
energy, optimism, and vitality within the crafts sector which
has been conspicuously absent from fine arts for some time.
What are we to make of this 'crafts revival'? Why should it be
happening now? Where will it lead?

One economic reason for the craft revival is, I think, middle-
class unemployment, and redundancy pay. A significant

percentage of those who are paid-off from, say, commercial design studios or higher educational establishments invest their handshakes in equipment for the craft studio they have long dreamed about . . . And they try to set up small businesses which will enable them to carry out genuinely creative work.

Clearly, however, despite the recession, there is a growing *demand* for as well as supply of craft products. The interest in the crafts must be seen as part of contemporary dissatisfaction with the anonymous and mass produced. An increasing number of individuals wish to surround themselves with at least certain objects which are the products of genuinely creative work rather than sterile, repetitive or mechanical toil. Thus the craft revival is self-evidently a response to the sense of loss engendered by industrialism and automated production. But how far will the crafts be capable of filling the void?

In one sense I believe their potential is enormous. More and more we are coming to realize that industrialization destroyed an 'aesthetic dimension' in human work. Once, man's need for playful, decorative, imaginative, and spiritual satisfaction could be satisfied even through his most practical pursuits (in the carving of a dagger handle, or ritual preparations for the harvest, for example). But mechanization and the intensification of the division of labour threatened all that. Today, however, it is possible to envisage a 'two-tier' economy (thanks to the micro-chip and full-blooded automation) in which objects of primary necessity will be made by machine, freeing men and women for the sort of fully creative labour offered by the crafts. This, I think, is the source of the sense of *promise* we feel when we look at a pot by Cardew, or a rug by Roger Oates.

Such works bear the finger print of the individual soul, and they celebrate the imaginative and physical pleasure that went into the making of them. Nonetheless, something is lacking in the modern craft movement if we compare it with any of the great craft traditions of the past. That something has nothing to do with the individual abilities of particular craftsmen . . . It is rather the absence of a living tradition of good pattern and sound ornament, *through* which the great craftsman can realize himself in something other than, or more than, an individualized gesture.

Donald Winnicott once pointed out that it is impossible to be original except on the basis of tradition. But the decline of a shared symbolic order (of a religious faith, in fact), combined

with the progressive proliferation of industrialism, has destroyed the traditions of pattern and ornament. In the crafts, tradition is now simply a matter of technique, rather than of living style. That is why, in order to be original, our greatest twentieth-century potters (like the Leachs, or Cardew) were compelled to turn to traditions deriving from cultures quite other than our own . . . It is also why lesser figures distort the impetus towards originality into a fashionable (but hopelessly degrading) manipulation of materials, or the conventions of the medium itself. Looking round 'The Maker's Eye', I realized that this absence of a living style is the major problem confronting the serious craftsman today. But, sadly, whether or not it can be overcome is not something which the craftsman, on his own, can determine.

1982

TEXTILES NORTH

'Textiles North' was a major touring exhibition of woven fabrics, rugs, tapestries, embroidery, printed cloths, felt, patchwork, knitting and textile jewellery. The organizers wanted to bring together creative textile work 'of the highest quality' from the north of England (defined for the purposes of this exhibition as stretching from the Scottish border down to Lincolnshire, Nottinghamshire, Derbyshire and Cheshire.) Anyone resident in the area, amateur or professional, was eligible to send in work and, in the event, 174 people submitted a daunting 550 pieces. A selection panel chose textiles by thirty-two women and two men. 'Textiles North' also had an educational aspect: seeking to acquaint the public with the work of the best craftsmen and to explain something about the technical processes they use. Of course, the organizers were conscious of the region's historical and sociological links with textile manufacture. They also hoped that industry would take some interest in what was being shown.

Inevitably, such a sampling was bound to be as uneven in quality as it was varied in range. Nonetheless, the exhibition was not without a coherence in diversity. Theo Morman, weaver, author, and one of the selectors, explained in the catalogue that a few decades ago, 'Textiles North' would have implied 'woollens and worsteds from Bradford and Huddersfield, cottons from Lancashire and silks from Macclesfield.' But, she argued, alongside all the activity on the industrial front, there now lay 'the large and energetic area of experimentation and creativity in the expanding world of handcraftsmanship of our own age.' Nothing, Moorman claimed, 'can now halt the encroachment into the world of the so called "Fine Arts" of those craftsmen with a valid artistic statement to make.' By and large, it was these encroachers who got accepted for exhibition in Bradford.

Now it would be churlish not to commend the enterprise of the organizers, or the intelligent way in which the chosen work

was displayed. Moreover, many of the pieces in 'Textiles North' were conscientiously made with an often acute awareness of Modernist dilemmas, e.g. Kate Russell's tapestries about tapestry making. But this concept of a 'valid artistic statement': the very phrase seems to me to beg all the questions. I remained unconvinced about the aesthetic merits of most of what I saw. Indeed, 'Textiles North'—like other recent 'art' textiles exhibitions, including the Sainsbury Centre's 'Contemporary British Tapestry', and the Crafts Centre's rock-bottom 'Stitchery'—tended to confirm my view that much of the recent upsurge in textile art activity is more like a shimmering mirage in a desert rather than a 'valid' revival of 'handcraftsmanship' in our own age. But I can only justify this judgement through an appeal to history.

Although the fibres used, and the modes of combining them, have been various, the manufacture of textiles appears to be a common feature of almost all human cultures beyond a certain level of development. But the initial impetus towards textile manufacture was probably not functional, at least in any immediately physical sense. Textiles seem to have been essentially an extension of man's aesthetic activity, which, itself, can best be thought of as a refinement of play.

The first aesthetic pursuits seem to have revolved around adornment of the body through face painting, scarring, decoration of the torso and limbs, etc. Man, born naked, imitated the ornamentation he saw all around him in nature. But his decorative activities were not, in themselves, immediately biologically functional: rather, they served his aesthetic, symbolic, and social needs. The specific constellation of decorative marks affirmed the unity of the tribe, and simultaneously allowed the individual to differentiate himself (according to both status and personal inclination) within it. Ornament was thus an arena for the inter-play between the conservation of traditional values, and innovation. Sensuous aesthetic delight merged inextricably with the expression of collective and personal belief.

But the evolution of this primary 'aesthetic dimension' characteristically involved a progressive displacement from the human body itself. Man had also acquired the capacity to *work*, or to transform the natural environment according to his material needs. But the 'aesthetic dimension' immediately entered into work, too; it plays its part in the manufacture of

weapons and utensils, and agricultural practices, as much as it does in the creation of objects of purely symbolic (or religious) significance.

This fusion of the aesthetic and the materially functional is nowhere more apparent than in dress, which, in primitive societies at least is usually rather more determined by symbolic and aesthetic factors than by protective or adaptive considerations. With the development of the capacity to combine available fibres, the textiles thus produced tended to become increasingly complex material expressions of shared values and individual talents. They also often extended outwards from mere body adornment to such embellishments of habitation as rugs, wall-hangings, etc. As a symbolic (and concrete) embodiment of values, textiles, not surprisingly, frequently served as currency in barter and exchange.

As Western society 'advanced', however, the 'aesthetic dimension' began its progressive retraction from the warp and weft of everyday living. Meaningful ornament became more and more displaced onto symbolic architectural shelters, like the great Cathedrals, or confined to the life-style of a privileged class. In the Renaissance, the disruption of shared religious belief was associated with the decline of craft, ornament and pattern. This was accelerated by the rise of capitalism, industrialization, mechanization, and secularism.

Thus threatened, the 'aesthetic dimension' ceased to be an element in all human work and activity; rather, it retreated to the special arena of the Fine Arts. 'Art' not only acquired a capital 'A', but became something exceptional and set apart from common-or-garden functional work. A new breed of professional 'Artists' began not so much to embellish and enrich everyday life as to create imagined worlds within the existing one: the worlds which came into being in the illusory space behind the picture plane.

Inevitably, in this situation, the crafts fell into decline. In the nineteenth century, for the first time in human history, textiles began to be produced without a true 'aesthetic dimension' at all. Insofar as the decorative or ornamental element survived, it tended to become a mechanically added extra, of merely sensuous rather than deep cultural-symbolic significance. Thus decorative devices often proliferated without restraint (as in the worst Victorian chintzs) or disappeared altogether (as in the dress of the working-classes.)

But, as William Morris rightly predicted, the Fine Arts found it almost impossible to prosper without the rich subtending soil of the decorative arts and crafts from which, historically, they had sprung. This tragedy of the Fine Arts is a story I have chronicled in detail elsewhere. But, in the twentieth century, they became increasingly vacuous, and increasingly devoid of real material, expressive skills. Much recent painting has merely pursued sensuous effects, without seeking symbolic or cultural significance. Worse still, a great deal of Late Modernist art has eschewed the idea of imaginative transformation altogether, and become obsessed with inert presentations of objects and materials through methods which accentuate manipulative processes.

Now it is perfectly true that today we *appear* to be witnessing a revival of handicrafts: nowhere does this seem to be more true than in textiles. And yet this is a curious kind of revival. The Fine Arts having arisen within, and transcended, the crafts, fell into decadence when they could no longer draw nourishment from them. But, today, the crafts increasingly appeal to the debased Fine Arts in order, quite literally, to *validate* themselves. (Remember Moorman's phrase: 'craftsmen with a valid artistic statement to make'.) But this increasing volume of activity in the crafts does little to hide the underlying malaise.

This was very much in evidence at Bradford. For example, some textile practitioners are now mimicking the traditional function of painting: its capacity to create an autonomous world within an illusory space behind the surface. Thus Josephine Budd began with drawings and colour slides; she then deployed fabrics as if they were paints, stretching them out over a wooden frame to depict 'realist' scenes. Verina Warren actually juxtaposed painting and embroidery, to create detailed mimetic landscapes against expansive colour fields. All this was ingenious, but no more than that. Indeed, it often seemed like wasted skill: the versatility and plasticity of oil paint on canvas, and its adaptability to constructed illusions cannot be rivalled; but nor can the decorative mode peculiar to good textiles be fully realized in such products.

Others sought to embrace the dilemmas of Fine Art's Modernists. Characteristically, Beryl Hammil announced that she considered herself 'an "artist" who happens to work in textile media not a "textile artist"'. Perhaps that was why her

work showed so little aesthetic unity, or regard for what is possible through specific creative practices. Indeed, a great deal of what was to be seen in Bradford manifested an over-labile pursuit of 'experimentation' or 'innovation', for its own sake—a kind of destructive investigation of the processes of manufacture, rather than an acceptance of their limitations as a means for the pursuit of genuinely imaginative aesthetic ends.

Without the restraints of vigorously established traditions, the curse of mixed media soon raised its Medusa's heads. Nothing, for example, could have been less successful than Barbara Milligan's confused thread, cloth and pulp construc-tions which are devoid of aesthetic merit and conceivable function alike. Although Sue Lawty's more skilfully made woven tapestries certainly involved the conservation and acceptance of traditional techniques, she, however, tended to deploy these as a sort of investigation of the material process of tapestry making itself—just as Modernist painters make the processes of painting the sole content of their work, or certain semiotic film-makers produce film-about-film. Because such work lacks significant space for imaginative transformation, or felt aesthetic effects, it ends up as a sophisticated bore. This dull pursuit of isolated material qualities and processes, so typical of the decadent Modernist ethic, achieved extreme expression in Beatrice Williams' masses of butter muslin, arbitarily organized within simple devices derived from local architecture, but predictably exploiting a textile surface for its 'tactile qualities' alone. (When will those who use this phrase begin to learn that when Bernard Berenson first wrote of 'tactile values' he was concerned with *illusions* of tactility, not with the present qualities of substances.)

For myself, the work which I found most interesting was that which had least truck with the failed Modernist experiment. Often enough, it accepted traditional textile techniques and formats as necessary starting points. Always, it addressed itself to the question of the disappearance of significant, expressive patterns from our everyday living. Rarely did it aspire to validate itself through the criteria of 'Fine Art'.

For example, Julia Ford creates delicate and original fabrics, often in response to commissions for scarves, shawls and home furnishings. Mary Godfrey uses silk to make cloth which is sensuously lovely, and functional. If their patterns appear

limited, i.e. without significant symbolic content, that must be seen as part of a cultural, rather than a purely personal, failing.

Again, I enjoyed Susan Foster's and Diana Roberts' intelligently straight-forward rugs; Geraldine Brock's more ambitious tapestry-carpets, which looked for solutions towards Turkish Prayer Rug motifs; and Dorothy Osler's and Anne McNamara's quilts. These practitioners seem, instinctively, to have understood that the crisis facing textile work (indeed work in general in our society) is inseparable from the crisis of meaningful pattern and effective ornamentation. Preoccupation with the Modernist problematic will never revive that 'joy in labour', and entry into the symbolic life of the community which modern industrialization has done so much to render impossible: rather the quest for good patterns, within the frameworks of the traditional craft practices, is still the most 'valid artistic statement' which contemporary craftsmen and women can make.

<div align="right">1981</div>

VI PHOTOGRAPHY

MORALITY AND THE PHOTOGRAPH

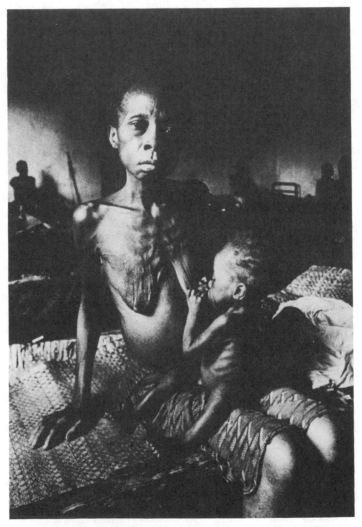

Don McCullin, *Biafra: Twenty-four-year-old Mother, her
Child suckling her empty breast*, 1970, photograph

Consider this image of an African mother with her baby: she sits on the edge of a bed in some dark dormitory and looks out at the camera. Her face shows that she still has her pride, and the residue of her physical beauty, but evidently she is old beyond her years. Her body has been distorted by wasting: her right arm is reduced to a mis-shapen twig; the starving child seated on her lap sucks at one of the breasts which hang shrivelled upon her chest like old leather purses. The caption reads simply, 'Twenty-four-year-old mother, her child suckling her breast'.

This photograph is one of Don McCullin's most searing images. Its effect on the viewer is so violent and immediate that at first he may feel it is inappropriate even to question his response. And yet as soon as he does so, he realizes that this image, like so many McCullin has published, forces him to consider a range of moral, political and aesthetic issues.

McCullin was born in 1935, of a poor, working-class family, and brought up in Finsbury Park, London, in unusually bleak circumstances. 'My mother, my father, my brother and I', he once wrote, 'slept in the dank basement room in which my father spent his life dying of chronic asthma'. He left school at fifteen and got through a number of jobs before his first photo story, 'Guv'nors of the Seven Sisters Road', appeared in *The Observer* in 1959: this was about the street gangs in Finsbury Park which he had run with as an adolescent. But McCullin was precipitated into photographic prominence in 1964 through award winning photographs he brought back from the Greek-Turkish conflict in Cyprus. From then on, he was known first and foremost as a war photographer. His most powerful images came from trips to Vietnam and Cambodia; from the Congo and Biafra; and from India and Bangladesh. In the late 1970s, he also photographed extensively in the Middle East. His last published war pictures, of the fighting in the Lebanon, appeared in the *Sunday Times* magazine in 1978.

After the Lebanon pictures, McCullin announced that he was giving up warring. In 1979, he published *The Homecoming*, a portrait of Britain in photographs; in his non-war photography, McCullin has shown himself to be concerned with the poor, the down-and-out, the injured—physically and mentally—and with outcasts and outsiders; typical 'homecoming' pictures depict alcoholics, a stripper waving her bottom at men in a Bradford pub, and Snowy, the Mouse Man from

Cambridge who allows white mice to crawl through the orifice that divides his lips.

But it remains McCullin's war pictures by which he will be judged; since 1964, these have excited almost continuous interest, revulsion and controversy. I think this has much to do with his capacity to observe and isolate a particular sort of detail from the field of human suffering and combat.

All those who know McCullin testify to his exceptional personal courage. William Shawcross, a journalist, accompanied him on a trip to Vietnam in 1972. 'He was a frightening person to work with', Shawcross later told John Le Carré, 'because he took such mad risks. Perhaps as a photographer he felt he had to. Perhaps as a journalist I should have felt the same. We went some of the way up Route 13 together, then Don just kept going. I didn't. It was frightful where he went but he still kept going'.

This courage often affects the point-of-view from which his pictures are taken: we know, simply from looking at McCullin's photographs, that many of them could not have been obtained except by risking, however momentarily, a fate at least comparable to that of those whose agony he was recording. In Cambodia, in 1970, McCullin shot a photo-sequence which demonstrated this was not just fantasy. The cover of the *Sunday Times* magazine of July 12, of that year, is a photograph McCullin took the moment before he was himself hit. Inside, there are a series of images of the wounded lying in a truck. McCullin took these while stretched out among them with his groin shot apart. I do not wish to fetishize this courage: on the other hand it is too easy for critics (who rarely take a greater risk in the course of their work than crossing the road to post their articles) to ignore it altogether. McCullin's courage not only enables him to get 'closer' than most (to use a phrase of Robert Capa's); it is also one reason why his photographs rarely lead us to think that he is just a parasitic voyeur upon the sufferings of others.

But courage by itself is not enough: it can be a peculiarly callous quality. However, immediately after describing McCullin's 'mad risks', Shawcross went on to say, 'The best thing about him was his gentleness'. It is true that McCullin himself has said things, particularly in his early days, which sound boorish and insensitive. Thus, in 1967, he declared: 'I used to be a war-a-year man, but now it is not enough. I need

two a year now. When it gets to be three or four, then I will get worried'. Despite the buccaneering rhetoric and the dubious enthusiasm for conflict, McCullin's work always manifested a kind of compassion towards his subjects, which became much more pronounced after he himself was shot. The way in which he photographs his subjects suggests that he never became inured to the horrors of what he saw. McCullin has referred to a 'moment of affinity' with his subjects, an instant in which they communicate their consent to be photographed, however appalling their situation. In part, this may well be wishful thinking: he has also said that most of his subjects are too shocked to care whether they are photographed or not. Nonetheless, the concept of 'a moment of affinity' is not just sentimentality: at the very least, his photographs testify to the fact that he would have liked the consent of those he pictures.

Paradoxically, however, McCullin's compassion is both defined and limited by the fact that he is, first and foremost, a professional photographer. He once said, 'I always take an exposure reading. Even in battle photography, I go over on my back and read the exposure. What's the point of getting killed if you've got the wrong exposure'. In one sense, this indicates an almost bizarre detachment from the reality of the situation. But it is a detachment comparable to, say, the surgeon's. Technique, for McCullin, is only an instrument: he usually has more than the right exposure. As Harold Evans, former editor of the *Sunday Times*, once pointed out, McCullin has 'an extraordinary talent for photographic composition': this is not just an extraneous 'aesthetic' consideration; *through* that composition, McCullin often renders his respect for his subjects manifest.

But McCullin's concern is, of course, limited in another way. He is not, and this is important, a 'committed photographer' in the sense of one who has a clear view of the world or of history. Douglas Duncan, by contrast, took the view that American intervention in Vietnam was justified, indeed necessary. This led him to avert his eyes from the ugliest aspects of the war, especially those involving Americans. Thus Duncan denied the authenticity of the My Lai massacre. It is inconceivable that McCullin would have thought, photographed, or acted in this sort of way. But equally he offers no especial commitment to those who, in historical terms, indubitably have right on their side. McCullin does not try to

discriminate between just and unjust wars. He extends his
concern and his professionalism, his ethic, if you will, towards
those who are suffering in the instant he confronts them.
Indeed, McCullin's discourse about his photographic practice
is always fundamentally *ahistorical*; he has shown himself to be
preoccupied with such moral issues as whether it is right to
look at, and to record, the suffering of others without taking
any action oneself. He says that he will do certain things—such
as carrying wounded men, bandaging their wounds, giving
them water, etc. But he does not believe that the photographer
should intervene beyond that level. To illustrate this, he
sometimes tells an anecdote, 'Once in Vietnam I tried to stop a
stream of lorries passing two wounded men. I snatched a rifle
and held it up towards the lorries, but no one stopped. In most
of the war situations one is like a speck of dust. If men are bent
on killing and destruction, one photographer with a Nikon will
not really affect their action'. Of course, McCullin's seeming
indifference towards a historical perspective has been criticized,
especially by Left commentators: but, for the moment, I want
just to compare the ethics of his position with those of, say, a
conscientious Red Cross surgeon.

Let us now look at the problem from the other end, from the
point of view not of the photographer, but of *the effects of his
work*. There are two popular arguments about these. On the
one hand, there are those who say that images like McCullin's
have little or no effect: we become inured to their sensational-
ism; like drug addicts, we develop an ever increasing 'tolerance'.
Thus, to be moved, we require more and more violent pictures:
and so, in the end, such photographs do no more than
acclimatize us to, perhaps even condone, the horrors of war.
On the other hand, there are those who say that such pictures
make us aware, and change our attitudes towards historical
events. Interestingly, McCullin himself oscillates between
these positions. During the course of a recent television
interview he seemed to be saying, at one moment, 'I've been
working all these years . . . and it hasn't done the slightest bit
of good. Wars go on as they always did', etc. Whereas, in the
next moment, he made the remarkable claim that a photograph
—not one of his own—had actually brought the Vietnam war
to an end. (The picture he had in mind may have been that of
the napalmed girl fleeing naked along a road; or it may have
been Eddie's Adams's picture of Lt. Col. Nguyen Loan, police

chief of South Vietnam, executing a Viet Cong suspect whose hands were tied behind his back.) But this sort of oscillation between a view of photography which considers it to be totally impotent and ineffectual, and another which proposes it as the motor of history should make us suspicious.

In his study of McCullin ('Photographs of Agony', in *About Looking*) John Berger points towards a third position: he says that, when a viewer is confronted with an extreme image of the suffering of others, he tends to experience this 'as his own moral inadequacy'. And this sense of moral inadequacy, Berger says, disperses the initial shock: 'Either he shrugs off this sense of inadequacy as being only too familiar, or else he thinks of performing a kind of penance'—like making a contribution to OXFAM. In both cases, Berger says, 'the issue which has caused that moment is effectively depoliticized. The picture becomes evidence of the general human condition. It accuses nobody and everybody'. So, Berger concludes, 'Confrontation with a photographed moment of agony can mask a far more extensive and urgent confrontation. Usually the wars which we are shown are being fought directly or indirectly in "our" name. What we are shown horrifies us. The next step should be for us to confront our own lack of political freedom'. Berger adds that, in political systems as they exist, we have no legal opportunity of influencing the conduct of wars waged in our name; he suggests that to realize this and to act accordingly is the only effective way of responding to what the photograph shows. But, he says, 'the double violence of the photographed moment actually works against this realization. That is why they can be published with impunity'.

Now, in one sense, I think that Berger is right: I do not think that we become inured to photographs like McCullin's; on the other hand, what he shows *is* stripped out of a political and historical dimension. Nonetheless, I think that Berger and those who think like him, may be missing the point about what photography like McCullin's—scrupulously committed to the particular suffering of the particular individual in the particular moment—can offer. Nor do I believe that this relentless focus upon a moral dimension which, as it were, refuses to reduce itself to ideological, historical, or political circumstances is necessarily a fault in photography; indeed, I think it constitutes McCullin's peculiar strength.

Let us return to the photograph I discussed at the beginning.

There cannot be many situations which shock us as deeply as this: a mother is so starved that she cannot feed her suckling child . . . But, in confronting this particular woman's suffering, and in responding to it with moral indignation, are we necessarily masking or evading some more 'urgent' confrontation? Many critics would undoubtedly answer in the affirmative; but I do not accept that the moral can be elided from history as easily as that.

Biafra was indeed one of those wars 'indirectly' fought in our name: the Ibos seceded from Nigeria under Lieutenant-Colonel Odumegwu Ojukwu, and declared an independent state of Biafra in 1967. This led to a civil war in which Britain and the USSR supplied the federal Government, whereas the French supported the rebels. The prolonged struggle brought appalling casualties from famine, injury and disease among the enclaved Biafrans, like this woman and her baby.

Now, evidently, none of this 'background' is even hinted at in McCullin's photograph—and it is difficult to see how it could be, unless he deliberately contrived that which he depicted, like, say, Douglas Duncan. McCullin's camera focuses upon the very specific, this particular woman's suffering, in a way which evokes the very general, i.e. that such things ought not to be so under any circumstances. McCullin leaves out all the mediations in between. But in what sense does this ethical or moral dimension 'mask' a 'real' confrontation with history?

Such images will not reduce themselves to the ideological newspeak of Governments justifying their war policies: indeed, they represent a great shout for that dimension which political analysis tends to leave out of account altogether. When it does so, of course, it is poor political analysis: McCullin does not just arouse our 'moral inadequacy' in the face of such things; his photographs compel us to consider the relationship between the ethical and the historical. He makes us ask ourselves such questions as when, and under what historical circumstances, if any, in the name of what causes, is it right to impose such suffering on others.

Indeed, he demonstrates that those who regard all such questions as being 'relative' (or subordinate to historical circumstance) are talking nonsense. For example, McCullin has published images of Congolese soldiers taunting and tormenting their prisoners as they await execution. Some

struggles are just in historical terms; others are not; a just struggle can be as bloody and brutal as an unjust one; in the course even of just struggles the summary execution of prisoners may sometimes be justifiable . . . Nonetheless, on looking at photographs like these it is possible to say that what is depicted is *absolutely* wrong. No historical circumstances, whatever, could possibly condone the soldiers' actions. Now some will undoubtedly say that such issues are 'trivial' beside the great historical themes on which the photograph is silent. Of course, ethical cannot be substituted for historical analysis: McCullin himself failed to realize this when he verbally criticized the North Vietnamese after he had seen a particular soldier urinating near his dead comrade's head. But those who believe that to focus upon specific incidents which raise momentous questions of ethics and morality is merely to evade or to mask the 'real' issue seem not to have learned the lesson of Cambodia. The photographer, as photographer, cannot offer a historical perspective: but we have surely had enough, and more than enough, of those historical perspectives which refuse to treat seriously those issues with which photographers like McCullin so remorsely confront us.

1981

VII WRITINGS

SEBASTIANO TIMPANARO

Classical Marxism emerged in the middle of the nineteenth century with the struggle for justice among the oppressed proletariats of European industrial countries. But when socialism came into being in the Soviet Union, it was not what had been promised. Stalinism was another form of oppression. A spectre began to haunt the socialist tradition—the spectre of Stalinism. By the 1960s, however, there was a new generation, and for many of us the problem of Stalinism no longer seemed central. We dissociated ourselves from it, believing we knew ways of evading those mistakes. We dared to pose again the promise of socialism. But in the late 1970s, *absolute* Stalinism erupted in Pol Pot's Kampuchea. It was a regime the vileness of whose acts surpassed even those of the Americans in South East Asia. Yet this, too, was socialism. One of the most urgent questions raised by Kampuchea is: 'Was the lesson of Stalinism truly learned?'

Much recent Marxist theory here and on the continent suggests not. In its fashionable Althusserian variants (Louis Althusser is a leading philosopher in the French Communist Party), the human subject is eliminated. Men are described as if they were mere effects, or shadows, of a structure outside themselves. Any emphasis on human agency is spurned as 'humanism.' Men and women are treated as if they only came into being with ideology. Their biological and physical existence is ignored. Inevitably, ethics and aesthetics are dissolved into ideology, too.

These systems of thought declare themselves to be anti-Stalinist. Yet those who eliminate the human subject in theory inspire no great confidence about what they would do in practice, given the opportunity.

Such philosophies are characterized by a rabid idealism. The validity of empirical observation of the objective world, of nature, is denied.

But there are signs this may change. The Italian Marxist,

Sebastiano Timpanaro, is one of those offering a frontal challenge to the prevailing theoretical orthodoxy. His British publishers, New Left Books, may not be exaggerating when they say that his work 'will be one of the central focuses of cultural and intellectual controversy within and beyond Marxism in the next decade.' One can only hope that he is among the first swallows of a new materialist summer.

Timpanaro has an implicit respect for the individual, and an acceptance of the reality of the natural world. His is a Marxism which allows one to pose again that promise of socialism, *in good faith*.

Timpanaro was born in Parma in 1923. By academic training he is a philologist, a specialist in Latin and Greek textual criticism. By all accounts, he is somewhat reclusive, not to say phobic, in his private life, spending long periods in his darkened book-lined study. But he has a long history of political activism. From 1945 to 1964, he was a member of the left of the Italian Socialist Party, and of its successor organization until 1972. He then joined a newly created proletarian unity party, established by former socialists and communists.

In 1965, he published a major study of nineteenth century Italian culture. This included a re-evaluation of Leopardi, a poet whose pessimistic cadences echo through his own work. But the two books which have caused controversy are *On Materialism*, which was recently published in Britain as a paperback, and *The Freudian Slip*, published here four years ago.

Socialists, he thinks, need to re-confirm and to develop a thorough-going *materialism*. 'By materialism,' he writes, 'we understand, above all, acknowledgement of the priority of nature over mind; or, if you like, of the physical level over the biological level, and of the biological level over the socio-economic and cultural level—both in the sense of chronological priority (the very long time which supervened before life appeared on earth, and between the origin of life and the origin of man), and in the sense of the conditioning which nature still exercises on man and will continue to exercise at least for the foreseeable future.'

He sets biological limits to political activism. 'We cannot,' he writes, 'deny or evade the element of passivity in experience: the external situation which we do not create but which

imposes itself on us.' His view is summed up in the sentence: 'Marxists put themselves in a scientifically and polemically weak position if, after rejecting the idealist arguments which claim to show that the only reality is that of Spirit and that cultural facts are in no way dependent on economic stuctures, they then borrow the same arguments to deny the dependence of man on nature.'

His themes are hedonistic and pessimistic. He is concerned with human happiness: he judges it central to the struggle for communism. But he rejects that vociferous tendency within socialism which vaunts a spirit of triumphant omnipotence in the face of nature. He repeatedly emphasizes the frailty of man, compared with the physical and cosmological universe. In the very long term, he says, it is more reasonable to project the end of the species, and of the world it inhabits, through natural causes than to posit realized communism as a kind of timeless 'Kingdom of Heaven on Earth,' in which man will live forever in everlasting peace.

Even if communism were achieved, he points out, we would remain constrained by the limitations of natural being. Men and women would continue to become ill, to suffer the physical and psychological debilitations of old age, mourning and inevitable death. 'A phenomenon like old age,' he writes, 'arose and continues to persist on the biological level . . . Old age remains a highly unpleasant fact. And no socialist revolution can have any *direct* effect on the fundamental reasons which account for its unpleasantness . . . Communism does not imply, in and of itself, a decisive triumph over the biological frailty of man, and it appears to be excluded that such a triumph could ever be attained (unless one wishes to indulge in science fiction speculation).'

Clearly, Timpanaro is not just criticizing the questionable Paris-based Marxism of recent years. He probes the roots of Marxism as a whole.

The problem is that, according to Marx, from the time when man started to labour and produce he entered into relationship with nature *only through work*. But this, Timpanaro says, is a limited conception of the relationship between man and nature. Marx has nothing to say about the fact that man enters into relationship with nature through heredity, and through 'innumerable other influences of the natural environment on his body and hence on his intellectual, moral and psychological

personality.' Neither tornadoes, nor spina bifida, nor death, can be ascribed to man's activity.

Timpanaro says that you cannot deny all this by dismissing it as 'positivism' or 'vulgar materialism'—standard labels among left-wing theorists. 'Facts do not allow themselves to be vanquished by labels.' Marxism has consistently ignored the reality of the 'passive' side of man's relation to nature, and it should now start to take it into account. Timpanaro praises the achievements and concerns of Engels, who was more deeply involved than Marx in exploring the importance of the natural sciences.

He suggests a radical revision (though not a rejection) of a central Marxist concept: the relationship between the underlying (economic) *structure* and the (ideological) *superstructure*.

Timpanaro says that this famous opposition 'represents a discovery of immense significance, both as a criterion for explaining social reality and as a guide for transforming it.' But he thinks that it isn't an exhaustive classification of reality, 'as if there were nothing that existed which was not either structure or superstructure.'

He identifies 'non-superstructural' (and hence ideologically neutral) elements not only in the natural sciences, but also in certain cultural activities and institutions. He calls for a closer consideration of that biological nature of man which Marxism, and paticularly contemporary Marxism, tends to disregard. This produces a furious response in critics who, I can only assume, would prefer to undergo open heart surgery, at the hands of a first-year medic who had read Althusser (and thus acquired a 'correct' ideological perspective), rather than an experienced heart surgeon who voted Tory at the last election.

Timpanaro's interest in the study of animal behaviour—'a fascinating science, which has already made and will continue to make great advances in our understanding both of the animality in man and of the rudiments of "culture" to be found in other animal species'—is refreshingly new.

In writing about ethology and socio-biology, he rejects crude social Darwinism. This 'transmutes itself from science to ideology' by seeking to 'leap over or circle around the fundamental moment of the establishment of social relations of production, the division of society into classes, the class struggle, and the new rhythm which the historical development of mankind has taken on since then.' Nonetheless, he

makes the point that 'to reduce man to what is specific about
him with respect to other animals is just as one-sided as to
reduce him (as vulgar materialists do) to what he has in
common with them.' What is required is a critical encounter
with the findings of the ethologists, and not a rejection of
them, out of hand. (Sexuality, for example, is not *just* a cultural
phenomenon. There is much that even socialists can learn
about human sexual behaviour from Desmond Morris.)

He is not a humanist. For him, man is not the subject of
history, let alone the ruler of the universe: he depends upon
nature, which he can never absolutely master. Man has an
origin and will have an end (or a transformation by Darwinian
evolution). Nonetheless, man has an underlying human
condition whose aspects, while not actually eternal, are very
long-lasting. As Timpanaro puts it, 'They have, relative to the
existence of the human species, much greater stability than
historical or social institutions.'

Timpanaro is already beginning to have a profound influence
on socialist aesthetics, which have recently been through a
most catastrophic period during which class was supposed to
'explain' works of art.

One of the most famous conundrums in that field is this. If
'social' or 'ideological' factors are all-important in a work of
art, how can we enjoy works of art of the past even when we
know little or nothing about the social condition under which
they were produced? Marx's own attempt to answer this
question was inept. For Timpanaro, one reason for this
'cultural continuity' is simple: 'Man, as a biological being, has
remained essentially unchanged from the beginnings of civil-
ization to the present; and those sentiments and representa-
tions which are closest to the biological facts of human
existence have changed little.'

He recognizes that the development of society changes
men's ways of feeling pain, pleasure and other elementary
psycho-physical reactions. There is hardly anything that is
'purely natural' left in contemporary man which has not been
enriched and moulded by the social and cultural environment.
But he insists that the general aspects of the 'human condition'
still remain.

Certain works of art express feelings of sexual love, fear of
death, grief at the loss or death of others, and so forth. They
are no doubt mediated by historically-specific cultural forms.

Yet they retain elements of common content which enable them to communicate actively (and not just as documents) beyond and across historical periods and cultures. We do not need to know anything about Greek mythology to be moved by the suffering of the Laocoon, or about Christian doctrines of salvation to respond to Grünewald's crucified Christ.

In a discussion of Timpanaro, Raymond Williams argues that the deepest significance of a relatively unchanging biological human condition may lie in the *basic material processes* of making art: the rhythms in music, dance and language, and the shapes and colours in sculpture and painting. About such things, there can be no reduction to simple social and historical circumstances. 'What matters here,' Williams says, '. . . is that art-work is itself, before everything, a material process . . . The material process of the production of art includes certain biological processes, especially those relating to body movements and to the voice, which are not a mere substratum but are at times the most powerful elements of the work.' Ideology has only a limited part to play in the making of a great singer, dancer or sculptor.

I hope that all this will bring an end to those shabby attempts to reduce art to politics—of the 'Art for whom?' variety—which proliferated throughout the 1970s. Eventually, Timpanaro's work may help to resolve another of Marxism's notorious gaps: *ethics*. He himself gestures towards hedonism —the pleasure principle—as the basis for a biological component in ethics. But his work might open the door for a consideration of socio-biological research into the genetics of altruism and ethical behaviour.

I have commented so far on those aspects of Timpanaro's work which I regard positively. It does not seem necessary to endorse, say, his over-favourable estimate of Lenin in order to agree with his central thesis. But I do take issue with his sustained polemic against psychoanalysis.

He thinks that psychoanalysis has been too concerned to detach psychology from neuro-physiology, and that it is 'permeated with anti-materialist ideology.' He mutters ominously that 'it may be that Pavlov will have more to tell us than Freud.' In *The Freudian Slip* he uses his considerable philological resources to demonstrate that many instances of slips of the tongue which Freud took to be determined by the unconscious, could well have far simpler explanations. There is

the process which Timpanaro calls 'banalization'—our tendency to use a familiar word (or spelling) rather than an unfamiliar, correct, one.

Timpanaro makes many astute observations on Freud's less than satisfactory modes of arguing his case. But there is a sense in which Timpanaro makes the same mistake as Freud about the nature of psychoanalysis. They both treat it as if it was a 'natural science,' like physics. The only difference is Freud is always saying, 'Look, pure science!'—whereas Timpanaro shouts back, 'No! This isn't like science at all.' But it may be that psychoanalysis is more like philology than physics. It might be, as Charles Rycroft has suggested, 'a theory of biological *meaning*.'

But this is an 'aside' in the context of Timpanaro's work as a whole. His importance is that he gives full recognition to the individual as a *relatively* autonomous entity, existing simultaneously in the natural and social worlds. He points the way towards a materialist handling of ethics and aesthetics, which does not reduce them to simple social or historical circumstances. As Stalinism demonstrated, and Cambodia so tragically confirmed, these remain vital tasks for all who call themselves socialists.

Herbert Marcuse, a member of the Frankfurt School of sociologists, spoke of the 'ultimate goal' of all revolutions as 'the freedom and happiness of the individual.' Timpanaro is dismissive of Frankfurt Marxism. But I often find myself reminded of Marcuse when I read him, not least when he writes of such things as 'the importance of the meaning of freedom as the absence of painful constraints, and the presence of all those conditions which ensure the happiness of the individual.'

I welcome the return of such cadences. I welcome, too, the sober pessimism that underlies them. There are few reasons why those who call themselves socialist can take pleasure in present historical circumstances. As Timpanaro puts it, 'We can no longer refer to any model of socialism either realized or on the road to realization in the world today.' But you cannot contest 'capitalist barbarism' without a *utopia*. Timpanaro interprets this as a scientifically grounded vision of a human reality other and better than the existing one. His work sketches the basis on which such a vision can be built.

1980

DONALD WINNICOTT

Donald Winnicott once wrote that he could see what 'a big part' has been played in his work 'by the urge to find and to appreciate the ordinary good mother.' Before he died in 1971, he had interviewed an estimated 60,000 mothers with their children. His concern was with 'the mother's relation to her baby just before birth, and in the first weeks and months after the birth.' He said that he was trying to draw attention to the immense contribution which the 'ordinary good mother' makes to the individual and to society 'simply through being devoted to her infant.'

Winnicott was among the most innovative and insightful members of that fertile yet contentious school of psycho-analysis which began to flower in Britain in the wake of Melanie Klein's discoveries in the 1930s. For about twenty-five years, his work has been well-known internationally in psycho-analytic, paediatric and psychiatric social work circles. In Britain, he has enjoyed a popular following for his radio talks, articles, and books on motherhood and child care. But his findings about the earliest phases of human development have not yet received the broader cultural consideration and application which they deserve.

For example, in his latter years, Winnicott turned away from clinical matters to concentrate upon the nature and location of cultural experience. This was the theme of his last book, *Playing and Reality* (1971). In my own researches into aesthetics, illusion, and the psychology of creativity, I have found the later Winnicott consistently clarifying and original. And yet I am always surprised at how few writers in this terrain cite Winnicott or realize the relevance of his work to theirs.

In part, this is the result of prejudice. Winnicott often denied he was an 'intellectual.' He insisted that 'a writer on human nature needs to be constantly drawn towards simple English and away from the jargon of the psychologist.' As his colleague, Masud Khan, once pointed out, Winnicott also

manifested 'a militant incapacity to accept dogma.' He would not have needed to be reminded of *The Poverty Theory*. His radical materialism led him to stress that 'mind is . . . no more than a special case of the functioning of psyche-soma.' None of this endears him to intellectuals. Paradoxically, his scepticism about intellectualism was one factor which helped him to become perhaps the best psychoanalytic theorist of infancy to have emerged anywhere since the last war.

'The word infant implies "not talking" (*infans*),' he once wrote, 'and it is not unuseful to think of infancy as the phase prior to word presentation and the use of word symbols.' He stressed that the infant depended on maternal care based on 'maternal empathy' and not on words, and he found a way of doing and writing psychoanalysis which respected 'the delicacy of what is preverbal, unverbalized, and unverbalizable except perhaps in poetry.'

Drawing on his reservoir of clinical experience, Winnicott demonstrated how innate 'maturational processes', can only develop satisfactorily through a 'facilitating environment' which, in the first instance, is the mother. Through the mother's care, he maintained, 'each infant is able to have a personal existence, and so begins to build up what might be called a *continuity of being*. On the basis of this continuity of being, the inherited potential gradually develops into an individual infant.' But if maternal care was not 'good enough' then 'the infant does not really come into existence, since there is no continuity of being; instead the personality becomes built on the basis of reactions to environmental impingement.' It manifests a 'false self.'

Winnicott was thus concerned with 'the whole vast theme of the individual travelling from dependence towards independence,' with the potential of becoming a fully human subject. By contrast, the currently fashionable Parisian psychoanalysis of Lacan and his acolytes conceives of only a 'de-centred,' disembodied ghost of a subject, constructed entirely through the impingements of the 'signifying chain' of a historically specific ideology.

This is roughly what Winnicott explains through the pathology of the 'false self.' I am sure that as the tenuous structures of such structuralism begin to look increasingly shaky, the relative strength and fullness of Winnicott's contribution will become more and more apparent.

Winnicott, born in 1896, came from a wealthy, middle class background. His father was a Nonconformist sweet manufacturer who became Lord Mayor of Plymouth. After training as a doctor, he gravitated towards paediatrics: in 1923, he was appointed to the Paddington Green Children's Hospital, where he remained for 40 years. That same year, however, he entered into a personal psychoanalysis with James Strachey, a prominent Freudian. This analysis lasted ten years.

Inevitably, Winnicott soon saw the significance of psychoanalysis for his work with children. 'I am a paediatrician who has swung to psychiatry,' he was to say later, 'and a psychiatrist who has clung to paediatrics.' His first book, *Disorders of Childhood* (1931), upset the paediatric establishment with its emphasis on the importance of emotional factors in infantile arthritis. 'By being a paediatrician with a knack for getting mothers to tell me about the early history of their children's disorders,' he wrote, 'I was soon in the position of being astounded by . . . the insight psychoanalysis gave into the lives of children.' But it was not a one-way process. Paediatrics made him increasingly aware of 'a certain deficiency in psychoanalytic theory.'

At this time, Winnicott complained, 'everything had the Oedipus complex at its core.' Psychoanalysts traced the origins of their patients' neuroses to the anxieties belonging to instinctual life at the four or five year period in the child's relationship to the two parents. Winnicott, however, saw that infants and even babies could become acutely emotionally disturbed. 'Paranoid hypersensitive children could even have started to be in that pattern in the first weeks or even days of life.' Winnicott's findings were disturbing to 'orthodox' analysts who 'saw only castration anxiety and the Oedipus conflict.'

Although he was the only analyst in paediatrics in Britain, he was not the only one questioning Freudian orthodoxy by pushing back psychoanalytic insights into the earliest phases of life. Winnicott tells how Strachey 'broke into' their analysis to let him know about Melanie Klein who was then pioneering psychoanalytic work with children in Britain. Winnicott went to see her and began working in collaboration with her, but this was not easy for him. For all her brilliance, Klein tended to be a sectarian: Winnicott soon found he did not qualify 'to be one of her group of chosen Kleinians.' 'This did not matter to me,'

he wrote, 'because I have never been able to follow anyone else, not even Freud.'

Winnicott learned from Klein about technique, especially the use of play in the therapeutic process. He came to see the child's manipulation of set toys and other forms of 'circumscribed playing' (for example, with a shiny spatula kept on the desk in his clinic) as 'glimpses into the child's inner world.' Like Klein, he stressed that the child conceived of himself as having an inside that is part of the self, and an outside that is 'not-me' and repudiated—though this theory he later extended. Winnicott also valued Klein's concepts of 'introjection' and 'projection': these she held to be mental mechanisms, of critical importance in early infancy, which developed in relation to the infant's experience of bodily processes of eating and defecating respectively.

Klein emphasized the intense ambivalence—or opposition of love and hate—in the infant's earliest relationship to the mother's breast. She spoke of the defensive 'splitting' of the idea of the breast into 'good' and 'bad,' and attributed to the infant various psychic manoeuvres to keep these widely separated. All this led her to write of the 'paranoid-schizoid' position of earliest life, which, she maintained, was only superseded by the achievement and working through of a 'depressive position' in which the infant came to accept that the loved and hated breast was but part of one and the same feelingful person, out there in the world, separate from himself.

Winnicott, too, stressed the importance of the achievement of what he called 'the capacity for concern.' But he remained sceptical about Klein's use of the model of madness to describe ordinary developmental processes. Although he reluctantly retained the term 'depressive position,' he rejected the 'paranoid-schizoid' model of early life. 'Ordinary healthy children are not neurotic (though they can be) and ordinary babies are not mad,' he wrote.

Indeed, the differences between these two thinkers are as important as their similarities. Klein, like Freud, rooted her psychology in a theory of instinct. She saw development as essentially determined by the operation of innate forces, the Life and Death instincts. Winnicott, rightly, rejected the concept of the Death instinct altogether. He stressed that a satisfactory state of being necessarily *preceded* a satisfactory

use of instinct. This state of being he saw as being dependent on the relationship between the mother and the child. 'Klein claimed to have paid full attention to the environmental factor,' he wrote, 'but it is my opinion that she was temperamentally incapable of this.'

Unlike many analysts who focused on the infant-mother relationship, however, Winnicott did not reject the idea of 'primary narcissism,' although he described it in very different terms from Freud. For Winnicott, in the beginning 'the environment is holding the individual, and *at the same time* the individual knows of no environment and is at one with it.' (This, of course, is the condition so often reproduced in mystical and 'sublime' aesthetic experiences.)

Freud had described the baby as an autoerotic isolate, forever seeking the experience of pleasure through the diminution of instinctual tension within a hypothetical 'psychic apparatus.' But Winnicott described the infant as being enveloped within and conditional upon the holding environment (or mother) of whose support he becomes gradually aware. 'I would say that initially there is a condition which could be described at one and the same time as of *absolute independence* and *absolute dependence*,' he writes.

Winnicott's most brilliant theoretical work describes the way in which this primary state changes to one in which objective perception is possible for the individual. He rejected the idea that a 'one-body relationship' *precedes* the 'two-body object relationship'; but this led him to ask what there was for the becoming individual before the first 'two-body object relationship.' He struggled for a long time with this problem and then, one day, he found himself bursting out at a meeting of the Psychoanalytic Society, 'There is no such thing as a baby.'

'I was alarmed to hear myself utter these words,' he writes, 'and tried to justify myself by pointing out that if you show me a baby you certainly show me also someone caring for the baby, or at least a pram with someone's eyes and ears glued to it. One sees a "nursing couple".' Later, he put it this way: before object relations, 'the unit is not the individual, the unit is an environment-individual set-up. By good-enough child care, technique, holding and general management the shell becomes gradually taken over and the kernel (which has looked all the time like a human baby to us) can begin to be an individual.'

Winnicott thought that the infant made his first simple contact with external reality through 'moments of illusion' which the mother provided: these moments helped him to begin to create an external world, and at the same time to acquire the concept of a limiting membrane and inside for himself. He defined illusion as 'a bit of experience which the infant can take as *either* his hallucination *or* a thing belonging to external reality.' For example, such a 'moment of illusion' might occur when the mother offered her breast at exactly the moment when the child wanted it. Then the infant's hallucinating and the world's presenting could be taken by him as identical, which, of course, they never in fact are.

In this way, Winnicott says, the infant acquires the illusion that there is an external reality that corresponds to his capacity to create. But, for this to happen, someone has to be bringing the world to the baby in an understandable form, and in a limited way, suitable to the baby's needs. Winnicott saw this as the mother's task, just as later she had to take the baby through the equally important process of 'disillusion'—a product of weaning, and the gradual withdrawal of the identification with the baby which is part of the initial mothering.

Winnicott argued that it was only on such a foundation that the individual could subsequently develop objectivity or a 'scientific attitude.' He thought that all failure in objectivity, at whatever date, could be related to failure in this stage of development. Clearly, his conception of illusion had taken him beyond Klein's sharp distinction between 'inner' and 'outer' worlds. This is what led him to his famous theory of 'transitional objects and transitional phenomena.' He began to describe what he called 'the third part of the life of a human being, a part that we cannot ignore, an intermediate area of *experiencing*, to which inner reality and external life both contribute.'

Thus Winnicott drew attention to 'the first possession'— those rags, blankets, cloths, teddy bears and other 'transitional objects' to which young children become attached. ('In considering the place of these phenomena in the life of the child one must recognize the central position of Winnie the Pooh,' he wrote.) He saw that the use of these objects belonged to an intermediate area between the subjective and that which is objectively perceived. The transitional object never comes under magical or 'omnipotent' control like an internal object

or fantasy; but nor is it outside the infant's control like the real mother (or world.)

It presents a paradox which cannot be resolved but must be accepted: the point of the object is not so much its *symbolic* value as its actuality. Winnicott often associated the infant's relation to transitional objects with the insoluble disputes within Christianity about the ontological and/or symbolic status of the eucharist. The use of the transitional object, he said, symbolized the union of two now separate things, baby and mother, and it did so 'at the point in time and space of the initiation of their state of separateness.'

In this way he came to posit what he called 'a potential space' between the baby and the mother, which was the arena of 'creative play.' Play, for Winnicott, was itself a 'transitional phenomenon.' Its precariousness belongs to the fact that it is 'always on the theoretical line between the subjective and that which is objectively perceived.' This 'potential space' he defined as 'the hypothetical area that exists (but cannot exist) between the baby and the object (mother or part of mother) during the phase of the repudiation of the object as not-me, that is, at the end of being merged in with the object.'

Thus the 'potential space' arises at that moment when, after a state of being merged in with the mother, the baby arrives at the point of separating out the mother from the self, and the mother simultaneously lowers the degree of her adaptation to the baby's needs. At this moment, Winnicott says, the infant seeks to avoid separation 'by the filling in of the potential space with creative playing, with the use of symbols, and with all that eventually adds up to a cultural life.'

He pointed out that the task of reality acceptance is never completed: 'no human being is free from the strain of relating inner and outer reality.' The relief from this strain, he maintained, is provided by the continuance of an intermediate area which is not challenged: the potential space, originally between baby and mother, is ideally reproduced between child and family, and between individual and society or the world.

In every instance, however, it is dependence on experience which leads to trust. Winnicott saw the potential space as the location of cultural experience. 'This intermediate area,' he wrote 'is in direct continuity with the play area of the small child who is "lost" in play.' He felt it was retained 'in the intense

experiencing that belongs to the arts and to religion and to imaginative living, and to creative scientific work.'

I have ignored important themes in Winnicott's work, such as the way in which he distinguished between psycho-neurosis and psychosis; his writing on the psychology of the psychopath; and his use of a technique of 'psychoanalysis on demand' which led some of his colleagues to complain that he induced 'regression' in his patients by adapting himself too readily to their needs. But I have done so because Winnicott's description of the earliest infant-mother relationship, illusion, transitional phenomena and the potential space is undoubtedly his most significant contribution.

It would be foolish to pretend that Winnicott arrives at an adequate theory of culture. He does, however, begin to indicate a biology of the imagination, and of cultural activity, and to locate their roots in the period of the separating of the self out from that of the mother, which is peculiar to the human species.

His concept of the 'potential space' also begins to point towards a way of avoiding both 'subjectivist' accounts of cultural experience on the one hand, and 'ideological' explanations on the other. It is true that Winnicott considered that the 'potential space' can be looked upon 'as sacred to the individual in that it is here that the individual experiences creative living.' But he also saw that in many cultural activities, 'the interplay between originality and the acceptance of tradition as the basis for inventiveness seems to be just one more example, and a very exciting one, of the interplay between separateness and union.'

Winnicott recognized that if the mother impinged too deeply into, or 'challenged,' the ambiguous character of the infant's emergent potential space, then the latter's potentiality for creative living would be seriously impaired. A similar occlusion of imaginative and creative potentialities may take place on a historic level when through, say, the proliferation of advertising, or of 'socialist realist' restrictions on artistic production the 'potential space' of the adult is diminished, or denied.

1980

INDEX